Art and Thought

New Interventions in Art History

Series editor: Dana Arnold, *University of Southampton*

New Interventions in Art History is a series of textbook mini-companions – published in connection with the Association of Art Historians – that aims to provide innovative approaches to, and new perspectives on, the study of art history. Each volume focuses on a specific area of the discipline of art history – here used in the broadest sense to include painting, sculpture, architecture, graphic arts, and film – and aims to identify the key factors that have shaped the artistic phenomenon under scrutiny. Particular attention is paid to the social and political context and the historiography of the artistic cultures or movements under review. In this way, the essays that comprise each volume cohere around the central theme while providing insights into the broader problematics of a given historical moment.

Art and Thought
 edited by *Dana Arnold and Margaret Iversen* (published)

Art and its Publics: Museum Studies at the Millennium
 edited by *Andrew McClellan* (published)

After Criticism: New Responses to Art and Performance
 edited by *Gavin Butt* (forthcoming)

Architectures: Modernism and After
 edited by *Andrew Ballantyne* (forthcoming)

Envisioning the Past: Archeology and the Image
 edited by *Sam Smiles and Stephanie Moser* (forthcoming)

Art and Thought

Edited by Dana Arnold
and Margaret Iversen

Blackwell
Publishing

© 2003 by Blackwell Publishing Ltd

350 Main Street, Malden, MA 02148-5018, USA
108 Cowley Road, Oxford OX4 1JF, UK
550 Swanston Street, Carlton South, Melbourne, Victoria 3053, Australia
Kurfürstendamm 57, 10707 Berlin, Germany

First published 2003 by Blackwell Publishing Ltd

Library of Congress Cataloging-in-Publication Data

Art and thought / edited by Dana Arnold and Margaret Iversen.
 p. cm. – (New interventions in art history; 1)
 Includes bibliographical references and index.
 ISBN 0-631-22714-8 (hardcover: alk. paper) – ISBN 0-631-22715-6
 (pbk.: alk. paper)
 1. Arts – History. 2. Arts – Philosophy. I. Arnold, Dana. II. Iversen,
 Margaret. III. Series.
 NX440.A78 2003

 2002011112

A catalogue record for this title is available from the British Library.

Set in 10.5/13pt Minion
by Graphicraft Limited, Hong Kong
Printed and bound in the United Kingdom
by MPG Books Ltd, Bodmin, Cornwall

For further information on
Blackwell Publishing, visit our website:
http://www.blackwellpublishing.com

Contents

 Stephen Melville

9 Museum as Work in the Age of Technological Display:
 Reading Heidegger Through Tate Modern 174
 Diarmuid Costello

10 *Eyes Wide Shut*: Some Considerations on Thought and Art 197
 Adrian Rifkin

 Bibliography 209
 Index 216

Notes on Contributors

Dana Arnold is Professor of Architectural History at the University of Southampton and Director of the Centre for Studies in Architecture and Urbanism. She is the series editor of *New Interventions in Art History*, general editor of two further series published by Blackwell, *Companions to Art History* and *Anthologies in Art History*, and editor of the journal *Art History*. Her recent publications include *Reading Architectural History* (Routledge, 2002), *Re-presenting the Metropolis: Architecture, Urban Experience and Social Life in London* (Ashgate, 2000), *The Georgian Country House: Architecture, Landscape and Society* (Sutton, 1998), and the edited volumes *The Metropolis and its Image: Constructing Identities for London c.1750–1950* (Blackwell, 1999) and *The Georgian Villa* (Sutton, 1996). She is the author of the forthcoming *A Very Short Introduction to Art History* (Oxford University Press, 2003).

J. M. Bernstein is presently University Distinguished Professor of Philosophy at the New York School for Social Research, having taught previously at Vanderbilt University. He is author of the *Fate of Art* (Polity Press, 1991), *Recovering Ethical Life* (Routledge, 1995), and most recently, *Adorno, Disenchantment and Ethics* (Cambridge University Press, 2001). A book of essays on aesthetics and painting provisionally entitled *Against Voluptuous Bodies, and Other Essays for a Late Modernism* is forthcoming.

Diarmuid Costello is Senior Lecturer in Contemporary Art Theory in the School of Humanities, Arts and Languages at Oxford Brookes University. He has published "Lyotard's Modernism" in *To Jean-Francois Lyotard* (a

special issue of *Parallax*, October 2000) and " 'Making Sense' of Nonsense: Conant and Diamond Read Wittgenstein's *Tractatus*" in Barry Stocker (ed.), *Post-Analytic* Tractatus: *A Reader* (Ashgate, 2001). He is currently working on a book on aesthetic theory and contemporary art.

Margaret Iversen is Professor of Art History and Theory at the University of Essex, England. She is author of a book on a founder of the discipline, *Alois Riegl: Art History and Theory* (MIT, 1993), and one on the feminist artist Mary Kelly (with Douglas Crimp and Homi Bhabha) (Phaidon, 1997). She edited a special issue of *Art History* called *Psychoanalysis in Art History* (vol. 17, no. 3, September 1994) which included her article, "What is a Photograph?" A book entitled *Art Beyond the Pleasure Principle*, on psychoanalytic art theory, is forthcoming.

Amelia Jones is Professor in the Department of Art History at University of California, Riverside. She has published most recently the book *Body Art: Performing the Subject* (University of Minnesota Press, 1998), a co-edited anthology entitled *Performing the Body/Performing the Text* (Routledge, 1999) and has edited the volume *Feminism and Visual Culture Reader* (Routledge, 2002). She is currently completing a book rethinking the historic avant-garde, focusing on New York Dada.

Stephen Melville is Professor of the History of Art at Ohio State University. His research interests include contemporary art theory and historiography. He has published widely on contemporary art as well as on issues in contemporary theory and historiography. Recent publications include *As Painting: Division and Displacement*, with Laura Lisbon and Philip Armstrong (MIT, 2001), *Seams: Art as a Philosophical Context*, edited and introduced by Jeremy Gilbert Rolfe (Gordon and Breach, 1996), *Vision and Textuality*, (editor, with Bill Readings) (Duke University Press and Macmillan, 1995), and *Philosophy Beside Itself: On Deconstruction and Modernism, Theory and History of Literature*, vol. 27 (1986).

Michael Podro's academic achievements lie in the fields of aesthetics, art theory, and the historiography of art history. His work has initiated a fruitful dialogue between art historians and philosophers. He is the author of three books: *The Manifold in Perception: Theories of Art from Kant to Hildebrand* (Oxford University Press, 1972), *The Critical Historians of Art* (Yale University Press, 1982), and *Depiction* (Yale University Press, 1998). He is Professor Emeritus at the University of Essex.

Griselda Pollock is Professor of the Social and Critical Histories of Art and Director of AHRB Centre for Cultural Analysis, Theory and History at the University of Leeds. She has published widely on the issues of gender, race, and class in the formations of modernism in late nineteenth-century Europe and America and the history of women in the visual arts. Her new research areas include issues of trauma, history and memory after the Holocaust, and Jewish Art and Modernity, focusing on the work of Charlotte Salomon, on which she is preparing a monograph. Recent publications include *Looking Back to the Future: Essays on Art, Life and Death* (Routledge 2000), *Differencing the Canon: Feminist Desire and the Writing of Art Histories* (Routledge, 2000), *Generations and Geographies in the Visual Arts: Feminist Readings* (Routledge, 1996), *Avant-Garde Gambits: Gender and the Colour of Art History* (Thames and Hudson, 1992), *Vision and Difference: Femininity, Feminism and the Histories of Art* (London: Routledge, 1988), *Framing Feminism: Art and the Women's Movement, 1970–1985* (co-authored with Rozsika Parker) (Pandora Books, 1987), *Old Mistresses: Women, Art and Ideology* (co-authored with Rozsika Parker) (Pandora Books, 1981), and *Mary Cassatt* (Jupiter Books, 1980).

Alex Potts is Professor of Art History at the University of Michigan at Ann Arbor and an editor of *History Workshop Journal*. He is author of *Flesh and the Ideal: Winckelmann and the Origins of Art History* (Yale University Press, 1994) and *The Sculptural Imagination: Figurative, Modernist, Minimalist* (Yale University Press, 2000), and contributor to G. Johnson (ed.), *Sculpture and Photography* (1998), A. Rifkin (ed.), *About Michael Baxandall* (Blackwell, 1999), and J. Pemble (ed.), *John Addington Symonds: Culture and the Demon Desire* (Palgrave, 2000).

Thomas Puttfarken, Professor of the History and Theory of Art at the University of Essex, England, is internationally recognized as a leading expert on Italian and French art and theory before 1800. He is the author of *Roger de Piles's Theory of Art* (Yale University Press, 1985). His latest book, *The Discovery of Pictorial Composition: Theories of Visual Order in Painting 1400–1800*, was published in 2000 by Yale University Press.

Adrian Rifkin is Professor of Visual Culture and Media at Middlesex University. His recent books include *Ingres Then, and Now* (Routledge, 2000) and *Street Noises* (Manchester University Press, 1993), and the edited volumes *Other Objects of Desire: Collectors and Collecting Queerly* (with

Michael Camille, Blackwell, 2001); *Fingering Ingres* (with Susan Siegfried, Blackwell, 2000); and *About Michael Baxandall* (Blackwell, 1998).

Jonathan Vickery is Lecturer in the History of Art at the University of Warwick. Previously he was Henry Moore Post-Doctoral Research Fellow in the Department of Art History and Theory, University of Essex. He is preparing a book on sculpture and theory in the 1960s.

Series Editor's Preface

New Interventions in Art History was established to provide a forum for innovative approaches to and perspectives on the study of art history. In this initial volume the way in which the discipline itself seems to be expanding and dispersing is the focus of enquiry. Traditional disciplinary boundaries are giving way to a productive exchange between art history and a wide range of disciplines. As a result art historians have become increasingly reflective about the nature of their field of enquiry and questioning of the limits of what counts as art history's objects and methodologies.

The original essays gathered here engage debate at a point where art history and philosophy intersect. In this volume distinguished writers in both disciplines test out new ways of harnessing philosophical concerns – epistemological, aesthetic, and ethical – for the practice of art history to present a theoretically refined and accessible analysis.

Art and Thought aims to present an incisive investigation into the intellectual preoccupations which inform the complex narratives of our aesthetic culture. It introduces the reader to the work of a broad range of thinkers, including Aristotle, Descartes, Kant, Heidegger, Merleau-Ponty, Lacan and Kristeva, in relation to works of art from Titian's paintings to the architecture of Tate Modern.

Dana Arnold
London, August 2002

Editors' Introduction

Art historians have become increasingly reflective about the nature of their discipline, perhaps prompted by the way the discipline seems to be expanding and dispersing. One way of responding to the challenge of this dispersion is to retrench, to police the borders where art history apparently exceeds its proper domain, and to find a determinate definition of Art History's objects and methodologies. Another response, the one pursued in this volume, is to engage debate precisely at those points where the boundaries are opening up. One such point, called "art theory," amounts to a give and take between art history and philosophy. This overlap does, of course, have a traditional and central role in the founding of the discipline by Riegl, Wölfflin, Warburg, Panofsky, and those other German speaking scholars whom Michael Podro called the critical historians of art. The revival of interest in their work is symptomatic of our reflexive mood. The essays gathered here, however, do not return to the work of the critical historians, but rather test out new ways of harnessing philosophical concerns – epistemological, aesthetic, ethical – for the practice of art history. Most often these concerns are found to be at the heart of the art under scrutiny, so that it is not a matter of bringing philosophy to the inarticulate matter of art, but rather of drawing out the ways in which art "thinks."

This "philosophical" self-understanding of art is different from the one that prevailed in the Renaissance. As Thomas Puttfarken's opening essay, "Aristotle, Titian, and Tragic Painting," makes clear, the model for understanding the way art thinks was at that time literary. This took the form of an analogy with the art of rhetoric as in Alberti or a Horatian sense of the fundamental similarity of painting and poetry. But these analogies are

quite different from the claim that Puttfarken makes with respect to Titian's mythological paintings. He argues that the influence of Aristotle's *Poetics* on Titian led him to invent a dramatic form of tragic painting. This approach is a challenge to the two competing and equally problematic interpretations of Titian's late mythological cycle, one which seeks to attach allegorical, moral or Christian significance to the histories that Titian painted so voluptuously and the other which emphasizes the sheer erotic provocation of the female nudes. Puttfarken argues that Titian followed Aristotle in painting moments of recognition and peripety and by compressing a logical sequence of events into a single frame in a way that arouses pity and fear. The (male) viewer's erotic contemplation of the female nude recapitulates the moment of downfall of the tragic hero, implicating him in the story's motivation and consequences. Here there is no contradiction between the seductive artistry of the painted scene and the revelation of a moral truth.

Jay Bernstein's paper, "Wax, Brick, and Bread: Apotheosis of Matter and Meaning in Seventeenth-Century Philosophy and Painting," makes the transition to the modern articulation of art and thought which has to do with conceiving of art as a form of knowledge. In his essay, Bernstein proposes two contrasting models or theories of knowledge summed up by the figures of a piece of wax and a brick wall. The piece of wax refers to Descartes' famous thought experiment in the Second Meditation where the substance changes all its perceptible properties when subjected to fire. Descartes concludes that our conception of the wax is not something available to the senses, but an ideal object transparent to the mathematical gaze. Bernstein contrasts this Enlightenment delegitimation of sensory knowledge with an alternative model of knowledge that is manifested in the painting of Pieter de Hooch. The finely rendered brick walls in de Hooch's courtyard scenes stand as testimony to the artist's attention to and knowledge of everyday sensuous reality that is now lost to us. Dutch art represents, for Bernstein, "a challenge to the claims of Cartesian Enlightenment" and so also "a powerful critique of rationalized modernity."

If Bernstein uses the distance between the brick wall and the piece of wax as mathematical object to illustrate a gap that has opened up between art and science, observation and discursive thought, mind and body, Podro sees the exceptional closing of this gap in the experience of the beautiful as proposed by Kant in his *Critique of Judgment*. Michael Podro argues in "Kant and the Aesthetic Imagination" that, although Kant excluded judgments of the beautiful from his theory of knowledge, they are set in relation

to cognition via his notion of the reflexivity of aesthetic judgment. This means that, instead of the concept dominating the object as in cognition, the object in all its sensible particularity is held in imagination while the understanding tries to make sense of it. The kind of satisfaction one derives from aesthetic contemplation is, then, not merely sensuous, but a harmonious relation of the faculties, ordering both capacity and sensory receptivity. One enjoys the spontaneity of the mind's constructive activity while at the same time appreciating the way the object seems fit for this activity. This latter aspect has the further implication that our immersion in the phenomenal world need not limit our freedom. The centrality of this text for all subsequent philosophical speculation about the relation of art and thought can hardly be over emphasized.

The themes pursued in Bernstein's and Podro's papers are given a feminist interpretation in Amelia Jones's contribution, "Meaning, Identity, Embodiment: The Uses of Merleau-Ponty's Phenomenology in Art History." Bernstein observes the relative autonomy de Hooch gives his women as compared with those we see through Vermeer's desiring gaze. And Podro alludes to the sense of gesture, as developed by Maurice Merleau-Ponty, to elucidate the way we might think about art spanning the gap between art and thought. Jones is interested in both these issues, but more especially in the way we might, as spectators, find a way of including the body in our encounters with art. She challenges the abstraction of Descartes and the disinterestedness of Kant by situating Courbet's notorious *Origin of the World* in a mesh of particular desiring identities of artist, subject, patron, and interpreters. She draws on the phenomenology of Merleau-Ponty, particularly his sense of one's embodied subjectivity and intersubjective relations. Subject and object are chiasmicly intertwined in "the flesh of the world." Extrapolating from this, Jones argues that it is impossible to interpret a work of art without it impinging on and changing us. However, Jones goes further than Merleau-Ponty by insisting that we take account of the specific identity of the embodied subjects whether they are painting, interpreting or depicted.

If, as Amelia Jones's essay testifies, Merleau-Ponty's work has been mainly associated with efforts to formulate an account of our relation to things as embodied and non-verbal, Alex Potts draws out the limitations of this view. His essay, "Art Works, Utterances, and Things," intervenes in one of the most contested debates in twentieth-century art theory – the question of the relation of language and visual art. Potts's key text is Merleau-Ponty's "Indirect Language and the Voices of Silence," first published in

1952.[1] It was a riposte to André Malraux's *Voices of Silence*, a book that celebrated the mute expressivity of art works as presented in the "imaginary museum" – the spectacle of decontextualized images created by modern museums and collections of photographic reproductions. Merleau-Ponty countered Malraux's view of art on the grounds that the immediate visual effect of an art work could not convey the historical and conceptual awareness articulated in language. The art object does not speak to us in the way a text does. In this he anticipated later Conceptual artists who actively opposed the idea that art had a meaning that could be projected at a purely visual, non-linguistic level. At the same time, Merleau-Ponty conceived of art as activating a mute embodied sense shared by verbal utterances. These too he thought of as intersubjective acts whose substance formed part of the fabric of everyday life. In common with later writers who critiqued a modernist privileging of visual form, Merleau-Ponty had a political motivation for stressing the way works of art are embedded in the "accident of the milieu out of which they are born." The imaginary museum of Malraux, in contrast, erases the contingency of art objects by presenting them as reified images that emit a silent, transcendent meaning. Something essentially caught up in all the complexity of human interaction, including its uglier aspects, is served up as something subjective, individual, and intuitive.

All of the essays in this volume raise questions about the ethics of looking – some indirectly, some emphatically. This is also what particularly concerns Jonathan Vickery in his essay, "Art and the Ethical: Modernism and the Problem of Minimalism." The essay goes to the heart of what has been one of the most important and persistent debates since the late 1960s. He asks what was at stake in the confrontation of modernist aesthetics, as exemplified by Michael Fried's position, and Minimalism. Vickery proposes that the reason why Fried's "Art and Objecthood" has elicited such response is that it involved serious claims about the nature of art and thought. In order to deepen our understanding of Fried's argument, he relates Fried's essay to the work of his intellectual interlocutor, Stanley Cavell. Modernist art, on this account, resists the rationalization of contemporary society and its form of knowledge. Cavell and Fried value it because of its capacity to overcome the Cartesian diremption of the particular and the general, the sensual and the conceptual, subject and object. Fried, like Kant, sought the value of aesthetic experience in its reflexivity, that is, its capacity to reveal something about the nature of our knowledge of the world, especially its conditioned, limited, conventional character. We

acknowledge its otherness in the way we ideally do confronting another person – endowing it with "presentness," beyond its presence as an object.

Griselda Pollock's "Does Art Think?" pursues what has emerged as one of the most insistent themes in this volume: the place of art between the body or sense experience and language or thought. Pollock addresses this issue by exploring the triangulation of feminist theory, artistic practice, and psychoanalysis. She draws on the writing and art practice of Bracha Lichtenberg Ettinger who proposes an archaic form of quasi-representation, the pictogram, situated between corporeal intensities and thought. If such a psychic register can be posited, there is scope for innovative forms of cultural representation close to feminine experience and phantasy, but not reducible to the female body. As Pollock's subtitle "How Can We Think the Feminine Aesthetically?" suggests, an engagement with the art practice of women may be one way of beginning to think differently, to alter the current symbolic order that so one-sidedly corresponds to masculine experience. As Julia Kristeva argued, poetry and art draw on archaic sources, pre-oedipal, pre-symbolic, allowing the artist/theorist to generate new signifiers articulating what is excluded from language and thought. Working in this way, a feminist artist would be able to make inroads into what is currently unthinkable. As Lichtenberg Ettinger puts it, "Artists continually introduce into culture all kinds of Trojan horses form the margins of their consciousness; in that way the limits of the Symbolic are transgressed all the time by art."

One of the key debates of the last decades of the twentieth century concerned the question of what constitutes post-modernism in the visual arts. Stephen Melville's essay approaches the question from an oblique and original angle, asking instead, "What was Postminimalism?" Melville takes his lead from Rosalind Krauss's important essay of 1979, "Sculpture in the Expanded Field".[2] In order to understand the nature of contemporary "sculpture," she argues, we have to cease thinking of it as a set of objects with certain properties and instead conceive of it as a system constituted by the pair of terms landscape/architecture, their negations and combinations. Melville draws out the similarity between Krauss's expanded field of sculpture and Hegel's "system of the arts." It is as though the reductive Kantianism of Greenberg or Fried, is opened up through this contact with Hegel. Melville tests this idea of Postminimalism or Post-Modernism against the work of Robert Smithson, an enduring touchstone of contemporary art. His mirror displacements in outdoor sites, gallery constructions, photographs, and texts inscribe within them a consciousness

of their "dialectical" status, that is, of their not being freestanding works. The surprising conclusion that Melville draws from this is that contemporary art is closer in spirit to Hegel's description of the moment of painting, which unlike the moment of the primacy of sculpture, knows itself to be ultimately inadequate to its aims and only able to sustain itself as a term in the system of the arts.

Against Melville's emphasis on painting and its internal division, Diarmuid Costello appears to find his dominant art in architecture. Costello engages in this discussion by taking Tate Modern – its architecture, spectacle, crowds, non-chronological displays – as a true work of art of our age. While Melville found in Hegel a way of describing the contemporary condition of art, Costello turns to Heidegger. He makes unorthodox use of the philosopher's conception of the work of art as a strife between world and earth in order to make Heidegger's thinking productive for debates in contemporary art theory. The work of art, according to Heidegger, is the "opening of a world," a form of life that is distinctive and new. The Greek temple is one example he offers of a work in this special sense. Yet the work also makes the "earth," the opaque materiality of the stone and rocky surrounds, "shine forth." Costello's paper aims to show that the relation between the building, the works that it houses and the way they are displayed, taken as a totality at Tate Modern and other large art spaces such as the Guggenheim Bilbao, are the functional equivalent for our time of the Greek temple.

The essay by Adrian Rifkin is placed last in this volume, not just because it attempts an overview of possible ways of conceiving the relation between art and thought, nor because its central exhibit, Stanley Kubrick's film *Eyes Wide Shut*, is recent. Rather, it is because his approach is so singular and experimental. In their various ways, all the papers straddle the disciplinary boundaries between art history and philosophy. Rifkin takes psychoanalysis as his main point of reference, and in this respect his essay is most closely related to Pollock's. Drawing on the writing of Julia Kristeva, both are concerned to articulate art's proximity to what we have not yet been able to think. Although a thought may seem to be first adumbrated in art, Rifkin wishes to avoid the sequential, causal logic this observation may imply. Rather he looks to the achronicity of the unconscious or the "deferred action" of trauma to understand the relation of art and thought. For example, the ceiling of a church in Rome that shifts between trompe l'oeil and flat paint, mimes Lacan's theoretical insight into the way we slip in and out of subjectivization in the symbolic. Or, Goya's

famous print, *The Sleep of Reason Produces Monsters*, is a thought that can only be articulated post-Freud, post-Holocaust: "It is a symptom of something that will have happened." For Rifkin, *Eyes Wide Shut* has a structure, or unstructure, that engages the spectator's oblique awareness of what is on the screen. This type of reverie may be the best place for thought to begin.

We began with Puttfarken taking issue with the two competing interpretations of Titian's paintings as high-minded Christian allegory or high-class soft porn. In retrospect, these diverse views can now be seen as symptomatic of a fault line running through our culture. The Cartesian Enlightenment, as Bernstein described it, is apparently still very much with us, separating mind from body, discursive thought from sense experience, and making our reception of art problematic. Kant's conception of the Beautiful, as Podro makes clear, was an attempt to bridge that gap, as were the subsequent phenomenological investigations of Merleau-Ponty invoked by Jones and Potts. Vickery also indicates that Cavell and Fried owe much to this phenomenological tradition. The penultimate two essays have more of a historiographic agenda, although they too draw on phenomenology. Both attempt to conceptualize the condition of contemporary art and both advance the view that we are prevented from thinking about recent art properly by our outmoded, reified conception of the individual work of art. If Melville imagines an expanded field of practices that should find an echo in our art historical and critical practices, Costello presents the possibility of a new and difficult barrier to our traditional practice: if the authentic contemporary work of art is best exemplified by the whole complex that is Tate Modern, then what becomes of the individual works of art it houses? How can they retain their density and opacity in this environment? What is perhaps most notable in both these conclusions is the premium both these essays place on criticism and description rather than interpretation within the practice of art history. This may indeed be the most salient consequence of any effort to address art as a mode of thought. Pollock and Rifkin would concur as both regard the enigmatic core of art, its baffling character, as the surest indication that art really does think, but in ways that we do not as yet have words to describe.

This volume is part of a growing body of literature that re-evaluates the theories and practices of art history. Michael Podro's groundbreaking book, *The Critical Historians of Art* (1982) opened the field of art history to reflection by recalling its highly philosophical origins. Donald Preziosi's *Rethinking Art History* 1991 provided an overview of the theoretical and institutional history of the discipline of art history which refutes the image

of art history as in crisis, asserting rather that many of the dilemmas of the discipline today can be traced back to its founding, institutionalization, and expansion since the 1870s. This expansion of the discipline of art history has required a reassessment of methods and terminology. Robert Nelson and Richard Shiff's helpful edited volume, *Critical Terms for Art History* (1996) is both an exposition and a demonstration of contested terms from the current art historical vocabulary, reading each through current debates and methods. Some recent work addresses the most basic questions about cultural production, questions such as how images function and how expectations and social factors mediate what we see. These questions are the concern of *The Subjects of Art History* edited by Mark A. Cheetham, Michael Ann Holly, and Keith Moxey (1998). It examines the historiography and theoretical approaches of the history of art and provides interpretations of the history and contemporary relevance of such important methodologies as semiotics, phenomenology, feminism, gay and lesbian studies, museology, and computer applications. In both the latter two volumes different theoretical modes of analysis and interpretation are explored by demonstrating how a particular approach can be applied to the understanding and interpretation of specific works of art.

Marxist sociological models of the analysis of visual culture or the psychoanalytical preoccupations of cultural studies set up a dynamic where theory informs the object at the expense of a consideration of the aesthetic. These theoretically-driven approaches can be seen as being in opposition to a more traditional form of art history with its emphasis on formal and iconographic analysis. In contrast to these antithetical methods of analysis, this volume explores the aesthetic as a means of mediating the relationship between the senses and thought with particular emphasis on post-Kantian philosophy and how the art itself informs these modes of thinking. This allows us to explore the tradition of the aesthetic as distinct from other models for the consideration of art which may place more emphasis on sociology or the effects of mass culture, both of which merit volumes in their own right.

Notes

1 M. Merleau-Ponty, "Indirect Language," *Signes* (Paris: Gallimard, 1960).
2 Rosalind Krauss, "Sculpture in the Expanded Field," *The Originality of the Avant-Garde and Other Modernist Myths* (Cambridge, Mass.: MIT Press, 1985).

1

Aristotle, Titian, and Tragic Painting

Thomas Puttfarken

Pin-ups or Christian Allegories?

Titian's mythological paintings have presented modern art historians with major problems of interpretation. This is not unrelated to his free and ample use of the female nude. The late cycle for Philip II of Spain is a case in question, as here the erotic assumes a central and thematic role. Opinions differ widely as to whether these pictures are the Renaissance equivalent of pin-ups and centerfolds, or highly esoteric and learned allegories. On the one hand there is no doubt that the erotic nudity is deliberately emphasized and made central to the appearance of the works; and this may appear to sit easily with the pictures' main literary source, Ovid's *Metamorphoses*. On the other hand, however, the patron was the Most Catholic Prince and then King of Spain, Philip II.

One way, often tried, to reconcile the blatant eroticism of both Titian's pictures and Ovid's poem with the militantly catholic disposition of the Spanish king, is to look at the poetic text in the light of the medieval *Ovid-moralisé*-tradition, which interpreted the *Metamorphoses* and other pagan stories in a Christian sense. In this tradition, one could accept the obvious nudities as superficial ornamentation behind which one would search for a deeper and more virtuous meaning.

Erwin Panofsky, for instance, quoted Franciscus de Retza's *Defensorium inviolatae virginitatis Mariae*, where "all the fairy tales of pagan myth and legend are used as 'proof' of Christian truth": "If Danae conceived from Jupiter through a golden shower, why should the Virgin not give birth when impregnated by the Holy Spirit?"[1] In this tradition Danae is a pagan

prefiguration of the Virgin Mary; her offspring, Perseus, then becomes a prefiguration of Christ: he liberates Andromeda/the Church/or the human soul from the sea-monster/the Devil. The pagan myth is turned into "a metaphor for Christ's salvation of mankind from Satan and His destruction of sin."[2] Even an obviously cruel theme like the death of Actaeon can be moralized and Christianized: Diana sprays the unfortunate youth with water, a reference to Christian baptism in which immersion in or sprinkling with water signifies the death of the old Adam.

Are such interpretations appropriate to Titian's works? Harald Keller[3] and, more recently, Jane Nash have claimed that they are. Keller saw the whole cycle as a Mirror of Princes, a reminder of ancient paradigms of virtuous behaviour. Unfortunately, his lengthy article fails to provide a convincing argument. Nash is more circumspect and offers an impressive array of supporting texts. She points out that as late as the second half of the sixteenth century, there were editions of Ovid's *Metamorphoses*, to which were added prefaces pointing to the allegorical Christian meaning behind the pagan fables. This was particularly true of Spain.

> In the most popular Spanish translation of the *Metamorphoses*, Jorge da Bustamente's *El libro de Metamorphoseos y fabulas del excelente poeta y philosofo Ovidio*, which first appeared in 1545, the author consciously set out to uncover for the common reader the Catholic dogma that he claimed was prefigured in the myths. To do so Bustamente emphasized the symbolic character of the myths, and drawing on medieval writers such as Saint Augustine and Isidore of Seville, he submitted every episode of Ovid's text to a moralizing interpretation until the *Metamorphoses* was itself metamorphosed into an explication of Catholic doctrine.[4]

Bustamente's translation remained the dominant one in Spain, and would, therefore, have provided the standard for mythological interpretation at the time when Titian's paintings arrived at Philip's court.

In Italy, the most important new translation was by Titian's acquaintance Lodovico Dolce. His version, of 1555, was dedicated to Philip's father Charles V; and while his text is not moralizing, a prefatory letter reminded the Emperor "that under the myths' apparent frivolous narratives lie instructive moral examples of vice and virtue".[5] While the possibility of reading these fables pleasurably for their own sake is generally admitted, it is emphasized that in doing so one would miss their true significance. Surely, so the argument goes, Philip, as the Most Catholic Prince and

King, would have been expected to appreciate a more esoteric Christian meaning in Titian's mythological paintings; in fact, he would have commissioned the cycle for this very purpose. According to this account, the very *persona* of the patron would prohibit a purely erotic or otherwise merely pleasurable response.

This argument, however, has to overcome some difficulties. The first one is that there is very little evidence that pictures (unlike texts) were actually read in such a moralizing or allegorizing way, or that they were commissioned with such readings in mind. The "allegorizing" tendency, in suggesting that there is a higher, more important meaning behind the erotic surface, does not actually explain *why* the surface, if that is what it is, is as erotic as it is. Surely the higher, intellectual sense of the picture could have been "hidden," if that was what was required, behind a less seductive and titillating surface. The possible argument that the erotic surface represented a moral temptation, that needed to be overcome, for true virtue to engage in the allegory, has – to my knowledge – never seriously been made.

There is a further complication in that an allegorizing interpretation normally presupposes a learned patron or adviser who controls the commission and who prescribes the relationship between overt pictorial surface and hidden meaning. In the case of Titian and the Prince of Spain our, admittedly limited, evidence suggests that the decision what to paint was Titian's, not Philip's. The Prince seems to have been unaware of what to expect next, yet he never seems to have complained about the female nudes sent to him from Venice.

If Titian had been helped by a learned adviser, he would not have been found at the Spanish court, but among his own friends in Venice. The closest among these friends was Pietro Aretino, not only a man of great and genuine erudition, but also the author of lascivious, libellous and outright pornographic texts, and an unlikely source of Christian moralizing.

Painting and Poetry

Some modern critics have tried to ease the problems of interpretation by pointing to the fact that Titian himself refers to his paintings after Ovid as *poesie* or *favole*. As a critical term of painting, *poesia* seem to emerge in the 1540s and '50s. According to Rensselaer W. Lee, the Venetian theorist Lodovico Dolce, in 1557, was the first to claim expressly for painting the

Horatian *ut pictura poesis*.[6] Later Armenini and others would distinguish between *istoria*, *poesia*, and *devozione* as the *genera* of painting. While *istoria* and *devozione* had to be true to historial or doctrinal texts, *poesia* gave the artist a certain poetical freedom to demonstrate his *invenzione*.[7] This concept of poetry as applied to painting has been used by some writers as an excuse to avoid precise and detailed interpretation. Poetry, it is assumed, is an evocative genre,[8] and it is in its nature to be ambiguous or merely suggestive.

However, even a superficial reading of Bernard Weinberg's monumental *History of Literary Criticism in the Italian Renaissance* should raise serious doubts about the appropriateness of such a definition of poetry as a fundamentally vague, emotive, and evocative genre.[9] This would seem to be a definition appropriate to the Romantic Age, not that of the Renaissance. Two texts dominated discussions about poetry in the Renaissance, Horace's *Ars Poetica* and Plato's *Republic*. Horace's was the more established and, initially, the more authoritative text. Plato's *Republic* was a relative newcomer. A third text, Aristotle's *Poetics*, began to make its impact only around the middle of the century – a point which is important for my argument.

Plato's text with its condemnation of the imitative arts had put the writers of poetics on the defensive. Horace's "aut prodesse aut delectare" was reduced to the simple requirement that poetry must teach and instruct. Only in its didactic purpose lies the *utile* of poetry, its usefulness. So in Pedemonte's *Poetica* of 1546: "Those provide utility, I say, who communicate in verse the precepts of the disciplines and of the arts, especially the precepts which are called moral, and who teach the norm of proper living . . ."[10] It is the task of poets, he says, "to envelop, in the wrappings of fables, doctrinal mysteries and moral instructions and a way of life." Pedemonte thus defines the "chief utility of poetry as residing in an allegorical function . . ."

Similarly Benedetto Varchi who, in 1553/4, compares Horace and Aristotle. He continues to argue in Horatian terms: "Much of what (Varchi) has to say . . . relates to the end of utility, which he sees as essentially a form of teaching. What is taught is primarily lessons for ethics, secondarily information pertaining to all branches of knowledge: the rewards of virtue, the punishments for vice, the elements of the sciences." "Those alone," says Varchi, "merit all praise who remove men from the vices and inspire them to the virtues; then the others, as they do this more or less, are to be more or less praised and held in esteem." Before we jump to the

conclusion that statements like this might be taken as justifying a pro-
foundly allegorical interpretation of Titian's Ovidian paintings, we should
note that Varchi regards Ovid and Catullus *not* as potentially Christian,
but as outright "obscene poets," who should be punished and, in keeping
with Plato's recommendation, banished from the state, alongside all satir-
ical poets.[11]

We could easily prolong this list of quotations; most of the poetics
written before or around the middle of the century do not allow for a
vague, evocative poetry. They demand a clear moral message. According
to their definition of *poesia*, the allegorical cycles painted around this time
by Florentine artists like Vasari and Zuccaro, after complicated programmes
by Annibale Caro or Cosimo Bartoli , would deserve the name of *poesia*
more than any of Titian's Ovidian paintings.

However, there developed over the 1540s and early '50s an alternative
way of thinking about poetry, and that was based on Aristotle. It still does
not allow for a definition of poetry as "evocative," but it shifts emphasis
from sententious moralizing to formal structure and the control of the
audience's responses.

Control of the audience's responses was, to a large extent, a function of
the *affetti*, again largely derived from Horace:

> As men's faces smile on those who smile, so they respond to those who
> weep. If you would have me weep, you must first feel grief yourself: then, O
> Telephus or Peleus, will your misfortunes hurt me . . . (101–4)[12]

Alberti had translated Horace's poetical rules (and Quintilian's rhetorical
ones) for pictorial use,[13] and Hans Belting has argued that this kind of
Horatian/Albertian expressiveness found its perfect visualization in works
like Bellini's Brera *Pietà*, where a little *cartello* carries the inscription *HAEC
FERE QUUM GEMITUS TURGENTIA LUMINA PROMANT/BELLINI
POTERAT FLERE IOANNIS OPUS* – "When these swelling eyes evoke
groans this (very) work of Giovanni Bellini could shed tears."[14]

Horace's, Quintilian's and Alberti's were precise, but relatively moder-
ate expressions of passions, emanating from the features, the bearings
and movements of individual figures, their natural or deliberate, artful
pronuntiatio. Our ability and willingness to mimic, to imitate by sym-
pathy, circumscribes and limits the strength of the passions displayed and
impressed upon us; as listeners and viewers we do not like to hear or view
extravagant expressions, as we do not like to be overcome by them.

It is in line with this sense of restraint, that elsewhere in his *Ars Poetica* Horace himself warns against the display of stronger expressions, as those that would result from the open representation on the stage of cruel and fear-inducing actions, "so that Medea is not to butcher her boys before the people, nor impious Atreus cook human flesh upon the stage, nor Procne be turned into a bird, Cadmus into a snake. Whatever you thus show me, I discredit and abhor."[15] Alberti would have agreed.

Titian had already sinned against the Horatian rule on moderation in the depiction of cruel and fearful actions. On the grand and public stage of the altarpiece he had departed from tradition by showing – in the *Death of St. Peter Martyr* of 1530 – a brutal murder in bright daylight; and the *Crowning with Thorns* in the Louvre (1540–2) is another example of large-scale presentation of extreme cruelty, clearly exceeding our sense of mimicking sympathy and quite unusual in Italian art of the sixteenth century. Later, in the two versions of the *Martyrdom of St. Lawrence* (Venice, Gesuiti, ca. 1548–57 and Old Church, Escorial, 1564–7) Titian depicts the cooking of human flesh on stage with considerable dramatic success. And what I am going to suggest is that in much of his later work, Titian deliberately sets out to achieve stronger emotional effects than those suggested as acceptable by Horace. I shall argue that the effects he is aiming at are much closer to those which Aristotle describes as tragic.

The Rediscovery of Aristotelian Tragedy

Dates are of some importance for my argument. Aristotle's *Poetics* had been available in print in Valla's Latin edition of 1498, which remained curiously inconsequential. The first half of the sixteenth century was dominated, in the field of poetics, by Horace and Plato, and in the field of tragic writing, as in Giangiorgio Trissino's and Giraldi Cinthio's tragedies, by the example of Seneca. The real discovery of Aristotle by theorists and practitioners of poetry came about in the '40s and resulted in a series of commentaries, among them Francesco Robortello's of 1548 and Vincenzo Maggi's of 1550, as well as Bernardo Segni's Italian translation of 1549.[16] Tasso later called the rediscovery of Aristotle's *Poetics* the greatest stroke of luck of the whole century, and what he had in mind were the activities of the '40s.[17]

Both Robortello and Maggi were professors at the university of Padua, as was Sperone Speroni, who seems to have initiated the public debate

about the true nature of tragedy when he composed his own tragic drama, the *Canace*, and read it to the *Accademmia degl'Infiammati* in 1542. When it was printed in 1546 and, again, in 1550, "it touched off a critical controversy that explored the whole theory of neoclassical tragedy."[18] We can be sure that this controversy did not bypass Aretino and his friends, of whom Titian was the closest. Aretino's literary circle included, among many others, Sperone Speroni, Fracastoro, and Daniele Barbaro. The importance which tragedy played in their discussions can hardly be overestimated: not only did Aretino personally know the main protagonists of the public debate about tragedy, he himself, having written five comedies, responded to and fuelled the discussion around Aristotle further by writing and publishing, in 1546 and again in 1549, his own important tragedy *Orazia* which still inspired Racine a hundred years later. And Aretino was not the only member of Titian's circle to participate actively in the revival of Aristotelian tragedy; Lodovico Dolce, who had already written five comedies between 1540 and 1550, published translations of tragedies by Seneca and Euripides, from the *Thyeste* of 1543 to *Le Troianne* of 1566, in addition to producing two major new tragedies of his own, the *Didone* of 1547 and *Marianna* of 1565.[19]

We know that Aretino was not keen on academic learning,[20] and we may doubt whether he ever read any of the lengthy commentaries written by friends and acquaintances like Maggi, who had dedicated to him an earlier work of his, or Robortello. Yet it seems safe to assume that he would have read the book at the center of all these debates, Aristotle's *Poetics*. And I think we can take it for granted that he would have kept his closest friend, Titian, who was at the very same time promoting himself as a painter of *poesie*, informed about the major new developments in poetry.

Aristotle and Tragedy in the Sixteenth Century

Aristotle defined tragedy thus: "A tragedy, then, is the imitation of an action that is serious and also, as having magnitude, complete in itself; in language with pleasurable accessories, each kind brought in separately in the parts of the work; in a dramatic, not in a narrative form; with incidents arousing pity and fear, wherewith to accomplish its catharsis of such emotions" (1449b).[21] The most important part of tragedy is the plot, and in this lies the main problem of transferring Aristotelian notions of poetry

to painting: "The first essential, the life and soul, so to speak, of Tragedy is the Plot; . . . Characters come second" (1450a). The tragic action, "complete in itself, as a whole of some magnitude" (1450b), involves the development of an action from beginning, through a middle to an end. It does not matter much whether we look at this primarily as a temporal development, from earlier stages to later ones, or whether we look at it in terms of the stringent logic which Aristotle seems to demand of tragedy: the beginning is not just temporal but causal, and the end is the final effect and result of that initial cause. The logical or causal structure requires as much change as the purely temporal one and is therefore as inimical to pictorial representation of a single moment of an action.

Yet there are two reasons why we should not dismiss altogether attempts to transfer Aristotle's notion of tragedy to painting: the first is that while it is true that the plot overall is defined primarily in terms of its temporal and logical development, it is also specifically defined as tragic by reference to its strongest effects; and while these effects should "arise out of the structure of the Plot itself, so as to be the consequence, necessary or probable, of the antecedents" (1452a), these effects can also be understood as momentary, and therefore as potentially pictorial. They are, in the first instance, the effects of peripety and discovery.

> A Peripety is the change . . . from one state of things . . . to its opposite . . . A Discovery is, as the very word implies, a change from ignorance to knowledge . . . in the personages marked either for good or evil fortune. The finest form of Discovery in one attended by Peripeties, like that which goes with the Discovery in *Oedipus*. . . . This, with a Peripety, will arouse either pity or fear – actions of that nature being what Tragedy is assumed to represent. (1452a,b)

> A third part is Suffering; which we may define as an action of a destructive or painful nature, such as murders on the stage, tortures, woundings, and the like. (1452b)

To these we may add, in the spirit of sixteenth-century interpretations of Aristotle, a fourth effect, that of wonder and the marvellous: "The marvellous is certainly required in Tragedy" (1460a).

The second reason for not being too dogmatic about Aristotle's definition of tragedy is that in practice he himself uses the term "tragic" frequently in less clearly defined ways, and this has led to at least 300 years of discussions about the true meaning of the *Poetics*. The mere representation of

serious pain and suffering, as we see it, e.g. in the *Martyrdom of St. Lawrence*, is in itself tragic as long as it awakens in us feelings of pity and horror or fear. We pity the person who does not deserve his fate, while horror or fear overcomes us when we are faced with something similar to ourselves.

It has recently been observed that Titian "sought clarification in several thematic areas by the means of the dramatic-cruel and the horrifying."[22] We have already noticed this in several pictures in which he breaches the Horatian rule of emotional restraint. We may take this intentional seeking out of the dramatic and the horrifying, as signifying a desire to instil in the viewers precisely those emotional responses which according to Aristotle are an essential feature of the tragic effect, namely pity and horror. Similarly Aretino, in a significant departure from Horatian rules, allows young Orazio, returning victorious from defeating the Curatii, to kill his sister Orazia on the open stage, in full view of the audience. Aristotle does not prohibit death or murder or tortures onstage, a point expressly emphasized by Cinthio as early as 1541, when the heroine of his tragedy *Orbecche* kills herself on stage: "it is not so remarkable, that I should depart from the laws of (Horace) and wish that her strong hand should dispense her own death with cold steel in view of the audience."[23]

It is probably true that depictions merely of suffering, of *pathos*, for Aristotle would be simple, relatively artless forms of tragic representation, forms which rely mainly on spectacle, on the actual acting in front of our eyes, forms which would not aspire to the highest form of tragedy, which is the complex one, with a logically necessary beginning, middle and end, of a size or extension which we can take in as a whole at once, and with a unitary myth or action, which carries us irresistibly with it, makes us partake through mimesis in the action and its *pathos* and leads us finally to *catharsis*.

In sixteenth-century terms, the final outcome of a tragedy was not a decisive factor. Only the very highest form of tragedy ends fatally; less elevated forms may end differently. It may thus come as a surprise to the modern reader, that Robortello in 1548 posited the "happy ending" as an acceptable part of tragedy – *felix actionum exitus*.[24] Giraldi Cinthio was also practicing this in his tragic plays at the court of Ferrara; for him a good tragedy with a happy ending was the "more pleasing to the spectators for ending in gladness,"[25] hence the *tragedia di lieto fin*.[26] This is not unimportant for my argument.

Another point needs to be made about the nature of sixteenth-century tragedy. Before the middle of the century there was clearly a preponderance

for assuming that tragedies, as the most serious form of poetry, ought to be about history not fiction. This may have as much to do with Plato's condemnation of poetical fiction as with the simple fact of historical precedence: those ancient tragedies that were known, mainly Seneca's and to a lesser extent those of Euripides, were regarded as being historical. "The traditional prescription for tragedy that had come down to the Renaissance from Horace . . . was that while comedy was based on a fiction tragedy was usually based on history." Aristotle does not make this distinction, and based on his authority Giraldi expressly rejected it:

> I hold . . . that the tragic plot, like the comic, can be feigned by the poet; moreover, that Aristotle, as judicious in this matter as in any other, grants it in more than one place in the *Poetics*.[27]

When Dolce, in 1547, published his first original tragedy, the *Didone*, he obviously followed the *Aeneid*. He could have presented this as a historical tragedy, yet in his *argomento* he chose not to do so: "The subject is taken from the feigned story by Virgil and not from the truth of history."[28] This enabled him to allow Cupid, in the form of Ascanius, to speak the prologue and to set the tone of the tragedy in an increasingly popular way in which love sets the tragic and bloody plot in motion: "I do not feed on ambrosia, as do the other gods, but on blood and tears." Love as the bringer of revenge and tragic destruction had already dominated the plot of Speroni's *Canace*,[29] and with Girolamo Parabosco's *Progne*, published in 1548, and Cesare de'Cesari's *Scilla*, of 1552, Ovid's supposedly light-hearted and erotic *Metamorphoses* assumed a major role as provider of subject-matter for new tragedies of love, blood, and tears.

Titian's "Poesie" for Philip II as Painted Tragedies

It has been said that it is impossible to paint tragedy. In the strict sense of tragedy as the logical development of the myth or plot over time that is surely right. Fortunately, we may say, Titian and other painters, like Veronese or later Poussin, did not know this. And here we return to Titian's *poesie* for Philip II, which I regard as a conscious and deliberate attempt to translate Aristotelian tragedy into painting. To see them as "tragic" paintings may help us to get away from the sterile contrast of purely visual erotica and highbrow Christian allegorizing.

For this exercise we shall accept as a pre-condition that Titian himself (with or without help from his learned friends) chose the subjects of his cycle, not some humanist at the Spanish court. It is worth mentioning that in the more recent literature every single one of these pictures has been called "tragic"; mostly this is meant in the rather casual sense in which we use the term "tragic" in normal parlance. My aim is to show that Titian meant the pictures to be tragic, and to have a tragic effect on the viewer, in the sense of sixteenth-century discussions of Aristotle's *Poetics*.

The subject of the *Danae*, the first of Titian's mythologies for Philip, seems to have been chosen by the painter himself, as the painting was a non-commissioned present from the artist, delivered probably in 1550. Charles Hope has said of it: "It is the most frankly erotic of all Titian's nudes, both in the design, even the residual drapery of the earlier Danae being omitted, and in the mood of the figure, who complacently accepts the embrace of her divine lover. Thus the spectator is now cast in the rôle of a *voyeur*." Hope further notes that the technique is novel: "The handling (is) looser than in any earlier painting." In conclusion Hope posits that Titian was "prepared to vary his style to suit the tastes of his patrons, and *Danae*, in both subject and treatment, was evidently intended as a young man's picture."[30]

It may be interesting to compare Hope's analysis with that of Keller, who considered the whole cycle as a Mirror of Princes and thus as depictions of virtue. He wrote of the gold ducats descending from above: "Their aim, the lap of Danae, remains invisible – the representation aims only at the spiritual side of the event. Jupiter's partner in the golden shower is the face of the young woman. . . ."[31]

I do not know what exactly Keller was looking at; but it seems to me prudish in the extreme not to acknowledge the erotic appeal which this picture must have had, and was intended to have, on a viewer like Philip (and, for that matter, most other male viewers). The importance of displaying the nude female body is expressed quite clearly a few years later, in 1554, in a letter from Titian to Philip, which accompanied the next *poesia* of *Venus and Adonis*:

> Because the figure of Danae, which I have already sent to Your Majesty, is seen entirely from the front, I have chosen in this other *poesia* to vary the appearance and show the opposite side, so that the room in which they are to hang will seem more agreeable. Shortly I hope to send you the *poesia* of *Perseus and Andromeda*, which will have a viewpoint different from these two; and likewise *Medea and Jason*.[32]

This has been taken, correctly, as part of the *paragone* between painting and sculpture: painting allows us – like sculpture – to be *voyeurs* in the round.

Yet the overt eroticism is not incompatible with other, darker aspects. Panofsky has already noticed that, compared with the earlier version in Naples, Philip's picture is not only more erotic, but also more ominous: "the atmosphere is one of dark foreboding."[33] We could develop this further, yet it is probably true to say that this is the least tragic of the series. The moment depicted is that of a peripety, the reversal of the expected into its opposite – Danae's fate changing from life-long imprisonment and celibacy, imposed by her own father, who has been told that he will be killed by the hand of his own grandson, to that of becoming the mother of one of the greatest heroes of antiquity and son of Jupiter. Perseus, the son, will, in due course and unwittingly, kill his grandfather. But nevertheless, it may be that the highly erotic and willingly compliant female body, which dominates the whole picture, is just too far removed not only from our modern notion of tragedy, but from the very notion of the dramatic, and that Titian has not yet fully developed his notion of tragic painting.

The next picture is *Venus and Adonis*, delivered in 1554 to London, where Philip was due to marry Mary Tudor. Its textual source is *Metamorphoses* (X.520–728). Venus, her breast accidentally grazed by one of Cupid's arrows, fell in love with the mortal, but exceedingly beautiful young Adonis. Titian's painting departs in important ways from Ovid's text and was criticized, for that reason, in 1584 by Raffaello Borghini. Hope has already made the point that "according to the tenets of contemporary criticism, fidelity to a written text was a prerequisite for a successful *istoria* or *devozione*, but when an artist painted a *poesia* he was permitted the same freedom of invention as poets."[34] I see the *Venus and Adonis* as an attempt by Titian to pull together pictorially the tragic elements which are clearly evident in Ovid's text but which are there dispersed by the poet's narrative procedure. There, Venus admonishes her young lover not to go out hunting; she then leaves him to attend some godly business; left alone, he is overcome by his love of hunting, valour and glory, he goes out and is killed by a wild boar; Venus returns and laments over his dead body. Of these different narrative scenes the most attractive would be Venus' lament, and that is what most painters depicted. Venus admonition to her lover, or Adonis going out hunting on his own would not make interesting pictorial compositions.

What Titian has achieved is a pictorial and dramatic concentration of the whole myth in one moment – and that moment is one of both recognition and peripety. He has even visualized the temporal and logical sequence of the myth; beginning with the sleeping Cupid on the left, whose careless scratching of his mother's skin with one of his arrows set the whole myth in motion; Venus fell in love with the next mortal man she encountered, who happened to be the most beautiful boy, Adonis. In the centre are the two protagonists, a Raphaelesque Venus and a Michelangelesque Adonis. In Ovid, Venus' admonition reveals a sense of foreboding in the knowledge that he was mortal and dedicated to hunting. Here, in Titian, her mouth opened in horror and her arms attempting in vain to hold him back, clearly indicate that she recognizes that the moment of his death, which she knows is inevitable, is drawing near. What has been prescribed by fate, is accelerated by the deliberate act of the young man, a determinate error according to Aristotle, an error deriving from his character; his love of hunting and glory is stronger than his love of the goddess of love herself; and the wilfulness of his action in the face of the most beautiful of all goddesses brings about the worst and most tragic of all peripeties, the change from divine love to premature and bitter death. As a peripety it stands in direct contrast to that of the *Danae*, where the intervention of divine love brings about liberation and new life. Adonis' impulsive, even reckless action brings to mind Aretino's *Orazia*, where the old father repeatedly stresses the youthful nature of his son:

> However great the wrong he may have committed, youth ought to excuse Orazio. The impetuous youth of Nature, which in his being is like a fierce, unruly stallion let loose in a fine meadow. . . .[35]

And Adonis' death, I believe, is hinted at in the background on the right. A beam of light, emanating from what I would identify as the chariot of the returning Venus, falls upon the edge of the wood below, and there, surely, we are meant to assume the young hunter dying or dead. If we understand Titian's composition as a concentration of a tragic plot into one moment of dramatic action, we do not have to find it "odd," as Nash does, that "Titian chose to ignore such striking subjects as the couple's romantic encounter, communal happiness, or even their melancholy parting."[36] None of these "striking" subjects would have aroused in the viewer the feelings of pity and fear, which Titian's scene does, in the vain attempt of the goddess to hold back her lover, in the desperate expression of her

face, in the determinate yet unknowing action of the young man, in the centrifugal arrangement of the figures, and in the foreboding of immanent death in the background.

Ovid gives a detailed account of the myth of *Perseus and Andromeda* (IV.672–740). Perseus flies across the world on the wings borrowed from Mercury, until he reaches Ethiopia. There he comes across Andromeda about to be sacrificed to a sea-monster:

> When Perseus saw the princess, her arms, chained to the hard rock, he would have taken her for a marble statue, had not the light breeze stirred her hair, and warm tears streamed from her eyes. Without realizing it, he fell in love. Amazed at the sight of such rare beauty, he stood still in wonder, and almost forgot to keep his wings moving in the air.

He talks to her and to her parents, and when the monster appears from the ocean, he offers to save the princess, "if only the gods are on my side," if she was given to him in marriage. He then throws himself, downward and head first, at the monster and, after a lengthy battle, emerges victorious.

> Cassiope and Cepheus were filled with joy: they greeted Perseus as their son-in-law, calling him the saviour and preserver of their house. The girl stepped down, freed from her bonds, she who was at once the cause and the reward of his heroic deed (*virgo, pretiumque et causa laboris*).

The composition is dominated by the large and almost entirely frontal figure of the Ethiopian princess. She again undergoes a complete peripety, although now in the sense of Robortello's happy ending: a change from the near certainty of death by being devoured by the sea-monster, to salvation and marriage to the great hero of virtue. Here, for once, we may have some sympathy with Keller's attempts to see Titian's pictures as a Mirror of Princes. The viewer, and that means in the first instance Philip, sees her precisely as Perseus saw her when he was flying by on the borrowed wings of Mercury, in her full beauty, resembling a marble statue, enlivened only by her moving hair and tears flowing from her eyes.

Her appearance, in her full, naked beauty, is the beginning of the myth, the cause of his action. Her appearance stirs him to love, and out of love he throws himself into the dangerous battle with the beast. As viewers we know the outcome of the peripety; yet in contemplating the pictorial moment, our certainty of the happy ending is joined, at the same time, by the erotic attraction of Andromeda, the horror of the monster, and the fear

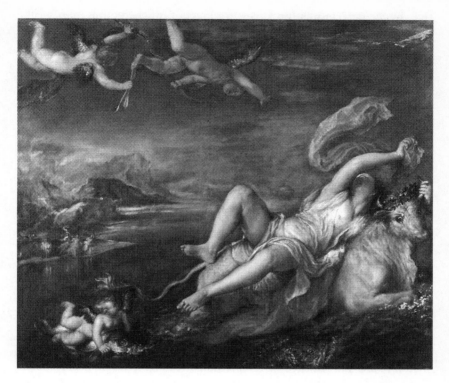

Titian, *The Rape of Europa*. Reproduced courtesy of Isabella Stewart Gardner Museum.

which she feels for Perseus and, like us, for herself. Horror, we remember, derives from what we feel to be similar to ourselves; in the loving contemplation of the nude Andromeda we know ourselves to be similar to Perseus; and should throw ourselves into battle with the beast, as he does. This, of course, we cannot do, and therefore prefer to shudder in horror.

This sense of identification with the hero of the action in contemplating naked female beauty we have already encountered in front of the *Danae*. We looked at her as *voyeurs* just like Jupiter did from a position of divine distance and invisibiliy. In *Venus and Adonis* we admire both bodies, that of the young man, who is loved by the goddess, and that of the goddess herself. Dolce described lovingly, how the softness of her bottom gives way under the pressure of sitting on hard stone.[37] The *morbidezza* and vulnerability of her naked beauty, even if seen only from behind, is sufficient to emphasize for us the hardness of his muscular physique and

thereby to make visible for us the hardness of the mind, the cause of the tragic error of Adonis.

The picture of *Medea and Jason*, promised in 1554 as a pendant for *Perseus and Andromeda*, is never mentioned again. Instead Titian painted, between 1559 and 1562, the *Rape of Europa*, now in Boston. Arthur Pope, in his small monograph, has described this painting very correctly as half tragic, half comic.[38] As with Perseus and Andromeda, we know that the ending of the myth will be a happy one. Like Danae, Europa will give birth to a great hero, King Minos of Crete. Yet the pictorial moment is one in which she feels the full power of a tragic peripety, in the course of which she is deprived of her status and dignity of a princess and exposed in oppressive solitude. As Keller observed, she has also lost grace and elegance, and while still erotically attractive, is shown as a threatened creature.[39] And Hope was moved, by this picture, to state: "Apart from their superb quality, Titian's *poesie* are exceptional not in the fact that they are erotic, but because they convey the genuine passion and terror underlying the familiar and often trivialized myths recounted by Ovid. In Titian's interpretation even subjects such as *The Rape of Europa*, so often treated in a light-hearted manner, acquired intimations of tragedy."[40]

By the time he painted the *Europa*, Titian had completed a further pair of *poesie*, the two Diana-pictures now in Edinburgh (1556–9). And no writer, to my knowledge, has ever doubted the truly tragic nature of the events, the myths themselves. Ovid's own text treats them as tragic events. The victims, Actaeon and Callisto, are both innocent: "you will find the cause of this in fortune's fault and not in any crime of his" (*Metamorphoses* III.140–142). Callisto is led from happiness to disaster yet again by the irresistible force of Jupiter's libido. Pity is an almost automatic response, and in the case of Actaeon also a sense of horror. Both pictures are meant to be seen together; as a Venetian display of nude femininity an equivalent to Michelangelo's cartoon of *The Battle of Cascina*.[41] Yet Titian takes us beyond the stage of admiring his mastery of depicting the female form; in contemplating all these beautiful goddesses and nymphs we commit the same crime for which Actaeon has to pay with his life.

Keller has observed that "the pictures of the cycle all hit the dramatic and, wherever possible, the tragic nerve of the Ovidian fables."[42] I am sure this is correct, and yet we can, again, be more specific: both these last scenes are scenes of discovery and recognition, leading in each case to peripety, to transformation and death in the case of Actaeon, transformation and endless suffering in that of Callisto. For the male viewer – Philip

– who identifies with Actaeon while looking at both pictures together, the
threat of Diana's cruel justice doubles: the goddess who condemns Callisto
is the same which destroys the young hunter. And the catastrophic inappro-
priateness of our watching all these naked women is brought home to the
viewer, with a sudden sense of horror, when he relates Actaeon's huge
hound in the foreground to the stag's skull hanging in the background. In
looking at the pictures we become involved in the myth, in observing
them carefully we are fearfully made aware of its tragic ending.

It seems to me that here, and to some extent in the earlier pictures,
Titian acknowledges one decisive shortcoming of pictorial tragedy and, at
the same time, introduces a remedy: unlike the play acted out on stage,
the painting cannot carry us away by the dramatic unravelling of the plot
over time. The sense of horror and fear evoked by a single moment of
pictorial drama cannot match our deep emotional involvement as we are
drawn irresistibly into the plot and toward its final *dénouement*. Yet the
visual arts have other forms of deep and irresistible involvement, and one
of these is undoubtedly the seductive force of the visually erotic. We may
claim that Eros and love, in their overwhelming, irrational power, are a
species of the genus of the marvellous, the wondrous, which Cinthio and
others had identified as the fourth tragic effect, alongside pity, horror, and
suffering. In dramatic tragedies we are more likely to find the overpower-
ing Eros not as the tragic effect, but as the irresistible cause of the tragic
plot. In painted tragedies, Eros can do both, set in motion the tragic
development and, at the same time, keep us, the male viewers of female
nudes, profoundly involved in that development.

Titian deliberately chose Ovidian myths which find their temporal and
logical starting point in the seduction of a male viewer by a female figure
(or, in the case of Adonis, the tragic failure of seduction); and in front of
the Danae, the Venus, Andromeda, Europa, and Diana and her nymphs,
our own involvement with the picture starts in much the same way.
Prudishly denying our erotic and even sexual attraction and arousal, as
Keller does, would deny us that emotional experience and involvement
which sets in motion the tragic plot of the scene. Jupiter, Adonis, Perseus
and Actaeon all react in different ways, yet they all do act in response to
an erotic stimulus, and their different responses, of lust, of rejection, of
bravery or horror, are all intermingled with and perhaps sharpened by
the overt sexuality of their respective encounters. In much the same way,
one could argue, our own responses of pity, fear or horror are activated,
enlivened, and powerfully sustained for more than just one moment of

drama by our own heightened erotic sense. The visual attractiveness of Titian's female nudes, sustained and enhanced by the visual attractiveness of his painting, gives both an emotional depth and an extension in time which our responses to a momentarily frozen plot, a pictorially abridged drama or a detached narrative, do otherwise seldom achieve.

Notes

This essay is part of a more extensive study of some of the later works of Titian. I gratefully acknowledge financial support from the British Academy and the AHRB.

1 E. Panofsky (1969). *Problems in Titian, Mostly Iconographic* (London: Phaidon), p. 45.

2 J. C. Nash (1985). *Veiled Images. Titian's Mythological Paintings for Philip II* (Philadelphia: The Art Alliance Press; London and Toronto: Associated University Press), p. 34.

3 H. Keller (1969). "Tizians Poesie für König Philipp II von Spanien." In *Sitzungsberichte der wissenschaftlichen Gesellschaft an der Johann Wolfgang Goethe-Universität*, vol. 7, 1968, no. 4, pp. 107–200 (Wiesbaden: Franz Steiner Verlag).

4 Nash, *Veiled Images*, p. 23.

5 Nash, ibid., p. 21.

6 R. W. Lee (1967). *Ut Pictura Poesis. The Humanistic Theory of Painting* (New York: Norton paperback [first *Art Bulletin*, 22, 1940]).

7 Ch. Hope (1980). *Titian* (London: Jupiter Books), p. 126.

8 See, e.g. D. Rosand (1971–2). "'Ut Pictor Poeta'. Meaning in Titian's 'Poesie'." In *New Literary History*, III, pp. 527–46, p. 533, no. 14.

9 B. Weinberg (1961). *History of Literary Criticism in the Italian Renaissance.* 2 vols. (Chicago: University of Chicago Press).

10 Ibid., p. 115.

11 Ibid., p. 136.

12 I use H. Rushton Fairclough's translation (1926, reprinted 1966) in *Horace, Satires, Epistles and Ars Poetica* (London: Heinemann; Cambridge, Mass.: Harvard University Press [The Loeb Classical Library]).

13 C. Grayson (ed. and trans.). (1972). *L. B. Alberti. On Painting and On Sculpture. The Latin Texts of 'De pictura' and 'De statua.'* (London: Phaidon), pp. 81–5.

14 H. Belting (1985). *Giovanni Bellini. Pietà. Ikone und Bilderzählung in der venezianischen Malerei* (Frankfurt/Main: Fischer Taschenbuch), pp. 28–36.

15 Fairclough, *Ars Poetica*, pp. 185–8.

16 For a useful summary, see W. Tatarkiewicz (1974). *History of Aesthetics*, vol. III. The Hague (Paris: Mouton; Warsaw: PWN-Polish Scientific Publishers), pp. 161–6. Also Weinberg, *History of Literary Criticism*, passim; M. T. Herrick (1965). *Italian Tragedy in the Renaissance* (Urbana: The University of Illinois Press); and P. Brand and L. Pertile (eds.). (1996). *The Cambridge History of Italian Literature* (Cambridge: Cambridge University Press), pp. 288–92.

17 Tatarkiewicz, *History of Aesthetics*, p. 175.

18 Herrick, *Italian Tragedy*, p. 124.

19 *The Cambridge History of Italian Literature*, pp. 289–91.

20 See, e.g. E. Camesasca (ed.) and F. Pertile (comm.). (1957). *Lettere sull'arte di Pietro Aretino* (Milan: Edizione del milione), vol. II, p. 240 (letter to Francesco Sansovino).

21 I use Bywater's translation in W. D. Ross (ed.). (1946). *The Works of Aristotle*, Vol. XI (London: Oxford University Press).

22 H. Ost (1992). *Tizian-Studien* (Köln, Weimar, Wien: Böhlau Verlag), p. 155.

23 Herrick, *Italian Tragedy*, p. 79.

24 Tatarkiewicz, *History of Aesthetics*, p. 177.

25 Herrick, *Italian Tragedy*, pp. 80 and 87.

26 Ibid., p. 132.

27 Ibid., p. 85.

28 Ibid., p. 167.

29 Ibid., p. 129.

30 Hope, *Titian*, p. 117.

31 Keller, "Tizians Poesie," p. 142.

32 Hope, *Titian*, p. 125.

33 Panofsky, *Problems in Titian*, p. 150.

34 Hope, *Titian*, p. 126.

35 Herrick, *Italian Tragedy*, p. 142.

36 Nash, *Veiled Images*, p. 31.

37 M. W. Roskill (1968) (ed. and trans.). *Dolce's "Aretino" and Venetian Art Theory of the Cinquecento* (New York: New York University Press), p. 215.

38 A. Pope (1960). *Titian's Rape of Europa* (Cambridge, Mass.: Harvard University Press), p. 15.

39 Keller, "Tizians Poesie," p. 176.

40 Hope, *Titian*, p. 137.

41 Hope, ibid., p. 133.

42 Keller, "Tizians Poesie," p. 146.

2

Wax, Brick, and Bread

Apotheoses of Matter and Meaning in Seventeenth-Century Philosophy and Painting

Jay Bernstein

I suppose it is correct to say that the Enlightenment was a motley, a variety of overlapping, diverging, crisscrossing trends. Historians are good at the gathering and replaying of such complexities. Philosophers, on the other hand, are, for all their abstruseness, simplifiers. And what I want to offer in this essay is a wild simplification, a way of thinking about the meaning of the Enlightenment through the consideration of two images: a piece of wax and some bricks, a brick wall really. My thought is going to be this: each of these two images, wax and brick, embody and thereby provide or project an account of the meaning of enlightenment, hence each image picturing an utopian moment that can be thought of as constitutive of the very idea of enlightenment; but, and here is the rub, in fact these two images stand in radical opposition to one another. Hence, what we are given through the two images, wax and brick, are two enlightenments, the one we have actually had, enjoyed and suffered, and an other enlightenment which has been lost almost from the moment of its appearance, that indeed has never been more than a painted image. Since precision is not part of this story, it is nice to know that each image is precisely dateable: the piece of wax is from 1641, and the brick wall from 1658.

Most of you will have already guessed the provenance of my piece of wax: those great paragraphs that conclude the second of Descartes' *Mediations on First Philosophy*. I still find this one of the strangest, most disturbing, and most breathtaking moments in all of western thought. Let me remind you of how this story goes. At this juncture in his account Descartes has already shown how even the most radical doubt, say that some evil demon is trying to deceive me at every turn, can be terminated by the knowledge, the certainty, given through the *cogito ergo sum*. I can never doubt that I exist since the very act of doubting presupposes that I exist. In the midst of doubting I necessarily affirm my existence and so myself. Knowing that I exist in this way, Descartes argues, I also know that I am a thinking thing. That too is indubitable. Nonetheless, Descartes worries; he is tempted by the commonsense thought that "corporeal things," physical objects, are more clearly known than one's own mind (153).[1] In order to test this idea he suggests we consider "the commonest matters, those which we believe to be the most distinctly comprehended, to wit, the bodies which we touch and see; not indeed bodies in general, for these general ideas are usually a little more confused, but let us consider one body in particular. Let us take, for example, this piece of wax: it is fresh from the honeycomb so it retains the taste of honey, the smell of the flowers from which it was gathered; its color, shape and size are manifest. It is hard and cold to the touch, gives out a sound when rapped with my knuckle" (154). Now, Descartes says, I will put the piece of wax by the fire: it loses the remains of its flavor, the fragrance evaporates, the color changes, the shape is lost, the size increases, it becomes fluid and hot, it can hardly be handled, it no longer gives out a sound if you rap it. Is this the *same* piece of wax? Of course it must be: no other piece of wax or anything else has come to replace it. Yet, its look, feel, taste, smell, sound have all either changed utterly or even disappeared. Every sensible feature of the piece of wax – "the sweetness of the honey, . . . the agreeable scent of flowers, that particular whiteness" – has altered. How can it be the same? "Abstracting from all that does not truly belong to the piece of wax, let us see what remains. Certainly nothing remains excepting a certain extended thing which is flexible and movable" (ibid.). Having rid the piece of wax of all its sensible features, or rather delegitimated those features of their author-ity as constitutive of the identity of the piece of wax and hence delegitimated sensory awareness of its authority as being capable of grasping the object, Descartes inquires into what we might mean by thinking of the wax as flexible and movable – ideas that perhaps are, seemingly, capturable by

the imagination. But not only can the piece of wax not be known through the senses, it cannot be imagined either since flexibility involves an "infinitude of changes," which is to say more changes than I could ever imagine: "I should not conceive clearly according to truth what wax is, if I did not think that even this piece that we are considering is capable of receiving more variations in extension than I have ever imagined" (155). With this in place, Descartes can now move to his conclusion: "We must then grant that I could not even understand through the imagination what this piece of wax is, and that it is my mind alone which perceives it."

Let me say immediately that some of the great power and magic of this passage actually stems from a misreading of it, and that it is the misreading and the actual argument together that have made the image of the piece of wax almost an emblem of enlightened thought. The misreading is quite natural since it tracks the apparent disappearance of the sensible piece of wax after its ordeal by fire. It is as if the actual fire and the fire of the mind had, together, truly purged the wax of all it sensory properties, such that the piece of wax known by the senses could disappear altogether in order to be replaced by its purely intellectual counterpart. Thus the only properties essential to the piece of wax are that it is something that fills space and can take on an infinite number of shapes. But this is just to say that what belongs to the wax essentially are just those features of it that are quantifiable, and hence those properties that make the only true knowing of the piece of wax the knowledge given of it by mathematical physics. For Descartes true knowledge of the wax is given not by the senses or imagination but by mental perception alone. Before our eyes, so to speak, the sensuous piece of wax with its delirium of taste and aroma and feel and look has disappeared and been replaced by an "object" whose true nature is to be expressed in a series of equations and formulas.

In fact, this is not quite what Descartes is arguing at this juncture; it is only in the *Fifth Meditation*, if anywhere, that he argues for the essence of matter being extension and hence for the ideal of a science of nature based on geometry. The actual argument of the *Second Meditation* is more modest. It starts from the belief that our *conception* of wax is derived from the senses, i.e. we conceive of the wax as something the senses reveal as hard, white, sweetly scented, etc. When all those sensible features change it follows that our conception of the piece of wax cannot have rested on them since we are still conceiving what we take to be the same piece of wax. Indeed, it is part of our ordinary conception of the piece of wax that it can change and change in an infinite number of ways and yet remain

the same piece of wax. It might even change so radically that it would stop being a piece of wax. But this is just to say that our ordinary conception of the piece of wax goes beyond information provided by the senses or the imagination. *My everyday conception* of the piece of wax draws on and is a work of the understanding rather than the senses. Hence, the common sense belief that the material bodies we touch and see are better known than our own minds is false: what we know of bodies is itself something that belongs strictly to the mind itself apart from the senses and imagination.[2] Of course, Descartes could not reach his conclusion that the mind is better known than bodies without fully anticipating the argument that makes the essence of material objects be solely their mathematical properties. Something that Descartes states with his usual vividness: "But when I distinguish the wax from its external forms, and when, just as if I had unclothed it, I consider it quite naked, it is certain that although some error may still be found in my judgment, I can nevertheless not perceive it thus without a human mind" (156). This image of the material world as merely clothed in sensory images, so that when unclothed and quite naked it reveals a perfect intellectual form without sensory residue, is still startling. It is hard not to think of the fire that burns away the sensory as the fire of the intellect, the purifying fire of enlightenment itself.

That course of argument in Descartes covers just six paragraphs; but in those six paragraphs the visible world of things known through the senses disappears and we are left with the refinements of mathematical knowing – the things themselves becoming somehow insensible. The truth of the visible world is the invisible world of insensible particles described wholly in mathematical terms. There are endless variations on this frightening and exhilarating moment in Descartes from Galileo to Eddington's two tables. But there is something exemplary about the piece of wax: having the familiar world of the senses first liquefy and then disappear into mathematical knowing is a fable for the fate of things in the modern world, and by extension a fable of modernity itself with which we have yet to get on level terms. The account of the piece of wax can have this power, because, again, what occurs, in its continuation of the abstractive process and achievement of methodical doubt, is a radical undermining of the authority of the senses, not merely in terms of their overall accuracy or veridicality or sufficiency in revealing what is truly there, but as properly cognitive mediums with objects corresponding to them in general. Delegitimating sensory knowledge takes with it the sensible world. It is not too much of a stretch to see the abstraction from particularity and sensory givenness as

the abstractive device of modern forms of social reproduction, that is to say, the subsumption of the use values of particular goods beneath the exchange value of monetary worth, or the domination of intersubjective practices by norms of instrumental reason that yield the rationalization or bureaucratization of our dominant institutions. Somehow the advance of the modern world, its enlightenment, is the advance of the process of abstraction and the domination of the qualitative by the quantitative. This, of course, is both a utopia and a nightmare.

What makes Descartes' dissolution of the sensible world even more disturbing is that in the very next decade the attempt was made to offer to the material world of the senses an authenticity, and so authority, beyond anything previously achieved, to transform the material world from a forever surpassed vehicle for spiritual – hence, ultimately, "other" worldly – activity and meaning into the perfected corollary of our being ourselves wholly embodied, sensuous, and finite beings. In putting the matter this way I am wanting to suggest that what happened in the following decade, in 1658, was the emergence, however briefly, of a different "naturalism" or even "materialism" than the naturalism or materialism we associate with the scientific revolution of the seventeenth century and its triumphal procession into the present.

My candidate for the author of an "other" enlightenment to the Cartesian one is the Dutch artist Pieter de Hooch.[3] In 1658 in Delft de Hooch began painting canvases of ordinary life which, I want to argue, gave to the visible, tangible experiences of everydayness a solidity, dignity, authority, and self-sufficiency which has found no equal. Whatever else is occurring in these canvases, which is to say, however else we might read and interpret these pictures, the dominant experience they render is of a material world suddenly "there" with a density and solidity not in themselves imaginable, and hence, by extension, a vindication of a wholly secular world that requires nothing outside itself for its completion. To put the same thought another way, I want to see these paintings as themselves a form of claiming, a way of rendering the sensible world of everyday experience such that it can be seen *as* self-sufficient and complete, hence fully worthy of our investment in it. If I may so put it: what de Hooch offers is everydayness raised to the level of the monumental, a sublime everydayness that in being sublime in this way images a life for finite creatures that does not call up any contrasting – infinite, otherworldly, heroic, etc. – values. Arguing this case is a complex matter since it involves, first, urging that these paintings are forms of making claims, considerable in their way

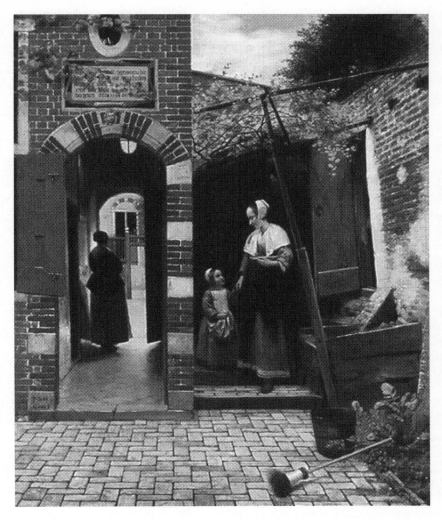

Pieter de Hooch, *The Courtyard of a House in Delft*. © National Gallery, London.

every bit as much as a philosophical argument is considerable in its; second, transforming, or at least deepening, the standard reception of de Hooch; and hence, third, distinguishing de Hooch's accomplishment from that of Vermeer. That Vermeer is the greater painter I will not dispute; but the likeness of their paintings in the period between 1658–60 may lead one to consider de Hooch simply the lesser artist rather than, as I shall

suggest, falling upon for a short period of time a unique vision, one that quite simply disappears almost as soon as de Hooch moves from Delft to Amsterdam sometime in 1660. But I am getting ahead of myself.

Although suggesting that Pieter de Hooch rather than, say, Locke or Hume or even Rousseau, provides the most profound challenge to the Cartesian version of Enlightenment (the version that reaches it fulfillment in the thought of Kant) is, I confess, wild; it in fact has a very precise echo in debates inside art history. Nor are these art historical debates idle for the purposes of my argument since they concern the kind of intelligibility which Dutch art of the seventeenth century might possess. Attuning ourselves to these issues takes some effort since, I suspect, for most of us no art seems more readily accessible and self-evident in its claims than the realism of the Dutch school. Yet neither traditionally nor even now is the meaning of realism, its point and purpose, nor its claims clear or uncontested. On the contrary. The easiest place to begin is the famous critique of the art of the Netherlands that Francisco de Hollanda attributes to none other than Michelangelo:

> Flemish painting . . . will . . . please the devout better than any painting of Italy. It will appeal to women and nuns and to certain noblemen who have no sense of true harmony. In Flanders they paint with a view to external exactness or such things as may cheer you and of which you cannot speak ill, as for example saints and prophets. They paint stuffs and masonry, the green grass of the fields, the shadow of the trees, and rivers and bridges, which they call landscapes, with many figures on this side and many figures on that. And all this, though it pleases some persons, is done without reason or art, without symmetry or proportion, without skillful choice or boldness, and finally, without substance or vigour.[4]

Let this passage stand in for, in general, the Italian critique of Dutch realism. This critique, in fact, has both a hermeneutical aspect and a connected if distinct normative, aesthetic aspect. The hermeneutical issue is there on the surface: what could be the meaning of an art that seems content to merely describe what it sees, that gives itself over to a world presumed to exist prior to and independently of its rendering in paint? What is the point of realism? Can realism have a point, or is it not, despite its technical accomplishment, pointless and empty, a mere collecting of particulars as if the heaping up of these by itself could be meaningful? The connected aesthetic challenge, lodged most fiercely by Gombrich in "Norm and Form: The Stylistic Categories of Art History and their Origins

in Renaissance Ideals," follows on directly: we can understand the non-classical ideals of Dutch art *only* from within the frame of the "objective core of the classical ideal."[5] In accordance with Gombrich's view, there is only one core, Italian aesthetic norm for modern European art in which the claims of *order*, on the one hand, and *fidelity to nature* on the other are competing axes of orientation that must be somehow reconciled. The ideal solution to the demands of the competing axes is the "classic solution," and it is that which the great art of the Italian renaissance represents.[6] What is thus denied is that there could be a non-classical aesthetic, at least for us. For Gombrich fidelity to nature is only ever *intelligible* as an axis in relation to the competing claims of non-material order. The competing axes are constitutive of the possibility of painting, and the "classic solution," which is thus "a technical rather than a psychological achievement" represents all that painting, in principle, could hope for itself; the classic solution might be repeated, but cannot be improved upon: "Deviation on the one side would threaten the correctness of design, on the other the feeling of order."[7]

One bold response to this critical charge is to deny that Dutch realism does flout the norms and expectations of the classical model. Rather, the argument goes, Dutch paintings were intended to delight and instruct, with the delight being the lure through which the predominately moral instruction was to occur, the moral instruction occurring through disguised symbolism.[8] The making out of this claim would inevitably be complex since it would have to traverse the full range of realist art: landscape, still life, portraiture, domestic scenes, et al. Nonetheless, one thread of this view bears directly on de Hooch. Nearly a third of all de Hooch's works are of domestic scenes containing women and children without husbands and fathers. While there were some anticipations of this prior to de Hooch, in particular by Gerard Dou, there can be no doubt that he exploited and developed it in a unique manner. At one level this may be thought unsurprising since in the seventeenth century we witness the first blossoming of the nuclear family as the primary social unit. Involved in this blossoming is both the raising up of the significance of marriage and the acknowledgement or invention of childhood as a fully autonomous stage possessing its own needs and joys. Simultaneous with the emergence of the nuclear family there appeared a deluge of heavily illustrated domestic conduct books, the most famous of which was *Houwelyck* (1625) by Jacob Cats; it is claimed that by mid-century there were over 50,000 copies of this book in circulation, and that every middle-class Dutch home would

have its copy of one Father Cats' book of manners propped up next to the family bible. If one is tempted to try and squeeze Dutch realism into the pattern of Italian narrative art, then the parallel phenomena of Cats' books of conduct and the sudden emergence of paintings of domestic scenes becomes irresistible. Hence we find Peter Sutton, the foremost commentator on de Hooch, staking himself to this iconological interpretation of the paintings, contending that the "representation of order and cleanliness is one source of the special beauty of de Hooch's paintings."[9] Exactly how the representation of bourgeois order and cleanliness is to become a source of beauty is, to me, deeply puzzling.

Without question the most influential book on Dutch art opposing the twin furies of Italian hermeneutics and aesthetics is Svetlana Alpers' *The Art of Describing: Dutch Art in the Seventeenth Century*; this work is clearly intended as a response to Gombrich, who was Alpers' teacher.[10] Although, as will become evident, my claims for de Hooch's Delft paintings stand slightly apart from Alpers', nonetheless it would not be wrong to say that my reading of de Hooch is a part of the attempt to construe Dutch art as an autonomous development with protocols not reducible to those of the South. Very quickly and baldly, what Alpers attempts to do is to demonstrate that Dutch art belongs to a wider set of cultural assumptions that are simply incommensurable with those of the Italian South. Alpers pointedly offers a passage of Panofsky's on Jan van Eyck that becomes, I think, the driving force of her reconstruction.

> Jan van Eyck's eye operates as a microscope and as a telescope at the same time . . . so that the beholder is compelled to oscillate between a position reasonably far from the picture and many positions very close to it . . . However, such perfection had to be bought at a price. Neither microscope nor telescope is a good instrument with which to observe human emotion . . . the emphasis is on quiet existence rather than action . . . Measured by ordinary standards the world of the mature Jan van Eyck is static.[11]

Alpers urges that the so-called "ordinary standards" invoked here are none other than the expectations of narrative action created by Italian art. Once the presumptions of those standards are put aside then the analogy between painting on the one hand, and microscopes and telescopes on the other becomes not only apt, but a kind of hermeneutical key to the project of much Dutch painting. Painting is a craft that means to interrogate the world in a manner analogous to how a microscope can be used to investigate the

world. "[N]orthern images," Alpers states, "do not disguise meaning or hide it beneath the surface but rather show that meaning by its very nature is lodged in what the eye can take in – however descriptive that might be."[12] In order to make her case, Alpers proceeds circumstantially, that is by placing Dutch art within the wider frame of a Dutch culture in which there were whole ranges of images, including those had through looking into microscopes and telescopes, whose purport could be understood as, broadly speaking, purely descriptive. On this account, picturing becomes a way or mode of seeing rather than a visualization of it; picturing might be thought of as a kind of "attentive viewing" whose aim is to reveal the individual case in its individuality rather than its belonging within or exemplifying some higher ideal.[13] If this sounds familiar, almost English, it should since part of the cultural setting for realist painting is Dutch Baconianism, which, with its extraordinary trust in the attentive eye, sought to remove illusions, idols, through the effort of careful and sustained observation. Only within a Baconian context with its privileging of identity (individuality) over resemblance (ideality), Alpers claims, can we make sense of why the Dutch pictorial tradition should have given so much weight to portraiture.

Although the embedding of realism within Baconianism is just one element of Alpers' account, it is the governing element. The problem with the analogy is that it is not clear how much of a favor to art it is. Here is Alpers becoming nervous over the status of her analogical creation:

> The Baconian program suggests that the artist's own craft . . . was itself considered at the time to constitute a significant form of acquiring knowledge. The distinction between the two forms of knowledge parallels the distinction between the two modes of seventeenth-century scientific thought . . . As I suggested at the conclusion of my introductory discussion . . . the nonmathematical, observational bias of the Baconian project, with its lack of ancient precedent, corresponds to the model of Dutch art; the mathematical, less empirical, and ancient bias of the classical sciences fits Italian art. The comparison between a science based on observation and one based on mathematics, like the comparison between the art of the north and that of the south, has not been treated as a comparison of equals. A sense of the inferiority of observation and experiment has persisted.[14]

Alpers' intention was to dignify Dutch realism by making it a legitimate branch of Baconian empirical inquiry. But this becomes something of a

poisoned chalice if, as Alpers begins to herself suspect, Baconian science has itself become for us a wholly delegitimated form of acquiring knowledge. Once the mathematical sciences underlined their reliance on experiment, verification, and careful observation *within* their overall practice, the primitive observational orientation of the Baconians could drop away as so much dross. Observation does not make for science. If science is used as the guiding thread then Descartes, and by implication Italian art, win. But if that is the case, then in a way we are back at the beginning trying to make sense of images too detailed and static for narrative purposes, pictures full of many small things that emphasize their surface color and texture rather than their place in legible space, images often unframed with no clearly situated position for the viewer and yet, despite all these divergences from the Italian norm, somehow strangely compelling. What might explain the power of compulsion here if neither hidden symbolism nor Baconian empirical observation? The problem with Alpers' analogy and assimilation is, I want to suggest, that it goes in the wrong direction. Rather than claim that Dutch art is an unrecognized form of observational science, we might try the thesis that Dutch art, painting, is a mode of viewing (encountering and responding to) reality that is *not* further translatable into science, hence that it is art or painting which is a model for knowing that expresses, if anything does, what was meant (desired and hoped for) by "observation." It is not a matter of waiting for the philosophers and historians of science to render a verdict on Baconianism, but, if possible, vindicating Dutch realist painting as, in certain moments, in fact, an achievement of "observation," as offering another telling of the world as a wholly secular, finite, material place. In putting the matter this way, I am, of course, raising the stakes terribly since I am claiming that a necessary condition for finding in Dutch art an alternative to Italian aesthetics is that it be able to issue a challenge to the claims of Cartesian enlightenment. And this is necessary because as things stand Cartesian enlightenment possesses an hegemony over the normative ideals open to us, what we can and cannot affirm or know.

I am not, at least here, likely to be able to convince you that painting can bear the kind of weight I am attributing to it, of being a material practice of meaning-giving that is not only or merely an enclosed, autonomous practice but a defused or displaced mode of rendering or encountering the world. Although putting the challenge this way, reminding ourselves of how deeply *puzzling* the actuality of painting is, both the evident consistencies of a practice of material inscription and the continuing enigma

of the aboutness of that practice, should underline that there is an unsettled score between art and science that recent debates about postmodernism have led us to simply forget. Postmodernism is the concession that art lost the argument. For the purposes to hand, however, it is enough if we acknowledge the overlap or convergence of the norms of Italian art with their insistence on transcendent ideals of order and so meaning, on the one hand, and the ideals of Cartesian enlightenment on the other with its purging of sensory encounter of any authority and its insistence on the privilege of the ideal, mathematical object over its empirical counterpart. Once that is granted, then clearing a space for Dutch realism as other than a mere deviation from the Italian model entails, at least, the existence of a potential rival to the Cartesian enlightenment. Hence, whatever my disagreements, I agree with Alpers about the stakes of Dutch realism and the currents it swims in; seventeenth-century Dutch realism is – ironically given its utter celebration of the bourgeois form of life – the leading edge of the critique of rationalized modernity.

Nothing prepares us for 1658. Certainly nothing whatsoever in de Hooch's own painting.[15] Prior to 1658 de Hooch produced mostly in the genre of guardroom painting, paintings of soldiers bivouacked in stables and inns, chatting, drinking, playing cards. For the most part, these are dimly lit scenes which use a very muted palette of browns and oranges; space is defined by the anecdotal relation of the figures with what lies behind them treated as mere backdrop, not itself spatial. It is hard to think of the paintings of 1658 as coming from the same artist. In putting together this moment what will be striking is a convergence between technical achievement and the emergence of new content. This overlap is not, of course, consistent but itself a moment within a more uneven development. Several of the canvases of 1658 continue de Hooch's use of the genre of the "merry" or "elegant" company, only these have now moved from stables and inns to apparently bourgeois interiors and courtyards. Some of de Hooch's technical innovation is palpable in *Card Players* in which the anecdotal action of four figures gathered around a table is overwhelmed by the movement of space and light: the space, initially defined by continuously receding black-and-white square floor tiles, extends out through an open doorway into a courtyard and then beyond into a dark passageway; in opposition to this receding space, light *floods forward* toward us through the doorway and the ceiling-high window framing the players. It is as if the movement of recession and the glare of the sunlight, especially on the door (turning its wood-brown to near white) and on the

tiles in the doorway (accented by the consequent darkness of the back wall), had become themes in their own right, almost displacing the now backlit and hence depersonalized figures – they have become things of shadow and light.[16] Even with the evident action – the drinking, smoking, smiling, the concentration of the female card player – there is about this image something indeed static; might we say "still and quiet"? The stilling of the scene, its de-narrativization, is a work of space and light. And what are we to make of the moving of this scene into what can only be a middle-class interior? If the card playing, drinking and smoking, the litter on the floor hint at deviance, the bathing of the scene in sunlight, its quietness, its whitewashed and tiled setting purify it, giving to the pleasures it pictures an innocence impossible in the earlier guardroom versions.[17] As will become evident directly, the alternation of inside and outside space, on the one hand, and the employment of multiple light sources on the other are significant de Hoochian signatures.

The second grand innovation in the de Hoochian moment concerns subject matter: we are suddenly offered scene after scene of women and children in either domestic interiors or courtyards. In order to appreciate this moment, it is important in the first instance to place it historically. As Elizabeth Alice Honig has convincingly argued, the role of women in Dutch painting needs to be keyed to the Dutch art market.[18] Dutch art was for the most part not a public art, but an art intended to decorate the walls of the wealthy and the middle classes. But the interiors to be decorated are ones that were increasingly defined by women as *their* space, one ideally distinct from the rapacious world of capital and manufacture outside. Thus it seems correct to say that Dutch painting was an art "made to be viewed within a sphere increasingly defined as "feminine." The anticipated beholder of this art must have been female at least as often as male, and the very act of beholding was a private, domestic one."[19] But if this is right, then two consequences immediately follow. First, it makes sense to think that women were actively involved in deciding which works were to hang on the family walls; and thus, secondly, it makes sense to begin thinking of these paintings as not simply to be seen by women, but to *appeal* to women, to their ideals, gazes, tastes.[20] Honig's trenchant claim here is thus that the combination of the social placement of art in the home on the hand, and the consequent role of women as audience for and purchaser of art on the other enable something like a female gaze to emerge from its space of otherness (goddess or whore), from its formation by the male gaze into something in its own right.

This is thematic in de Hooch. In *A Woman with a Baby in her Lap, and a Small Child*, we are offered an image of great naturalness and intimacy: the mother quietly telling the sleeping infant on her lap about his (?) sister who, in imitation of mother, is holding the family dog which she is intending to show to her sibling. The "action" of the painting is meant to create a small, closed, feminine universe: the woman is pointing to her daughter whilst gazing at her baby, with the daughter too fixing her look on the infant. The surround of this universe: the white-washed walls of the room with a small room behind it whose windows let in a light that although bright is indefinitely softened as its slips through curtains and along walls becoming finally defused as it descends into the embrace of the room below. I am almost tempted to say that de Hooch makes the falling light and surround of the room objective correlatives of the holding and embrace enacted by mother and daughter: protecting their vulnerable animal, which is to say finite and natural others – for the mother it is the baby, for the daughter the dog. Still, we know from the glare on the door (again nearly whitened) that the sun outside is bright; so bright that it bleaches to the point of near unrecognizability the portrait of what must the father of the house hanging on the wall of the small room. This enclosing space is generated by the exclusion of the male gaze; blinded by sunlight, he knows nothing of the world he naively believes he oversees.

To my eye the idea of a secular madonna, the closed world of women, children, animals is overreached and strained in a painting like *A Woman Nursing an Infant with a Child and a Dog*; whilst failing, the painting underlines the relative autonomy of the domestic universe that I am claiming is being constructed by de Hooch at this moment. By contrast, consider the relaxed and lovely *The Bedroom*, in which the movement from the bedroom with its recessed bed at the right of the picture, the mother standing before the bed, making it, through the room to the doorway with the playing child holding the door handle, and then out into an entrance hall or public room, then out into the yard and beyond creates perhaps the most continuous movement from private into public, or better, from private out into city and nature, so that the connection between inside and outside is felt to be porous, casual, immediate. In this case the use of the dual sources of light (through a door at the back and a window on the left of the painting) – with the breathtaking reflection of the sunlit window on the back left wall – perfectly complements the thematic opening or fulfilling of the private interior in the wider world beyond.

These paintings are certainly celebrations of domesticity. Yet, it would I think be brutal and misguided to assimilate these paintings to any conceivable idea of modeling domestic conduct. It is not that such thoughts are impossible with respect to de Hooch – it is difficult not to consider *A Mother and Child with its Head in her Lap* as somehow connected to the virtue of cleanliness – , it is, rather, that such readings miss everything that makes the painting compelling. Surely, the image of the mother cleaning lice from her child's head, if that is what she is doing, says more about a kind of intimacy betwixt mother and child, their absorbed activity so complete that while they "belong" in the space they inhabit, they and the space exclude any attempt to frame or employ that enclosure. To use their intimacy for the sake of warnings or prescriptions would, aesthetically, be a violation. But this is to suggest that "domesticity" is a charged and ambiguous concept in this setting.

We might consider de Hooch's courtyard paintings the perfect synthesis of his formal and substantial innovations. *Two Women and a Child in a Courtyard* must be an early go at this genre since space here is still flattened toward the picture plane and de Hooch's palette reminiscent of his guardroom paintings. Nonetheless, what is striking is how this domestic activity (one woman is washing linen in a wooden tub, her daughter watching; another woman drawing water from a well) is framed by a cityscape, so that what occurs in the yard belongs intrinsically to the life of the city, or better *is* the city's life. Something even more emphatic in the finer *A Woman and Child in a Bleaching Ground* – which has a meticulously described crumbling brick wall "framing" the scene from the left. In *Figures Drinking in a Courtyard*, on the right of the picture we find two seated men and a woman standing next to them with a glass of wine in her hand in a recessed corner of the courtyard. In the center of the painting, on the raised floor of the entrance to a passageway leading directly to the street, sits a young girl with a white puppy on her lap. I take de Hooch to be attempting here to merge the domestic theme (we are to take the child and dog as belonging to the woman) with the merry company genre. While there is something stilted and posed about this painting, it would nonetheless appear to underline the connection betwixt sociality and domesticity as joint emblems for nothing other than a self-sufficient secular world. Ironically, it is that same courtyard that reappears in what I take to be de Hooch's finest painting, *A Courtyard in Delft with a Woman and Child*, where in the recess, which is distinctly shabbier than in the previous painting, stands mother and daughter holding hands, gazing fixedly

at one another. In this painting the courtyard really is a quiet, protective, and nurturing interior that has been moved outside. (One should notice that in de Hooch's Holland it is always summer.) Here, rather than the exterior being glimpsed through a window or doorway, we have an exterior that is an interior, and then an interior passageway that gives out into both the interior of the home (with the doorway on the left of the passageway), and out into the street; at the end of the passageway there is a woman with her back to us is looking ambiguously into the open street and the interior of the house across the way. The ambiguity or continuity between inside and outside is echoed in the makeshift character of a trellis supporting the vine out of whose shadow mother and daughter are emerging. De Hooch's signature inside/outside movement is itself thematic since the interlocking character of interior and exterior, the composing of interior space through aerated sunlight is the self-sufficiency of these scenes, their sense of being complete, wanting in nothing. But for me what really does it, what gives this painting its bounded intensity is the brickwork, both around the arch above the entrance of the passageway and, above all, the wall on the right: the brick and mortar precisely rendered, each patch of wall in a slightly different state of decay. Has anyone ever been as enamored of masonry as de Hooch? It is the fineness of those brick walls that give to the scene its materiality, its earthiness, its firmness of place.

De Hooch's bricks are themselves correlatives of the thematic inside/ outside structure. What we see is a range of brickwork: the brickwork around the archway is elegant, decorative, yet clearly utilitarian all at once; above is the brickwork of the house, solid and in good repair; neither decorative elegance nor good repair can be ascribed to the right-hand wall: the bricks themselves are worn, the mortar crumbly, and toward the bottom serious lime leaching has occurred. If the bricks offer everything possible in the way of culture in aesthetic and utilitarian terms, they are nonetheless material stuff, bits of nature that have been worked up, *fired* to hardness, to create a wholly human and humane habitat, which, for all that, belongs (as the crumbling and lime leaching denote) intrinsically to finite nature.

This is truly an extraordinary and, as we shall see, incredibly fragile moment. De Hooch does generate a conception of order, and thereby an aesthetic, that can provide an alternative to the Italian model. For the Italian model, and the classical solution, although "composition" and "fidelity to nature" represent different axes, the fidelity to nature axis has

no independent or autonomous authority. Rather, and Gombrich is un-abashed at this, fidelity to nature is merely the vehicle for presenting or representing rational order. Because rational order, classical norms, are ideals, and while there can be a competition about which ideals are most worthy of our allegiance, painting nonetheless lives off the "objective core of the classical ideal": "For all critics of the past both Beauty and Truth were acknowledged values. What Caravaggio was accused of . . . was to have sacrificed Beauty to Truth, while the academic tradition was attacked for sacrificing Truth to Beauty. The true accusation in both cases was perhaps that both sacrificed more of the rival value than was absolutely necessary to do justice to their supreme norm."[21] In making realist painting an analogue of a lens, telescope or microscope, Alpers plays into Gombrich's hands rather than resisting him. What is necessary for that resistance is to locate some specificity to *painting* itself that enables it to provide a different conception of order and ordering.

De Hooch can paint the world because the world is the constant crossing of nature as matter and order, and culture as matter and order. De Hooch's painterly materialism continually works so as to dissolve any permanent boundary between nature and culture, between subjective lives and the material conditions for those lives, without ever denying the difference between them. In this respect his formal innovations – aerated light opening up an emphatically spatial world in which what is interior and what is exterior alternate with one another – and thematic creations – the constellation of woman, child, animal, and domestic interior or courtyard as simultaneously private interiors and naturalized cityscapes – parallel and repeat one another. But the interlocking of formal innovation and thematic creation is precisely what yields a novel grammar which is painting's own. The constant reversibility or continuity or exchange between nature and culture, matter and form if you wish, entails that order and its absence are *everywhere*, hence there is no holding nature or disorder or matter or woman at bay, fending them off, transcending them, excluding them. On the contrary, natural order, say feminine procreativity or nature as perpetual summer, and disorder, nature as decay and death, are mirrored in the material order and decay of the human artifice. Hence the orderliness of de Hoochian realism can be paratactic, the accumulation of many small things each with its own weight and gravity in relation to those contiguous with it, rather than hypotactic (order from the vantage point of the ideal), and that order be itself *expressive*. This, by the way, shows what is most profoundly wrong with Alpers' strategic assimilation of painting to

observation, lenses, mapping; it can make no sense of the intense expressive power of what is supposed to be likeness. Dutch realism, if measured from the standpoint of de Hooch, is a *relishing* of the world, savoring and delighting in it without consuming. It can do so because for a precious moment human ordering could consider itself both a working on nature, the production of the artifice of home and city, and simultaneously a part of a wider nature. Although in *Two Women in a Courtyard* de Hooch beats this idea to death, once we catch on to the schema of his realist materialism, there can be no doubt about what we are perceiving. The woman sitting with her back to us spinning is forming nature into something useful, while her maid, moving from sunlight into shade as she carries water from the well to the house, is absorbed in cyclic labor of protecting the human habitat from natural erosion; hence she polices the boundary between nature and culture which, as the recessive movement from courtyard to backing homes to church (Nieuwe Kerk) to sky implies, are nonetheless continuous with one another. A continuity and discontinuity that is, again, thematic in the lime-leached brickwork on the right. (Have I mentioned that de Hooch's father was a bricklayer?)

In his courtyard paintings de Hooch provides us, more radically, emphatically, and perspicuously than anywhere else, with the syntax and semantics for a materialist realism, hence with the elements that compose the claim of Dutch realism. Nonetheless, this is an extremely fragile moment. How fragile becomes clear if we compare de Hooch with two rival paintings by Vermeer, also from around 1658, and clearly intended to be continuous in inspiration with de Hooch. Most obvious comparison is with Vermeer's *The Little Street*. Although this painting includes what would appear to be so many signature de Hoochian elements – the finely described brickwork; the porousness between inside and outside, private and public, culture and nature; the connecting of domestic life, the life of women and children, into a wider cityscape, etc., together with a similar palette – this is still a different kind of picture. Although even less framed and hence more a glimpsed reality than de Hooch, the glimpsing is done from a distance. Given the unframed character of the image, the distancing gives the whole something of the feel of a snapshot. Even if that thought is resisted, nonetheless the distance from which the scene is observed is not just spatial. With the figures diminished and their actions frozen in time, the whole has the feel of an emphatically past moment, of something thus lost in the past, something that belongs in the realm of memory, "fixed in an artifice of eternity."[22]

If there is any painting of Vermeer's that might be thought to compete with de Hooch in its materialist realism, which is to say, in its capacity to embody an image of a self-sufficient secular world, it would be *The Milkmaid*. And indeed there is something almost hallucinatory in the intensity and realism of Vermeer's basket, bread, pitcher, and milk. Equally there is a contrast between the freshness of milk and bread in comparison with the deterioration of the wall beneath window or the disrepair of the wall at the back. And the sun blessing the lot. Nonetheless, there is little doubt that the sensuousness of Vermeer is of a different order than de Hooch. At the very least one would have to say that bread, basket, pitcher, bowl, and cloth are *too* real, hyper-real; the bread possessing the richness of a precious gem. It is as if these objects have, through the intensity of their presence, become symbols. Symbols of what? To be sure, symbols of themselves, but symbols nonetheless. But then this is a highly composed and structured work, every inch of it thematically worked. Here is Edgar Snow commenting on the relation between the milkmaid herself and her environment:

> The terms of that world comment on her presence. Note the elaborately contrasted images of things open and closed (the brass and the whicker basket, the pitcher and the standing jug, the whole and the broken loaf), full and empty (the basket on the table and those fastened to the wall, the blue overskirt and the cloth hanging from the table, the dense bread and the cavernous jug); and of interior disclosed and concealed (the lifted overskirt and the covered table, the pitcher and the standing jug again, different aspects of the footwarmer), unknown (the standing jug) and known on trust (the table under the tablecloth, the emptiness of the hanging baskets). These counterpointed objects are like facets of a meditation on both the woman's presence and the "worldness" of the world.[23]

Even if this passage is slightly overwrought, its overwroughtness is at one with its object. Above all what Snow points to is how the contrasts in Vermeer differ from those in de Hooch. I would put the matter this way: that in place of interior/exterior as the governing structure, Vermeer has disclosed and concealed; and what is concealed, unknown, mysterious in Vermeer is, above all else, woman. Vermeer's women are women seen by men; women who possess a depth of inwardness which is the inwardness, the unknowness of their sexuality. Hence, what I have called the overwroughtness of Vermeer's painting is just the sense that whatever he paints, he paints his desiring by painting its object as the perfected object of

desire. Let me concede, this thematic and Vermeer's unbelievable touch together produced paintings that are consistently riveting in a manner de Hooch cannot touch. But, equally, Vermeer's power is at a certain cost, at least from a de Hoochian perspective, since if what Vermeer paints is the object of desire, then what we receive is as much fantasy as reality. In brief, Vermeer still paints within the ambit of the male gaze, picturing woman as other, while de Hooch's realism involves finding the terms for an autonomous female gaze which, understood aright, is the look of a wholly secular modernity.

While I think there are overwhelming reasons to think that while de Hooch knew that in 1658 he had discovered something (since it is only then he begins occasionally to date his paintings), there are equally good reasons, namely the paintings he produced shortly afterward in Amsterdam, to think he mistook the nature of his own achievement. This is obvious from just the quickest of looks at a typical Amsterdam painting: *Portrait of a Family Making Music*. While this is certainly a celebration of the family, their music making the symbol of their harmony together, the opulence and richness of setting and clothing drives out any thought that what we are witnessing is either everyday or ordinary. This is a celebration of bourgeois wealth, full stop.

In the experience of de Hooch's best paintings one's eyes are continually diverted from the human protagonists and their actions to the setting, natural and man-made. Have brick walls, wooden doors, baskets and linens, windows and floors, brooms and buckets ever seemed less indigent than in de Hooch's Delft paintings? Have human artifacts – houses, alley-ways, sheds, patios – ever seemed so self-contained and world-making, composing so complete a human world – as in de Hooch's scenes of Delft life? De Hooch, I am suggesting, gave us for the first and only time a wholly sensible world of touch and sight that was sufficient in itself, a world of things that was fully or properly knowable through the senses and thus which affirmed us in our sensuous nature.

If Descartes' account of the piece of wax is a fable of modernity, then de Hooch's brick walls can uncomfortably be felt as *simultaneously* the most concrete and the most utopian rendering of a wholly secular everydayness since what is lustrous and self-sufficient in that image now seems impossible.[24] Compared to de Hooch's brick walls we will find the mountains of Cézanne or the chairs of Van Gogh as a *longing* for visibility, a desire for things whose truth can be gathered through unaided seeing. With the brick wall before our eyes, the immediacies of a Pollock or a de Kooning

can be felt as the wounded abstractions they are, perhaps as encapsulations of the moment when the material object has been "liquefied" prior to disappearing into the vacuum of mathematics. But if we cannot render the world of everydayness with the solidity that de Hooch gave it, then that world, no matter how simple, sensible, and material it is, is still a world lost, hence a utopia of the ordinary rather than its fact.

The contrast of Descartes' piece of wax and de Hooch's brick wall are for me the image of unreconciled modernity. The most profound challenge to the unity and unifying work of culture is the separation, diremption, gap, abyss separating the sensible world we aspire to live in everyday, the world of things known through sight and sounds and touch and feel, and the exactitudes of scientific explanation. Of course this gap between the visible and the invisible, the sensible and the insensible, what is observable and what theoretical, between art and science, is not one gap but a variety of gaps and separations as well as connections. Nonetheless, there can be no doubt that the fable of the piece of wax has been the dominant trajectory of modern experience, with de Hooch's courtyards becoming more and more a fiction, a desire, a Vermeerian longing. Yet, what object could be more material and sensible, more everyday and ordinary, more a simple thing of the world than a bit of brick wall? How could this simple thing have become so remote? More precisely, how could the authority of the material world of the senses, the brick and bread of everyday life, have become so evanescent?

Notes

1 All references in the text are to *The Philosophical Works of Descartes*, Volume I, translated by Elizabeth S. Haldane and G. R. T. Ross (Cambridge: Cambridge University Press, 1969).

2 For what I take to be the correct reading of this passage see Bernard Williams, *Descartes: the Project of Pure Enquiry* (Harmondsworth: Penguin Books, 1978), ch. 8.

3 A major de Hooch exhibition ran from December 1998 through March 1999 at the Wadworth Atheneum in Hartford, Connecticut. The exhibition had also appeared in the autumn of 1998 in the Dulwich Picture Gallery in London. The beautiful and useful catalogue for the exhibition is available: Peter C. Sutton, *Pieter de Hooch, 1629–1684* (New Haven: Yale University Press, 1998).

4 Francisco de Hollanda, *Four Dialogues on Painting*, trans. Aubrey F. G. Bell (London: Oxford University Press, 1928), pp. 15–16; quoted in Svetlana Alpers,

The Art of Describing: Dutch Art in the Seventeenth Century (Chicago: The University of Chicago Press, 1983), p. xxiii.

5 E. H. Gombrich, "Norm and Form: The Stylistic Categories of Art History and their Origins in Renaissance Ideals," in his *Norm and Form: Studies in the Art of the Renaissance* (London: Phaidon, 1966), p. 96.

6 I take it as given that some of the power of Gombrich's analysis turns on the match between his claims for the internal dynamic between order and fidelity to nature with Kant's contention that concepts (order) without intuitions (fidelity to nature) are empty, and intuitions without concepts blind. Hence, the "classic solution" becomes an anticipation of the ideal of cognitive synthesis, and deviation from the ideal thus a failure in the sense of accomplishing no synthesis at all; to depart radically from the ideal is thus tantamount to not *painting* at all. And this will sound potent, indeed unimpeachable, until we recall that Descartes' fiery dissolution of the piece of wax into its wholly intelligible counterpart entails the radical *blinding* of intuitions as such to the point that there is no sensible or sensuously particular nature for painterly order to be faithful to. This I understand to be the suppressed dilemma of modern painting, the pressure that generates abstract painting as simultaneously resistance and defeat. Thus I am locating in de Hooch the anticipation of that dialectic of resistance and defeat which I take to be the project and fate of modern painting.

7 Ibid., p. 95. For Gombrich the axes are both descriptive and normative. He takes it as obvious, e.g. that an "increase in naturalism" can only mean or accomplish "a decrease in order" (p. 94), where it is assumed that the decrease in order is a technical failure that a fortiori entails an aesthetic failure. If order necessarily has the sense of fit with an *ideal* of unity, hence fit with demands that are necessarily extrinsic to their material objects, then the ambition of Dutch art and what succeeded it are necessarily empty: painterly modernism is in principle impossible and without authority. I am thus construing the adventure of Dutch realism as providing the genealogical conditions of possibility for modernist painting, as instituting the idea of painting as response to wholly secular world set free from ideals forever transcending it. Said another way, I am ascribing to de Hooch, above all his brick walls, a conception of material signification that can dispense with reliance on signifiers in principle detachable from their material embodiment.

8 For the core example of this approach see Eddy de Jongh, "Realism and Seeming Realism in Seventeenth-Century Dutch Painting," trans. Kist Kilian Communications in Wayne Franits (ed.), *Looking at Seventeenth-Century Dutch Art: Realism Reconsidered* (Cambridge: Cambridge University Press, 1997), pp. 21–56. See pp. 258–9 for a bibliography of de Jongh's writings; "Realism and Seeming Realism" was originally published in 1971.

9 Sutton, *Pieter de Hooch, 1629–1684*, p. 70.

10 I am grateful to Gregg Horowitz for pointing out to me the way in which Alpers' work responds to Gombrich.

11 Erwin Panofsky, *Early Netherlandish Painting*, 2 vols. (Cambridge: Harvard University Press, 1953), 1:182; quoted Alpers, *The Art of Describing*, p. xxi.

12 Alpers, *The Art of Describing*, p. xxiv.

13 Ibid., p. 78.

14 Ibid., p. 102.

15 This is to concede that some of the "elements" that will appear in the canvases of 1658 are anticipated elsewhere. Perhaps the most interesting developments in the use of perspective is found in the paintings of church interiors by Gerard Houckgeest, Pieter Saenredam, and Emmanuel de Witte. With respect to the possibilities of cityscapes, de Hooch is anticipated by Carel Fabritius and Daniel Vosmaer. With respect to interiors it is customary to mention Nicolaes Maes, Samuel van Hoogstraten, and Isaack Koedijck. In the case of the latter three, the connection to de Hooch remains speculative.

16 More precisely, the white garments of the woman and the standing man are clearly being lit by a sunlight that is coming through the just barely visible windows on the far left. Which, I should add, makes the glare on the door more difficult to understand.

17 On the significance of smoking see Ivan Gaskell, "Tobacco, Social Deviance, and Dutch Art in the Seventeenth Century," in Franits (ed.), *Looking at Seventeenth-Century Dutch Art*, pp. 69–77. By 1658 smoking was losing its association with social deviancy and the lower classes, and becoming an acceptable middle-class recreation – but "becoming" is the operative word here. De Hooch, I think, employs the ambiguity, heightening the interplay between low pleasure and sunlit innocence. In putting the matter this way, I do mean to imply that de Hooch's gesture here should be regarded as one of securalizing: sunlit sociality becoming perceptible as a good in itself.

18 Elizabeth Alice Honig, "The Space of Gender in Seventeenth-Century Dutch Painting," in Franits (ed.), *Looking at Seventeenth-Century Dutch Art*, pp. 186–201.

19 Ibid., p. 193.

20 Ibid., p. 194.

21 Gombrich, "Norm and Form," 97.

22 Edward Snow, *A Study of Vermeer*, revised and enlarged edition (Berkeley: University of California Press, 1994), p. 109.

23 Ibid., p. 12.

24 The major task required to substantiate my interpretation of Delft materialism, as I think of it, would be to show how in painting ordinary objects de Hooch and Vermeer rendered visible how so understood such objects are not merely useful but good in themselves. But this is just a vision of how ordinary life, visionary domesticity, is intrinsically good.

3

Kant and the Aesthetic Imagination

Michael Podro

The Context of the Critique of Judgement

Philosophers have discussed the *Critique of Judgement* with very diverse concerns: most frequently to clarify how Kant conceived the relation between discursive understanding and our sensory contact with the world or to make more intelligible the link between his epistemology and moral theory.[1] Recent discussion has focused primarily on the way Kant's conception of judgments of beauty could become symbolic or instrumental in furthering a sense of morality, thereby establishing its value.[2] Here I shall be concerned with how the core aesthetic judgment itself is already value charged, imbued with a sense of the mind's independence. This requires picking out some of Kant's concerns and leaving many others aside, giving emphasis to a thread of argument which for Kant himself was subsumed in a wider project, and pressing his thought beyond his original intention.

The arguments of the *Critique of Judgement* share the problematics of the major writers on aesthetics in the second half of the eighteenth century. Their point of departure was the question of how to accommodate – how to provide a theory – for the way that the interest of works of art both eluded our rational understanding and yet in doing so could nevertheless be valuable. The problem arose out of the post-Cartesian and post-Lockian epistemologies which tied the understanding respectively to what was statable in clear propositions or could be scrutinized in the isolable features of the perceived world. Propositionality and perceptual scrutibility (whichever was to have priority) were the marks of knowledge; whatever within our thought eluded them was to be excluded, raising the question

of how it should be valued as part of our mental lives. Admittedly, the elusiveness and suggestiveness which escaped literal propositions or focal perception had been crucial to previous discussions of beauty and of taste – they were to be found in all sophisticated discussion of art – but with perception and language now conceived of as instruments of knowledge, whether rationalist or empiricist or subsequently Kantian, the status of such experience became increasingly problematic. The situation was made starker when the notion of transcendent divinity could no longer be called on to give value to effects that eluded our rational grasp.

In later eighteenth-century writers – from Diderot to Herder, Kant, and Schiller – we find two kinds of account of such elusiveness and both occur in each of our writers with various levels of tension. On the one hand an account of the particular experiential structures which aesthetic responsiveness involved: specifically, the use of the mind in forming relations, analogies, or unities which lay outside the rule of our propositional thought or consistent objective. We might, taking the word from Diderot, call it the *rapport* theory, a theory of implicit rather than overt connection. Diderot distinguished between the relations between represented features, considered in themselves, and relations – *rapports* – which presupposed a viewer or auditor; for instance, the difference between the objective relations between parts of buildings of the Louvre and those relations which it possessed only with reference to minds like our own: the *rapports* associated with beauty are relations which entail both objective and subjective conditions; they obtain between features or aspects of an object only if we consider them in relation to the observer.[3] Admittedly, all perceived relations may imply a viewpoint from which they are observable, but our judgments of these relations need not include a reference to the viewpoint. In our sense of beauty, however, the relevant *rapports* must include such a reference; a sense of relations emerging for a viewer or reader or audience. This was later to form the core of Kant's pure aesthetic judgment or judgment of beauty. But each of our writers will also have another component theory covering such elusiveness, a theory which refers to expressive gestures, conceived as prior to grammatically and logically articulated language. (The crucial text of this theory is Diderot's "Lettre sur les sourds et muets."[4]) These conceptions – of implicit connection and of expressive gesture – will take different forms as we move from writer to writer but both are present in all of them. The way the two models connect or fail to connect with each other should, I suggest, be central to the interest they now hold for us.

The present essay on Kant has been written with two problems in mind: how the conception of aesthetic judgment was aligned to and differentiated from his conception of knowledge and how the two component theories – of *rapports* and of expressive gesture – could be related to each other.

The Starting Point in the *Critique of Pure Reason*

What was Kant's theory of knowledge from which judgments of beauty were banished and how was the same theory of mind then turned to give an account of just such judgments? A brief and I think uncontentious account of Kant's theory of cognitive judgment might run like this. Kant assumed – with Locke and Hume – that we could only have knowledge of the world grounded in perception; the question then arose of whether perception could be enough for knowledge. How could we account for the way our world was structured by stable objects, set out in space and time, so that we were not simply subject to fleeting sensory impressions occurring in unrelated spaces? Kant's answer was many layered as he examined the route from sense impressions to those stable objects in a coherent world. Centrally the mind had the power of synthesis: "Synthesis in general . . . is the mere result of the imagination, of a blind though indispensable function of the soul, without which we should have no cognition at all, but of which we are seldom even conscious" (B 103). This synthesis was not a matter merely of linking impressions which followed each other, nor of linking present sensations with similar past sensations as Locke and Hume believed, for this would not explain how those sensations could be *of* stable objects and how those objects could appear in different ways, nor how they related to us as continuing subjects of experience.[5] Synthesis could not be explained by chains of association.

We have representations in us, of which we can also become conscious. But let this consciousness reach as far and be as exact and precise at it wants, still there always remain only representations, i.e. inner determinations of our mind in this or that temporal relation. Now how do we come to posit an object for these representations, or ascribe to their subjective reality, as modifications, some sort of objective reality? Objective significance cannot consist in the relation to another representation (of that which we want to entitle the object), for that would simply raise anew the question: How does

this representation in turn go beyond itself and acquire objective significance in addition to the subjective significance that is proper to it as a determination of the state of mind? If we investigate what new characteristic is given to our representations by the *relation to the object*, and what is the dignity that they thereby receive, we find that it does nothing beyond making the combination of representations necessary in a certain way. . . . (A 197 B 242)

Given that we are situated in the world as we are and that we *do* gain knowledge of what lies about us, we must assume a mind capable of bringing this about. "The impressions of the senses supplying the first stimulus, the whole faculty of knowledge opens out to them, and experience is brought into existence" (A 86 B 118). The whole faculty of knowledge, that is, lies in readiness to be brought into play by the senses. (This thought still underlies perceptual psychology: however it comes about that we have this capacity – we would now say through evolution – the mind *unscrambles* sense impressions, positing objects in a consistent space to give us a model of the world.) Kant did not know how the mind did this, and even said that it lay in some unfathomable capacity, but *that* it did it was assumed. Whether our overall view of the world, including its structure of space and time, was in some ultimate sense true to whatever it was that lay outside the to scope of our knowledge was for him an ill-formed question. The only world we could talk about intelligibly was one which appeared in our experience, and this assumed that sensory stimulation had been gathered together in a spatio-temporal order and presented objects as independent of our perceiving them.

Aesthetic Judgment: Reflective and Reflexive

The question raised for Kant by aesthetic judgment was how, within this view of the mind, there could be not only objective judgments about the external world but judgments in which the imagination became engaged in introspectable reflection. He gave a summery answer in his First Introduction:

By the designation "an aesthetic judgement about an object" it is therefore immediately indicated that a given representation is certainly related to an object, but what is understood in the judgement is not the determination of the object but of the subject and its feeling. For in the power of judgement

understanding and imagination are considered in relation to each other, and this can, to be sure, first be considered objectively, as belonging to cognition . . . but one can also consider the relation of the two faculties of cognition merely subjectively, insofar as one helps or hinders the other in the very same representation and thereby effects the *state of mind*, and [is] therefore a relation which is *sensitive* (which is not the case in the separate use of any other faculty of cognition). (First Introduction, AA XX:223)

The internal dynamics of such judging cannot be captured in the description of the object itself nor of the impact of the object on the subjective state of the perceiver, nor in the mere addition of one to the other. It is a mode of mental activity directed upon the object in which we apprehend "a regular, purposive building with one's cognitive capacities . . . this forms the basis of a very special capacity of discriminating and judging" (204). The judgment has an ineliminable subjective reference as well as a reference to the object being assessed. One way of putting this is to say that it is not a judgment about the object but a procedure for reflecting upon an object which at the same time takes within its scope its own engagement.[6] The aesthetic judgment is "subjectively, object to itself as well as law to itself" (288). It is a reflective judgment, in that it does not simply identify what is objectively present by placing it under an empirical concept, but entertains the possibility of different ways of seeing it and it is also reflexive in that it returns recursively to its own making. The satisfaction it yields is in the functioning of our cognitive capacities; more specifically the interplay between sensibility and understanding, or – as Kant prefers to put it – between the imagination and understanding.

We should here dispose of a significant inconsistency in Kant's use of terms. He talks not only of the relation of sensibility and imagination but sensibility and understanding, which seems to leave imagination out of the picture. But the relation between sensibility and understanding is functionally equivalent to the relation between imagination and understanding. When he talks about the latter, sensibility is included in the domain of the imagination; when he talks about the former, imagination is included in the domain of the understanding. Kant himself says at one point in a footnote in the *Critique of Pure Reason*: "It is one and the same spontaneity that, there under the name of imagination and here under the name of understanding, brings combination into the manifold of intuition" (B 162). His theory is fundamentally a relation between two basic factors: the externally precipitated manifold of sensation encountered by

the spontaneous ordering processes of the mind. The imagination functions for Kant as the mediating term between order and the matter which it orders; it is the aspect of mental life through which elements or sub-components are integrated. In perception, the imagination manifests itself, for Kant, in two contexts: in our ordinary recognition and understanding of the perceived world, where we take its operation for granted – it functions blindly – and in contrast to this where we reflect on perceived objects seeking order or pattern within them. What the two functions of the imagination have in common is that in each the mind goes beyond what is posited as initially present to it: in one case a sensory manifold which by virtue of the imagination we come to see as coordinated and yielding the perception of objects and, in the other, an object to which by virtue of the imagination we adjust and explore. The imagination is the capacity to elaborate what we see or think into some more extensive awareness.

Aesthetic judgments are elaborations. "In order to judge whether something is beautiful or not, we do not relate the representation by means of the understanding to the object for cognition, but rather relate it by means of the imagination (perhaps combined with the understanding) to the subject and its feeling of pleasure or displeasure" (203). What is meant by referring to the subject is establishing the relation between the object and the subjective conditions of its perception. Whereas in the case of cognition the understanding dominates our relation to the object, drawing the object under a concept in making a judgment about it, in aesthetic judgment it is the imagination which dominates in the sense that the mind's concern is with an object in its particularity, prompting the understanding to find a way of making it intelligible, finding some unity or gestalt within it. Kant talks obscurely here of the harmony of imagination and understanding. The thought has its root in an earlier, pre-critical assumption of Kant's thought which distinguished intuition from understanding, and we can clarify the notion of the priority of the imagination and the harmony between imagination and understanding by reference to that earlier opposition.

Intuition and Understanding

Our intuitive relation to an object registers a characteristic of its appearance. A conceptual relation to an object is one in which the characteristic is not only attended to in perception but is taken up in a discursive judgment;

that is, the object is attended to in such a way that its characteristic is thought – or thought of – in its universality, i.e. as substitutable by other instances; our thinking of that object is in discourse, i.e. in language. It is true that our intuitions, insofar as they already register a characteristic (*Merkmal*), must involve the use of concepts in a broad sense but that does not mean there is no distinction.[7] For the understanding's specific manifestation is discursive thought, whereas the imagination's specific manifestation is intuition.

In the published *Logic*, which was based on his lecture course given over many years, he wrote: "Logical distinctness rests on the objective, aesthetic distinctness on the subjective clarity of characteristics. The former is clarity through *concepts*, the latter through *intuition*. The latter kind of distinctness therefore consists in a mere *vividness* and *intelligibility*, that is, a mere clarity through examples *in concreto* . . . Not seldom, objective distinctness is therefore possible only at the expense of aesthetic distinctness, and conversely, aesthetic distinctness – through examples and similies that do not exactly fit but are taken only after some analogy – often harms logical distinctness (*Logic*, Introd. VIII, trans., p. 68).

Admittedly, Kant never makes the transition between characteristics present in intuition and their being taken up in conceptual or discursive thought very clear; that is primarily because in this context he gives no account of language as a spontaneous social activity interacting with the perceived world; without this it is hard to see how you could relate characteristics in intuition and in discourse to each other.[8] Kant had a conception of such linguistic activity but it does not form part of his central theory of mental mechanisms in the Critiques. It is introduced only as a parallel to such mechanisms in his discussion of poetry. To this I shall return at the end of this essay.

The gap between intuition and understanding – perceptual and conceptual cognition – becomes clearer if we ask about the difference between developing awareness in the two cases. An intuition might develop or extend itself, extend its awareness of the object, by differentiating what is at first indistinct: "Sensible distinctness . . . consists in consciousness of the manifold of intuition. I see the Milky Way as a white band; the rays from the individual stars in it must necessarily have entered my eye. But the presentation thereof was only clear; it becomes distinct through the telescope, because now I see the individual stars comprised in the milky band" (*Logic*, p. 39); the point is not materially altered because he uses a telescope rather than alters the mode or focus of attention; an intuition

may be developed by differentiating or by coordinating the initially observed characteristic with others in that intuition; put a little differently, the characteristic of an object which enters our awareness in intuition is essentially permeable to and transformable by its sensory context; e.g. tones in music. In contrast to this, the conceptual thought of the object is developed by linking the initial (abstracted) characteristic with other concepts in language, i.e. discursively. In intuition our initial awareness is developed by being merged with or differentiated from others and in the process losing its identity in the new gestalt; whereas our conceptual awareness is developed by relating our initial concept to further concepts. The distinction is adumbrated in a Reflexion probably dating from twenty years earlier, but nevertheless suggestive for his later thought.

"Reason [later he would say 'understanding'] represents only the relation of concepts, but in intuition the absolute and inner character of the object is thought. As far as clarity is concerned, it is thoroughly compatible with intuition. For *clarity comes from the differentiation* of the manifold in a whole representation. Insofar as these pieces of cognition are thought through general concepts, the clarity is an effect of the understanding; if it happens through [component] individuals, it is a form of sensibility. The first occurs through subordination, the second through co-ordination. In music one has no concepts of the tones, but only sensations, without cognizing their relations by number; that is, according to general rules" (R 643 AA 15.2; my emphasis). Beautiful objects, Kant will go on to say, are those that please by virtue of being unified according to the laws of intuition, "Schöne Gegenstände sind, deren Zusammenordnung nach den Gesetzen des *intuitus* gefällt" (R 646 AA 15.2).

But how does Kant's earlier intuitive/cognitive distinction relate to his later distinction between aesthetic and cognitive *modes* of judgment in the *Critique of Judgement*? How does the distinction between perceptual attention to the particular and discursive thought get turned into that later distinction between objective judgment and aesthetic adjustment – the harmony between imagination and understanding? The first part of the answer is that both pairs (the intuitive/cognitive and the aesthetic/cognitive distinction) represent alternative kinds of attention, alternative ways of summating our experience which are in potential conflict. Kant's point in the third critique is that if exploring a particular object is to yield satisfaction – and it is assumed that this is what occurs in aesthetic judgment – and if that satisfaction lies not in mere sensory stimulus or gratification – which is also assumed, then it requires our understanding, our

capacity for synthesis, to be directed upon the object and it requires that the *relation* between the object and that reflective synthesis yields satisfaction. What the earlier account of aesthetic responsiveness lacked was any ground for attributing a reflective satisfaction to intuition; for once intuition had been separated from the use of concepts it was unclear what the satisfaction could be beyond sensuous gratification. What is crucially new in the *Critique of Judgement* is that the understanding's pursuit of unity ("the general lawfulness of the understanding") is separated from the discursive use of concepts; the synthesis achieved by the imagination could then be seen as in harmony with – as *fulfilling* – the understanding's concern for that unity even if it did not place the manifold under a concept; it yielded a configuration which had cohesion and was not merely a set of unrelated impressions. But what would the working of the imagination have to be like to satisfy that search for unity beyond or beside the normal fit between the receptive and cognitive capacities of the mind, beyond or beside the fit which our ordinary cognition of the world would assume?

Non-discursive Reflection

In Kant's account of the matter, when the understanding and the imagination are in free play, the mind has a certain "independence" in relation to the material objects to which it directs itself. The sense of independence lies first of all in our being able to accomplish something with regard to our perception of the object rather than something accomplished by the object in fulfilling a need. I do not have a prior need or want which the object alleviates beyond, perhaps, the need to engage with the perceivable world. "We can easily see that, in order for me to say that an object is *beautiful*, and to prove that I have taste, what matters is *what I do with this presentation within myself*, and not the sense in which I depend on the object's existence" (205; the latter emphasis is mine). If we ask why this registers our independence and not some inner *compulsion* like an appetite, an appetite to unify the sensory experience into an ordered manifold, the answer is that the notion of reflection itself implies independence, for only a creature with independence could be reflective. Because we are aware of our own reflectiveness in aesthetic judgment it offers evidence to us of that independence. (We might see this sense of independence anticipated in Rousseau's conception of what is distinctive about human language as opposed to the pre-set patterns of animal response.[9] The sense of

independence has a later analogue in Wittgenstein's notion of seeing an object in different ways, when such alteration is under the dominion of the will; that is, where we try to see things under the guidance of different thoughts about it or within different contexts; or perhaps simply changing the focus of attention to see how the object might reconfigure itself.[10]) But *how* – for Kant – is reflectiveness experienced so that it yields a sense of satisfaction in its exercise? Will any flexibility of attention serve?

In the "General Remark on the First Division of the Analytic" of *Critique of Aesthetic Judgement*, the part in which he has laid out the basis of pure aesthetic judgment, Kant summarizes his position briskly: "If we take stock of the above analyses, we find everything comes down to the concept of taste, as a faculty of judging an object in relation to the free lawfulness of the imagination" (240). What Kant means by the free lawfulness of the imagination is the kind of imaginativeness which does not merely associate – on the basis of past experiences – round a given focus of perception, drawing it under a concept, but connects one aspect of an array with another, so subjecting it to a further level of integration; this is found satisfying because it is an inherent purpose of the mind to integrate its contents. Kant assumes that in aesthetic judgment we are pursuing this kind of satisfaction, which he distinguishes from other kinds of satisfaction which in the past had been confused with it, in particular satisfaction in the "perfection" of an object, in the object's fulfilling a criterion of what it should be. What is found satisfying is not the link between the object and some concept which we recognize it as instantiating but the way the object brings into play the relation between the ordering capacity of the mind and its receptivity to sensory impressions.

But how, we must now ask, can our imagination be free while at the same time it is restricted to what is presented to it? Kant answers: "although in apprehending a given object of sense it [the imagination] is tied to a determinate form of this object and to that extent does not have free play (as it does in composing poetry [*Dichten*]), it is still conceivable that the object may provide it with a form that contains precisely such a composition of the manifold as the imagination, if it were left to itself, would freely design in harmony with the *lawfulness of the understanding* in general" (241). The mind that would be producing forms out of itself would not be, in this account, a blank abstract mind, but one already engaged with the perception of the array before it; the object would be prompting the mind to observe some aspect of itself in the light of others, finding continuities or symmetries; it would do so – in Kant's account

– because it was assumed to seek the integration of its contents; in aesthetic judgments we become aware of a reciprocity between our imagining and the objective world; and even further, that what lies outside us appears to us as expressive of our own thought, the object offering the imagination "just the sort of form in the combination of its manifold as the imagination, if it were left to itself, would freely design . . . "

The experience in aesthetic judgment is necessarily double: it is of a form which is perceived and then re-realized as fulfilling an anticipation that it had itself set up. But this is problematic: for surely what Kant means here could not be that what the imagination finds is the fulfillment of a clear anticipation which subsequent perception confirms (I expect to find a lily in this Annunciation, and lo and behold – there it is), because our anticipation cannot be assumed to be so precise or itemizable. We must rather assume a feedback mechanism by virtue of which anticipation becomes sharpened by what we actually find to be available to us. But once we have acknowledged this, we need to explain why it is not simply a matter of our perception becoming more replete, as when we observe a tree or a person in greater detail, or see the features of an object as part of a larger gestalt. What is it that is distinctive about the phenomenology of aesthetic judgment? We should surely read Kant's answer to this not as a matter of the real time sequence of our perceiving, but of something in the perceived structure of the object as we finally resolve it. To take the simplest case, we perceive two aspects which are discrete but each as modifying how the other is seen; within the object one form or configuration is seen as the response to another or as issuing out of another or as the analogue or the completion of another. What is perceptually necessary for aesthetic judgment is that there must be (a) a discontinuity between aspects such that one can enter and impinge on the other *without* removing either their separateness or the need on the viewer or reader's part for adjustment between them, and (b) that sense of the separate aspects and of our adjusting between them remaining constitutive of our interest in making our judgment (as it doesn't when the judgment is cognitive in purpose). But, of course, when we set out to regard an object – centrally a work of art – in that way aspects of the object might not be amenable to this kind of interplay, or not to any significant degree, with the result that when the object is amenable we have a sense of good fortune, of the fit between our mind and the world.

Kant's thought here runs parallel with his account of scientific discovery in which he says "it is contingent, as far as we can see, that the order of

nature in terms of its particular laws should actually be commensurate with our ability to grasp it"(187) so that new extensions and unifications of knowledge bring with them a confirmation of the fit between the mind and the world. When we find the world amenable to the construction and unification of our theories we are encouraged to think that our mind and the world are in their underlying purpose adapted to each other. In this way an aesthetic judgment provides an analogue or model of an underlying fit between world and mind. It presents itself as evidence, a symbol or even a confirmation that the world of appearance is one which is compatible with the exercise of our freedom. (And beyond this the intimation that we may conceive the world as purposive for our cognition of it.)

Constraints on Non-discursive Reflection

We gain a clearer insight into Kant's sense of the mind's independence at a phenomenological level when we see what it is contrasted with, what it excludes. "In the estimate of free beauty (according to mere form) we have the pure judgement of taste. No concept is here pre-supposed of any end for which the manifold should serve the given object, and which the latter therefore should represent – an incumbrance which would only restrict the freedom of the imagination that, as it were is at play in contemplating the outward form" (230). Kant's thought here assumes a distinction between two ways in which the manifold is synthesised: one where we generate or re-apply a concept to which that earlier experience had given rise; the other where we take up relations internal to the object that is present.

He would seem to make the two functions of the imagination incompatible rather than just distinct. In some passages he writes as if placing something under a concept and *also* finding satisfaction in it would turn our judgment into a judgment of perfection; it would become a matter of satisfaction in the fit between the manifold and a concept. But to apply a concept and to take satisfaction in something to which it is applied is not necessarily or even probably to take satisfaction in applying the concept. Nor does seeing something under a concept entail judging it as a perfect instance of that concept. His point here is that, insofar as we regard judgments as registering satisfaction, the satisfaction of an aesthetic judgment is never in the fulfilment of a prior criterion or purpose, or the adequacy of an object to a presupposed design. For Kant's all our mental activity is

purposive and its products correspondingly are fulfilling in different ways (242). We must therefore distinguish between different purposes within cognition broadly understood, and so different kinds of completion. If our purpose is to judge by some prior criterion that will be incompatible with fulfilment being aesthetic.

A further kind of constraint on the freedom of the imagination arises from the limitations of the object we address: "Everything that shows stiff regularity (close to mathematical regularity) runs counter to taste: the consideration of it because it does not allow us to be entertained for long . . . it induces boredom . . ." There are several components in Kant's thought here: there is first a psychological observation: regularity leaves no surplus in the manifold for our understanding to synthesize; in geometrical figures our perception and our conceptualization come locked together. Geometric regularity has an authority over our perception which would leave no room for the harmony of the faculties; it would pre-empt seeking out and finding unity because its gestalt would compel a particular set toward itself: "these are called regular precisely because the *only* way we can present them is by regarding them as the *mere exhibition* of a determinate concept that prescribes the rule for the figure (the rule under which alone that figure is possible)" (241). (In the first critique he had said that mathematic forms are constructed by the mind according to a priori principles (CPR B 221) and this would seem to apply to geometric relations.) This would, for instance, disallow geometric patterns as in mosaic pavements from sustaining aesthetic judgment, but one must take Kant's psychological point here as applying to single shapes and more generally to forms that may be *too simple or obvious* to make aesthetic satisfaction possible. When he takes up the issue in the discussion of fine art he writes: "although the two cognitive powers, sensibility and understanding, are indispensible to one another, still it is difficult to combine them without constraint and without their impairing one another; and yet their combination and harmony must appear unintentional and spontaneous; otherwise it is not *beautiful* art. Hence anything contrived and painstaking must be avoided . . ." (321). So, on the one hand the possibility of exercising aesthetic judgment depends on whether the object or array is of the kind – complex enough – to stimulate and satisfy aesthetic judgment, and on the other whether our minds are purposed to exercise such judgment.

Kant's primary purpose has been less to exclude the use of concepts than to indicate that alternative mode of perceptual fulfillment; for this alternative he adduces the examples of abstract pattern, designs on wallpaper

and *foliage à la grèque* as paradigmatic objects for aesthetic judgment, configurations which elude the application of empirical concepts. In these examples of overall pattern, so we must take Kant to imply, we respond to repetitions and continuities which override spatially consistent reading or separation between objects. Kant would not have to make the two modes of synthesis completely efface each other; for, first of all we might apply empirical concepts without making a cognitive judgment, as when we see a tree in its shadow or in a picture; and secondly such recognitions of – say – trees or foliage might be subsumed in an overall sense of pattern. He will himself make a similar point when later he talks about painting, landscape gardening and decoration. "In painting in the broad sense I would also include the decoration of rooms with tapestries, bric-à-brac, and all beautiful furnishings whose sole function is to be *looked at* . . . paintings properly so called (those that are not intended to *teach* us, e.g. history or natural science) are there merely to be looked at, using ideas to entertain the imagination in free play, and occupying the aesthetic power of judgement without a determinate purpose." Kant is surely right (231) that there are different mental sets, two different ways of addressing the objects of perception, that they are in tension and one has to dominate the other.[11] (In another discussion of poetry, in his lectures on Anthropology, he insists that although both understanding and the senses are involved, priority must always be given to one or the other. [XXV.2 p. 987f].) Thus a sense of freedom in aesthetic judgment lies not only in its spontaneity and its symbolization of freedom but also in allowing the laws of intuition to sustain themselves without the responsibility of conceptual judgment. But why, we must ask, in the Kantian frame of things should understanding be constraining? The thought that is adumbrated (to be more fully developed by Schiller) is that what we value in reflective life cannot be limited to our determinate thought; that our reflective life has sensitivities which are not summated in cognition – for instance, our responsiveness to the beauty of plants as opposed to our understanding of botanical structures. (We can legitimately call on this distinction whether or even if we reject Kant's making natural beauty rather than works of art the focus of aesthetic judgment.)

 To summarize so far: to the question of why the exercise of the imagination should yield a sense of freedom, Kantian answers would be (i) that our sense of our own independence, the pleasure in the constructive power of our minds, as we connect and transform the material of perception, is something we experience ourselves as doing; it is not the objective nature

of things in the world that completely determine our experience but something which we bring about and which transforms what is offered in perception, whereas to reside within our cognitive conceptualizing judgments is to experience the world as determinate. (ii) We allow intuitive movements or configurations to sustain themselves beyond the scope empirical understanding, not as mere sensory stimulation but as representations which the mind can sustain reflectively without the duty of cognition. The implication here is not only of freedom from the constraint of natural appetite but from the constraint of understanding. (iii) We become aware of a reciprocity between the external object and our own projecting or imagining, so that we can experience one as corresponding to the other; and this attunement between ourselves and the world in which we find ourselves, for Kant, can symbolize – if it does not actually exemplify – the compatibility between nature, the world of causally structured appearances, and our freedom as rational beings

Imagination's Freedom, the Larger Sense

These three aspects of imaginative freedom – the sense of independence toward its object, the sense of being relieved of certain constraints, and the sense of fit between the mind and its object are extended in a further sense of imaginative freedom: the imagining of transcendent ideas in the light of which the immanent and cognizable world might be seen. Kant develops this in his discussion of fine art. "Among all the arts *poetry* holds the highest rank . . . It expands the mind; for it sets the imagination free, and offers us from among the unlimited variety of possible forms that harmonize with a given concept . . . that form which links the exhibition of the concept with a wealth of thought to which no linguistic expression is completely adequate, so poetry rises aesthetically to ideas . . . it lets the mind feel its ability – free, spontaneous, independent of natural determination – to contemplate and judge phenomenal nature as having aspects that nature does not on its own offer in experience, either to sense or to the understanding, and hence poetry lets the mind feel its ability to use nature on behalf of and, as it were, as a schema of the supersensible" (326). Kant continues: "Poetry plays with mere appearance [*Schein*], which it produces at will, yet without using mere appearance to deceive us, for poetry tells us itself that its pursuit is only play, though this play can be used purposively by the understanding for its own business" (327). So the

freedom of the mind in poetry, unconstrained either by the literal charac-
ter of nature or – in language – by the logical stringency of consistency of
meaning serves as a symbol of the mind's freedom. "In this process we feel
our freedom from the law of association (which attaches to the empirical
use of the imagination [i.e. the imagination which enables us to re-deploy
empirical concepts developed in earlier experience]); for although it is
under that law that nature lends us material, yet we can process that
material into something quite different, namely into something that sur-
passes nature" (314).

 In this further and grander sense of freedom, artists and their audiences
utilize such independence toward their borrowings from nature to enter-
tain transcendent ideas, ideas of what lies beyond the bounds of sense,
centrally the ideas of human freedom, of God, immortality and the
immeasurability of creation. This is not only a matter of representing spe-
cific notions which can only be intimated and not realized in perception,
but more generally of art reaching beyond the the limits of our cognitive
range. Such transcendence is an extention of the independence of the
imagination in the following sense: that we imagine how the world might
look from a more comprehensive perspective than we ourselves can ever
obtain, because of the necessary limitations of knowledge. (This in turn
is linked to Kant's conception of the sublime which I shall not discuss
in depth here. Briefly, in the sublime we are led to reflect on two kinds

of human inadequacy: on our physical vulnerability before the power of
nature and on our intellectual limitation before its infinity. The effect of
sublimity arises from our sense that there is something within us which is
not limited by these inadequacies: our rational and moral being.)

Intuition and Language

Kant's sense of the unliteral use of language readily aligns itself with
Diderot's conception of poetic language in the "Lettre sur les sourds et
muets." Kant wrote: "if we wish to divide the fine arts, we can choose for
this, at least tentatively, no more convenient principle than the analogy
between the arts and the way people express themselves in speech so as
to communicate with one another as perfectly as possible; namely, not
merely as regards their concepts but also as regards their sensations. Such
expression consists in *word, gesture,* and *tone* (articulation, gesticulation,
and modulation). Only when these three ways of expressing himself are

combined does the speaker communicate completely. For in this way thought, intuition and sensation are conveyed to others simultaneously and in unison" (320). (This conception of primitive language games can be found not only in Diderot's "Lettre sur les sourds et muets" but in Rousseau's *Origine des Langues.*)

But are his sense of the expressiveness of language and his theory of the harmonious play of the faculties logically related or integrated, beyond both involving communicability? More interestingly, can the consideration of expressive language throw any light on Kant's initial account of aesthetic judgment? Despite uncertainty about how the individual terms of the two respective triads might be thought to correspond (thought, intuition, and sensation: word, gesture, tone), what links the pure judgment of taste and the account of expressive language is that each spans the gap between sensibility and thought. What, first of all, we should correlate are not individual items – word, gesture, tone, and so forth – but the relation running through each triad: the conception of language as initially a matter of communicative gesture linking the sensible world and the utterer's thought, as intuition or imagination linked sensibilty and understanding. Gesture, like intuition or imagination, is a means by which we attach the sensible world to our communicable thought about it. Ironically, the sense of language was precisely what was missing when Kant had discussed the relation of intuitions and concepts. This suggests that there was a latent thought on Kant's part, inaccessible to the main lines of the Critiques, that intuition – or imagination – might be seen on analogy with a primitive language game, one like that of Diderot or Rousseau, closely engaged with the sensible material world to which it directed attention, and not only on analogy with some unfathomable perceptual mechanism.

Beyond a putative exegesis of Kant it seems fruitful to pursue the analogy between pure aesthetic judgment and expressive gesture. For aesthetic judgment – beyond its intersubjective communicability – exhibits an internal communicative structure, something like the pattern of utterance and response. It does so because, from the perspective of the viewer/reader the work must – as we have seen – elicit and satisfy expectations which it has itself set up. A dialogue is thus enacted within the viewer's awareness of the work; in Kant's words discussed earlier: "the object may offer to it [the imagination] just the sort of form . . . as the imagination, if it were left to itself, would freely design . . ." The experience in aesthetic judgment is, as we have seen, necessarily double: it is of a form fulfilling some anticipation that it had itself gestured toward, in the light of which it

is to be re-understood. What links the proto-linguistic sense of intuition and aesthetic judgment more closely is that the linguistic gesture is made in anticipation of others taking up its import, of their attending to what it directs their attention toward, as one aspect of a painting directs attention toward another, the viewer following the movement within herself. Merleau-Ponty wrote: "The accomplished work is thus not the work which exists in itself like a thing, but the work which reaches its viewer and invites him to take up the gesture that created it and leaping over the intermediate steps to rejoin, without any guide other than the movement of the invented line, an almost incorporeal trace; the silent world of the painter, now proffered and accessible."[12] In this way we might conceive of the work of art itself as made up of gestures and the context into which they are directed; the form that serves as a gesture will itself also serve as the context or object to which other gestures are directed. Put another way, the forms within a work of art may be seen as inviting us to see each other in particular ways without those ways being definitive.[13] In this we may identify the distinctive imaginativeness of an art.

Notes

1 References to Kant in the text to the *Critique of Judgement* are given by the page numbers of the standard Deutsche Akademie Ausgabe of *Kants Gesammelte Schriften* which are shown as running numbers in most translations. References to the *Critique of Pure Reason* are prefaced by A or B, representing the first and second editions. Other references to Kant preceded by AA indicate the volume and page numbers in the Akademie Ausgabe. The most recent translations of Kant's works into English are in the Cambridge Edition of the Works of Immanuel Kant: *Critique of Pure Reason*, trans. and ed. Paul Guyer and Allen W. Wood (Cambridge University Press. 1998); *Critique of the Power of Judgement*, ed. Paul Guyer, trans. Paul Guyer and Eric Matthews (Cambridge University Press, 2000). I have generally used these for the sake of their greater accuracy but occasionally used my own phrasing or that of earlier translators. References to Kant's *Logic* are to the translation by Robert S. Hartman and Wolfgang Schwarz (New York: Dover, 1988). Now standard commentaries in English are Paul Guyer, *The Claims of Taste* (Cambridge, Mass. and London: Harvard University Press, 1979) and the translation and commentary of the *Critique of Judgement* by Werner S. Pluhar (Indianapolis: Hackett, 1987). I am indebted to Fiona Hughes *The Role of the Concepts of* Reflexion *and* Harmonie *in Kant's Critical Philosophy* (Ph.D.

Dissertation, Oxford, 1993); I have also benefited greatly from discussions with her on the third critique.

2 See Paul Guyer, *Kant and the Experience of Freedom. Essays on Aesthtics and Morality* (Cambridge University Press, 1993); Dieter Henrich, *Aesthetic Judgement and the Moral Image of the World* (Stanford University Press, 1992).

3 D. Diderot, "L'Origine et la nature du beau," *Oeuvres esthétiques*, ed. Paul Vernière (Paris: Garnier, 1965), pp. 387–436.

4 D. Diderot, "Lettre sur les sourds et muets" ed. Paul Hugo Meyer, *Diderot Studies VII* (Geneva: Droz, 1965).

5 See P. F. Strawson, "Imagination and Perception" in his *"Freedom and Resentment" and Other Essays* (London: Methuen, 1974), pp. 46–65 and J. Michael Young, "Kant's View of the Imagination," *Kantstudien*, 1988 pp. 140–64.

6 The conception of aesthetic judgment as irreducible to a single proposition raises questions discussed by Paul Guyer 1979, p. 84 and the same author's "Pleasure and Society in Kant's Theory of Taste," *Essays in Kant's Aesthetics*, ed. Ted Cohen and Paul Guyer (Chicago and London: University of Chicago Press, 1982), p. 22: "the justification for a judgement of taste requires a duplex process of reflection, involving both a direct reflection on or estimation of an object, and a further act of reflection on one's experience of the object, which issues is an aesthetic judgement of taste. These two forms of reflection are logically distinct, in that the latter both presupposes the former and is also subject to a condition – an express consideration of communicability or intersubjectivity of the experience – to which the latter is not." For a contrary view Hannah Ginsborg "Reflective Judgement and Taste," *Noûs* (Cambridge, Mass., 1990), pp. 63–78. On the reading of Kant that I am suggesting there is no proposition which constitutes the aesthetic judgment but an exercise of the mind which has the sense of the mind's independence toward the object presupposed and constitutive of it. It is not as if we have the pleasure, then have to check up that it was caused in the right way, and then issue the judgment. Guyer's two processes of reflection would, I believe, be called for only as a subsequent argument in justification of the original judgment being indeed an aesthetic reflective judgment.

7 See Houston Smit, "Kant on Marks and the Immediacy of Intuition," *Philosophical Review*, vol. 109 (2000), pp. 235–66.

8 Nevertheless, Kant was clear that the distinction between intuitions and concepts was crucial, holding that while Leibniz had treated perceptions as though they were already concepts, Locke had treated concepts as if they were perceptions (A 271/B 327).

9 J. J. Rousseau, "Essai sur l'origine des langues" *Oeuvres Complètes* (Paris: Gallimard, 1991), vol. V, pp. 378–409.

10 L. Wittgenstein, *Philosophical Investigations* (Oxford: Blackwell, 1953), pp. 199–200.

11 On whether the use of concepts is excluded from aesthetic judgement see
 Malcolm Budd, "The Pure Judgement of Taste as an Aesthetic Reflective
 Judgement," *The British Journal of Aesthetics*, vol. 41 no. 3 (2001), pp. 252–4
 and Anthony Savile, *Kantian Aesthetics Pursued* (Edinburgh University Press,
 1993), pp. 108–10.
12 M. Merleau-Ponty, *Signs*, trans. R. McCleary (Northwestern University Press,
 1964), p. 51.
13 This interaction is discussed in Michael Podro, *Depiction* (New Haven and
 London: Yale University Press, 1998), pp. 5–17 and passim.

Meaning, Identity, Embodiment

The Uses of Merleau-Ponty's Phenomenology in Art History

Amelia Jones

Gustave Courbet's 1866 painting *The Origin of the World*, commissioned by Turkish diplomat Kahil Bey, is a justly notorious painting, not the least for its provocative conflation of pornographic content with high-art mimesis.[1] It depicts, in Courbet's signature realist style and with lubricious detail, the fleshy, slightly swollen genitals of an anonymous reclining female nude, presented as a truncated torso.

But the painting also promotes another conflation with even greater ideological consequences – that of the hallowed notion of the female body as the site of human generation, the ultimate "origin" of life and meaning, with artistic creation. This latter fusion, which, by extension, poses Courbet (the male artist) himself as "origin of the world," begs some of the most profound questions that inevitably arise in relation to the visual image: what kind of thing is a picture? how do we engage with it? what kind of body/bodies do we experience or perceive hovering within or in relation to it? who produced it and what does it mean?

The stakes of pinning down the meaning of this particular work – determining its *identity* and, by extension (as we shall see), the identities

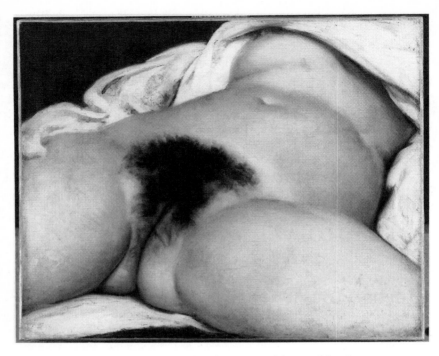

Gustave Courbet, *L'Origine du Monde* (The Origin of the World), oil on canvas,
46 × 55 cm, 1866. Photo: Michèle Bellot. Musée d'Orsay, Paris, France. Reproduced
courtesy of Réunion des Musées Nationaux / Art Resource, New York.

of its depicted subject, its author, and its interpreter – are high, as sug-
gested by the heated contempt expressed by Maxime du Camp in his 1881
interpretation of the *Origin*:

> To please a Moslem who paid for his whims in gold . . . Courbet . . . painted
> a portrait of a woman which is difficult to describe. In the dressing room of
> this foreign personage [Kahil Bey], one sees a small picture hidden under a
> green veil. When one draws aside the veil one remains stupefied to perceive
> a woman, life-size, seen from the front, moved and convulsed, remarkably
> executed, reproduced *con amore*, as the Italians say, providing the last word
> in realism. But, by some inconceivable forgetfulness, the artist who copied
> his model from nature, had neglected to represent the feet, the legs, the
> thighs, the stomach, the hips, the chest, the hands, the arms, the shoulders,
> the neck and the head. The man who, for a few coins, could degrade his
> craft to the point of abjection, is capable of anything.[2]

The act of identifying the author (as producer of a "degraded" painting, as the *origin* of the *Origin*, as it were) is intimately linked to the self-identification of the person doing the interpretation: du Camp proclaims his cleanliness by opposing himself both to the mendacious "Moslem who paid for his whims in gold" and to Courbet's supposed abjection. However, one could convincingly argue that, through the very intensity of his description, which imagines an orgasm taking place where there is only still, painted flesh, du Camp also implicates himself in it.

This example points to the fact that the interpreter, in complex relation to the subject who made the work, produces its meaning; in the case of a picture of a body or bodies, as here, the interpreter can also be seen to produce the identity of the subject(s) depicted therein (in this case, a truncated woman, supposedly "moved and convulsed" in a state of orgasm). The meaning of the work, the perceived identities of its maker and depicted subject(s) are all, then, intertwined in the act of interpretation. In a reciprocal circuit, these identities are all implicated in the identity of the interpreter.

It is through a certain philosophical view of the relation between bodies and pictures – a view articulated by the mid-century French phenomenological philosopher Maurice Merleau-Ponty – that we can begin to explore the intricate and highly charged processes through which meaning emerges (over and over again, with each act of interpretation) in relation to works of art.[3] Notably, Merleau-Ponty's model could be viewed as one way of rethinking the dilemma of aesthetics as crystallized in the work of Immanuel Kant at the end of the eighteenth century: how to understand a relation we have to objects which involves both *subjective* aspects (most obviously, the subjectivity of vision itself) and yet proffers the possibility of *non-subjective* judgment (a judgment that can be extrapolated across subjects and thus secures the possibility of determining aesthetic value, or even of what is art and what is not). Merleau-Ponty's theory of the *chiasmus* in particular can be viewed as at least a partial solution in that it argues for a reciprocal interrelation between the viewing subject and the object she views, and between the viewer and the subject who is identified with the object as its maker.[4]

Merleau-Ponty's work, because of its theorization of the human experience of the world in terms of *embodied, and thus specifically identified, subjects*, is also of great use to the understanding of how our experience of visual images and objects informs who we are (not to mention, of how we engage these works and give them particular meanings and values). As we

can see with our brief look at Courbet's *Origin of the World*, the specific bodily desires and identifications of the subjects involved in the work (Courbet, the woman partially depicted, the interpreter) determine how it comes to mean. A supposedly disembodied viewer is one who can still retain the illusion of authority attached to the pure mind of Cartesianism (or, correlatively, to the "disinterested judgments" of the interpreter in classic aesthetics). It is not enough, then, to understand the social and cultural effects of visual imagery purely in terms of a disembodied structure of the "gaze."

Merleau-Ponty's Chiasmus

Merleau-Ponty's observations about the contingency and reciprocity of the embodied self/other, and the way in which his model enables a critique of vision-oriented theories that polarize subject/object relations and suppress or ignore corporeal relations, make his work particularly useful for the analysis of visual art. Merleau-Ponty, however, was not specifically sensitive to the ways in which reciprocity always entails aspects of *specific* differences such as those relating to gender and sexuality. It will be clear in the remainder of this paper that the feminist interpretations and critiques of Merleau-Ponty's ideas – by Simone de Beauvoir and the poststructuralist theorists Judith Butler and Iris Marion Young – deeply inform my own reading of Merleau-Ponty's phenomenology; the model of interpreting art I will proffer here reads his work through theirs.[5] My inability to separate out a "pure" Merleau-Ponty can be taken as an instantiation of the impossibility of knowing one object or subject in isolation from one's other views and political commitments (in this case, my feminism).

In earlier works such as *The Structure of Behavior*, Merleau-Ponty took a firmly phenomenological view (with a noted Hegelian inflection) of the interdependence characterizing the self-other relation:

> The behavior of another expresses a certain manner of existing before signifying a certain manner of thinking. And when this behavior is addressed to me, as may happen in dialogue, and seizes upon my thought in order to respond to them . . . I am then drawn into a *coexistence* of which I am not the unique constituent and which founds the phenomenon of social nature as perceptual experience founds that of physical nature.[6]

As Merleau-Ponty's work developed, however, and specifically under the pressures exerted on the phenomenological model by his increasing attention to visual imagery,[7] he pushed beyond this relatively abstract model of intersubjectivity to posit a more complex conception of embodiment and the relation between the subject, other subjects, and visual images.

Particularly in his late work, such as the 1961 "Eye and Mind" and his "The Intertwining – The Chiasm" (published posthumously in 1964), Merleau-Ponty specifically uses non-semiotic aspects of visual experience to explore the subject as embodied and ambiguous rather than as telescoped into an abstracted "gaze" or alienated object of the gaze, structured in and by language (as in Lacan's model). Through a theory of vision as carnal and networked to the flesh of the world, Merleau-Ponty argues for the coextensivity of the self and the other, the body and the "flesh" of the world. Using the example of the subject's perception of color in the visual field, a perception that is not codifiable in structural or semiotic terms but which, rather, exceeds such linguistically inflected models, he argues that

> vision is question and response. . . . The openness through flesh: the two leaves of my body and the leaves of the visible world. . . . It is between these intercalated leaves that there is visibility. . . . My body model of the things and the things model of my body: the body bound up to the world through all its parts, up against it → all this means: the world, the flesh not as fact or sum of facts, but as the locus of an inscription of truth: the false crossed out, not nullified.[8]

Merleau-Ponty's anti-empiricism and his insistence on the fully embodied nature of intersubjectivity enables him to conceptualize subjectivity as imbricated rather than (as in Hegel's model) oppositional – indeed, as fully interdependent rather than staged in relation to fixed oppositional social positions. Merleau-Ponty posits self/other and subject/object relations, as the passage above suggests, not as conflicted but as reciprocal; these relations produce subjects not in relation to oscillating positionalities but, via the "chiasmus" that intertwines them, in terms *of simultaneous* subject-/object-ification. Every person is *always already simultaneously both subject and object (for herself as well as for others) at the same time* (and yet never either fully – our subject-ness mitigates our object-ness, and vice versa).[9]

Merleau-Ponty's writings usefully articulate an understanding of intersubjectivity as dramatically, chiasmically *inter-corporeal*, as embodied as

well as contingent. He insists, against the Cartesian model, that "every thought known to us occurs to a flesh" (and not only "to" a flesh, but through and because of the sensory texture of this flesh).[10] It is through this understanding that Merleau-Ponty definitively puts the lie to the Cartesian subordination of body (the perceived flesh of the world) to mind (the abstracted locus of pure thought) and thus offers a newly complex model for understanding not only subjects but the works of art they create in a newly complex world saturated with visual images.

Merleau-Ponty in Art Discourse

In spite of his explicit attention to painting and to problems of visuality, Merleau-Ponty's work was not often made central to theorizations of the visual arts in Anglophone art history and art criticism in the post-World War II period.[11] However, there are interesting and important – if somewhat submerged – instances in which art historians called upon Merleau-Ponty's work to make sense of contemporary art works. Stemming from a renewed attention to embodiment on the part of a generation of artists coming of age in the 1960s in New York – including Robert Morris and Vito Acconci – Merleau-Ponty's work emerged briefly into public discussions about body art and Minimalism, two movements pivoting around the reassertion of body/space relations, during this period.[12] This interest in embodiment was linked both to a desire to counter the prevailing hegemony of Clement Greenberg's disembodied formalism and to the increasing pressure of political rights discourses, which depended on the understanding of the subject as socially embedded and corporeally specific, a subject capable (per Sartre's Existentialism, extremely influential in US intellectual discourse in the post-World War II period[13]) of taking action and producing cultural change.

In particular, Michael Fried, Rosalind Krauss, Annette Michelson, and Robert Morris himself wrote essays proposing a new conception of sculptural form and making use of the theories of Merleau-Ponty.[14] Morris's own development of Minimalist sculpture and theory was deeply informed by phenomenology. As Michelson put it in her rigorous analysis of Morris's work from 1969 to 1970, his sculpture produces "a spatial situation [that] suggests an aesthetic analogy to the posture and method of phenomenological inquiry."[15] Fried's analysis, in his now somewhat infamous 1967 essay "Art and Objecthood," was articulated in opposition to the

Minimalists' production of large-scale abstracted works that insisted on the viewer's recognition of her corporeality in relation to them.[16]

Along with Michelson, it is Rosalind Krauss who has most convincingly elaborated the links between phenomenology and, in particular, Minimalism. In her 1982 essay "Richard Serra: A Translation," written for a French catalogue on this American artist, she pivots around the work of Merleau-Ponty as a means of bridging the cultural gap between the concerns of Minimalism, a movement closely tied to the Greenbergian models it rejected, and French culture.[17] Opening her essay with a quotation from *Phenomenology of Perception* ("I am not the spectator, I am involved" in the situation I view), she goes on to note the limitations of Sartre's existentialist view of meaning and subjectivity, so well known in post-war American culture, and argues for the usefulness of following the Minimalist artists and turning instead to Merleau-Ponty's more nuanced phenomenological account of, in her words, "[t]he body as the preobjective ground of all experience of the relatedness of objects."[18]

Krauss's intellectual trajectory in her subsequent work paralleled the general tendency, at least in Anglophone art history, to move away from an explicitly phenomenological account of visual art as one of the means through which the embodied subject is reversibly connected to the flesh of the world and towards a more abstracted Lacanian model. Following this compelling use of Merleau-Ponty, which convincingly parallels the Minimalists' own accounts, by the late 1980s Krauss had largely turned to Lacan and other theoretical models to theorize opticality in her work (although her use of Lacan is, commendably, far more attuned to issues of embodiment than other Lacanian accounts tend to be from this period).[19]

Aside from a scattering of interesting interventions here and there, then – in particular the ongoing work of Richard Shiff on the paintings of Cézanne and the Abstract Expressionists[20] – Merleau-Ponty largely disappeared from the radar screen in Anglophone art history until the re-emergence of interest in the body on the part of artists and theorists in the 1990s. My own 1998 study of body art, *Body Art/Performing the Subject*, draws on Merleau-Ponty's conception of embodiment to link the earlier body art practices of the 1960s and 1970s to this more recent body-oriented work.[21]

Expanding on this project on body art, the last half of this essay, then, will make a strong argument for a renewed attention to Merleau-Ponty. As I have suggested, his theory of intersubjectivity and of the way in which subjects are interconnected with objects in the flesh of the world provides

a crucial and appropriately nuanced model for theorizing how we make meaning in relation to works of art – a model that has particular political relevance in this period of global networking and the collapse of conventional identity politics as these were articulated in the 1960s, 1970s and beyond. Merleau-Ponty, I will argue, provides a crucial way of thinking about how we make meaning from the world, from other subjects, and for ourselves as embodied subjects; in this sense, he provides a model of understanding the *process* through which we determine meaning and identity; his model indicates precisely that these determinations are never fixed but, rather, always fluid.

Reciprocity

For our purposes here, the most crucial aspect of Merleau-Ponty's theory is that it not only implicates the viewing subject in determining the meaning and value of the thing in the world but also understands this object as a kind of subject in its own right: what used to be thought of as subject and object are chiasmically intertwined; both are what Merleau-Ponty felicitously calls "flesh of the world" (where, he writes, "are we to put the limit between the body and the world, since the world is flesh?").[22] The two reciprocally – but not symmetrically – determine one another as "bodies" or "subjects";[23] my body is both visible and seeing (both sensible and sentient, both object and subject), but my seeing body "subtends this visible body, and all the visibles with it. There is reciprocal insertion and intertwining of one in the other."[24] With the interpreting subject thus immersed into the "subject" of the work of art, identity – or the question of whose identity is at stake in viewing visual images – becomes all the more appropriately complex.

In turning to Merleau-Ponty, I want to insist, then, upon the usefulness of acknowledging the complexity of identity as we understand it in relation to visual images – the fact that it is determined and experienced in an ongoing, reciprocal relation between interpreters and the objects or images we interpret (objects or images which, as I have argued, become kinds of "subjects"). The identity we ascribe to a particular image or object (an identity connected, inevitably, with a posited making subject) is intimately connected to our own psychic desires, fantasies, and projections.

This is not to say that it is entirely phantasmagorical (that the form and content of the work are meaningless or completely arbitrary in relation

to the identity we excavate or construct in relation to it). The identity we ascribe to the work is circumscribed in relation to the visual image – to our perception of its structure, its content, its history, its "context,"[25] and, implicated in all of these, of its author (a subject we project as what Michel Foucault called the work's "author-function"[26]). Our perception of the work and the identity it suggests to us, in turn, informs our own sense of who we are (again, we can return to du Camp's investment in categorizing the *Origin* as smut in order to make this point clear). The work, then, can't just mean anything. And the exchange goes both ways: as with any conversation or engagement with another, our reading of it changes us, if infinitesimally, as subjects.[27]

It is in this sense that the identity connected with a work of art is far more porous but also generates a far greater, if more subtle, pressure on meaning than is often acknowledged by models of interpretation that insist either upon ignoring identity or upon emphasizing it as singularly determinative of the work's meaning (I am exaggerating the dichotomy here somewhat for the sake of polemics). The former approach is characteristic of modernist formalism; drawn from an oversimplified version of Kant's model of aesthetic judgment, modernist formalism in the hands of Roger Fry, Greenberg and others, positions the work of art as autonomous and as meaningful purely in formal terms, bracketing if not fully repressing the work's relation to making and viewing subjects – and the bodies implied therein. By so doing, the practitioner of modernist formalism substantiates his claims for meaning and value and supports his claim, to be precise, of making what Kant termed a *disinterested* judgment, one untainted by sensual appreciations or bodily desires.[28] The latter approach would of course be associated with the rise of identity politics in the 1970s and beyond.[29]

Whose Art History?

The two aspects of interpretation indicated above are played out in fascinating ways by Fried and art historian Linda Nochlin specifically in relation to Courbet's paintings of women in their essays for the 1988 Brooklyn Museum exhibition catalogue *Courbet Reconsidered*. As I admitted above, my polar opposition of the two aspects is forced, as a brief comparison of these two interpretative models will confirm: both interpreters interweave aspects of each position. The published debate between Fried and Nochlin indicates that the stakes of whose identity is circulating in relation to

works of art are clearly high (at least for art historians!). It will be clear that I find Nochlin's biases more appealing than Fried's, especially since the former are openly admitted rather than tortuously veiled (per Fried's text) in an elaborate rhetoric of self-authorization.

In his provocatively entitled essay "Courbet's 'Femininity'," Fried appropriates the terms of 1980s feminist visual theory to legitimate his reading of Courbet as merging with his female figures, arguing that Courbet "undo[es] his own *identity* as beholder of his pictures by transporting himself quasi-bodily into [his depicted women's bodies] . . . in the act of painting."[30] Identifying the painter as radically bigendered and refusing the disembodied rhetoric of formalism, Fried thus legitimates him within the contemporaneous, and dominant, terms of feminist critical approbation.

And yet, suppressing the *reciprocity* of identity formation in relation to Courbet's work, Fried denies what I would argue to be one of feminism's most important insights: that all readings implicate the identity (the desires and projections) of the interpreter. Fried argues that the identity of Courbet is merged with the identities of his painted female figures, but the exchange stops there. For Fried to acknowledge his own implication in this determination of Courbet's/the women's identities (an implication made obvious, in my view, by his eroticized descriptions of the, in his words, "ravishing," "dazzling," and "sensuous" images[31]) would be for him to deflate the authoritativeness of his own pronouncements of meaning and value. Such a deflation he is clearly adamant (if probably entirely unconscious) about avoiding.

Courbet's identity is also gendered for Nochlin, but she begins from a position of deep identification with feminism and the women in Courbet's paintings, unlike Fried who appropriates feminism to legitimate a masculinist critical project. Starting from the feminist premise that Courbet's work (in particular, his 1855 painting *The Painter's Studio*) "constitutes a lesson about the origin of art itself [as residing] in male desire," Nochlin, needless to say, comes up with a different set of identifications for Courbet from those generated by Fried. Far from identifying *with* his female figures, she argues, "Courbet goes so far as to cross out woman . . . by substituting 'nature' for her as the signifier of his creation . . . [H]e depicts himself [in *The Painter's Studio*] as fully and unequivocally phallic, actively giving form to inert matter with his probing, dominating brush."[32]

Nochlin's reading takes on a crucial feminist position *vis-à-vis* the question of "identity": the painting is not to be viewed as simply a "portrait" of

the woman depicted therein, nor does it transparently express the willfully articulated ideas of Courbet. Rather, she links its identity to the anxious and *unconscious* imaginings on the part of the artist as indicative of the workings of patriarchy itself – in particular, she links Courbet's nudes to the castration anxiety at the basis of all masculinist representations of fetishized women's bodies (and what, after all, is the theory of fetishism but a theory of identity in relation to the image?).

It must be noted that Nochlin does acknowledge her own role in positing this particular "Courbet," thus crucially recognizing the reciprocity of meaning production. At the same time, her reading, in its inspired feminist polemic, is aimed at fixing a rather singular set of meanings for Courbet's works, all of which pivot around his purported phallicism.[33] For Nochlin, the social meaning of the work, then, is linked to particular personal prejudices, which she attaches both to a specific, supposedly actual individual (the artist and the man, Courbet) and to the broader biases of patriarchy. Necessarily, given her particular feminist agenda and the limitations of the feminist theory of the male gaze, Nochlin's argument cannot accommodate a deeply nuanced and open-ended negotiation of the author-function Courbet. Like Fried, then, Nochlin starts from a position of having *already identified a particular person Courbet*, and then proceeds to attempt to prove her identification "correct." (One might ask at this point what else we can or should *do* as art historians or critics, given our approach to the object as a kind of subject.[34])

In his response to her reading, Fried accuses Nochlin point-blank of "oversimplif[ying] and in the process misrepresent[ing] the treatment of gender in Courbet's art."[35] Fried's authority is thus proclaimed via Courbet's identity as a gender critic as well as via his labeling of Nochlin as "oversimplifying" and "misrepresenting" in her readings (a labeling that, of course, functions most importantly to cast Fried's readings as "correct"). To this end, he fulfills precisely the kind of gesture Nochlin identifies as indicative of Courbet's positioning within the logic of patriarchy: the dichotomizing (one might say "master/slave") impulse by which masculinity gains its authority by posing itself in opposition to a failed, weak, wrong ("oversimplifying"), or penetrable femininity.[36] Accusing her, rather haughtily, of "art-historical positivism" and "reductive, biological feminism," which conspire together as "rigid, exclusive systems of meaning," Fried is unable to acknowledge the rigidity of his own proclamations of the paintings' meaning (and, by extension, of Courbet's merging with his feminine figures).

Whose *Origin*?

Moving towards an ending, I would like to posit a series of readings – or rather, and this will be part of my point, a reading-in-process – of Courbet's *Origin of the World*. As I have already suggested, we tend to view works of art (more so than popular culture imagery) as extensions of a particular person (the artist) – as themselves "subjects" of a kind. Both Nochlin and Fried thus attempt to define what Courbet's images of women mean by extrapolating from them what kind of a man and a painter they think he was; correlatively, they also project onto the works what they think they know about Courbet. Their relationships to the paintings, and the figures depicted therein, are predicated on their perception – or construction – of the subject Courbet. I am, following Foucault, calling this subject an author-function, inasmuch as I am arguing it is determined in relation to the image and does not designate the person who preexisted the works and produced them.

The key question here, I would like to suggest, is why Nochlin and Fried have such a high stake in setting forth the "correct" identification of Courbet in relation to the women he depicts. Surely because, recalling the reciprocal dimension of meaning making I sketched earlier, they recognize, whether consciously (Nochlin) or not (Fried), that the Courbet they define will reflect back upon them. Not only do we art historians hope to pin down the identity of the work (the identity of the subject we associate with it, as well as, in the case of a portrait, the identity of the sitter(s) depicted therein); we also, most crucially, in doing so in a way that compels agreement among our readers, hope to cohere ourselves as arbiters of meaning. That is, if I can compel you to accept *my* Courbet (and thus *my* definition of what the paintings mean), then my identity – not just as a feminist or as an art historian, but as a subject – is, in one small but crucial way, confirmed. Not only because I'm "right" (and thus a "good" art historian or feminist), but because you have reciprocally confirmed my own sense of the world by accepting my construction of Courbet, which is really a construction of myself – in projection, of course. The reciprocity goes on.

What if we change the trajectory and view the *Origin* as a "portrait" of sorts; after all, it does, nominally, depict a single human body (if in woefully fragmented form). This picture thwarts the practice of finding the "identity" of the work as aligned with the person represented therein, as we might be tempted to do with a portrait of a single person. It "gives" us

(part of) a body but refuses to deliver a subject who can be identified beyond her femaleness and seeming whiteness (I am not stressing race here but, of course, as du Camp's interpretation of Kahil Bey's motives as necessarily nefarious and mendacious belies, the process of fetishization relies just as much on racial othering as it does on expelling or objectifying the female sex). This refusal certainly explains Fried's rather odd dramatization of the tendency to conflate the artist uncritically with the work – his argument that Courbet, out of his "painterly desire" for their bodies, *merges with* the naked or partially naked women in his paintings.

This is not to say that the cunt in this painting has no agency – no suggestion of identity or subjective volition – whatsoever. The "subject" Courbet has depicted has no face, no eyes – and yet she *sees me* and, in so doing, in phenomenological terms she *gives me body*, producing my body as an object of desire.[37] It is by *being seen* that our body is made manifest to us as an object; however, as Merleau-Ponty is careful to insist, this production of our bodies as objects works always in reciprocal relation to our experience of our body as an extension of – or, more accurately, an enfleshing of – our mind: "I am not in front of my body, I am in it, or rather I am it."[38] The "gaze" of the cunt in *Origin of the World* thus brings my objectification (my existence as "slave") to the surface, even as I "master" the cunt (the image) through interpretation. Courbet's *Origin* thus, when viewed in one way, can be seen to stage the very reciprocity of subjectivity in the chiasmus Merleau-Ponty's model describes, a reciprocity that puts back in motion the congealing effects of the gaze, which, in Jean-Paul Sartre's and Jacques Lacan's models, alienates the "looked at" subject (in Sartre, through a reversal of power relations) or (in Lacan's case) exposes her profound lack.[39]

The fact that Lacan, astoundingly, owned Courbet's *Origin* after WWII simply reinforces the argument I am making regarding reciprocity – for it seems that the *Origin* might have contributed to Lacan's theory of the alienated gaze, a theory I am finding useful here in examining the *Origin*. Perhaps it was the very fleshy "presence" of the *Origin* which scared Lacan away from theorizing a fully embodied looking relation? At any rate, the cunt points to the absence at the "core" (at the origin, as it were), of all subjects but also, via Merleau-Ponty, I am arguing, the fully embodied and contingent nature of subjective existence in the world. We are "absent," we "lack," because we exist only ever in relation to others.

In closing, I would like simply to suggest that the effectiveness of Courbet's painting lies in the fact that, by presenting a female sex that

looks back at us without eyes, it refuses to finalize the subject – the identity – at stake in the making and viewing of works of art. Whatever the author "Courbet" thought he intended, the *Origin of the World* points to the final impossibility of positing identity in any but the most provisional of ways – whether in relation to representations or people. Both are flesh of the world. Both are implicated in me, I in them, as I attempt to make meaning of the world around me. Merleau-Ponty's insistence on embodiment and reciprocity in the chiasmus allows us to think more deeply, in this way, how visual images come to mean.

Notes

1 On the history of the painting see Linda Nochlin's catalogue entry in *Courbet Reconsidered*, ed. Sarah Faunce and Linda Nochlin (New York: The Brooklyn Museum, 1988), pp. 176, 178.

2 Du Camp, from his 1881 *Les Convulsions de Paris*, is cited by Neil Hertz, "Medusa's Head: Male Hysteria under Political Pressure," *Representations* 4 (1983), p. 34.

3 There are specific reasons, articulated at great length by Merleau-Ponty himself in his essays specifically on modern painting, why this model has a particular usefulness in relation to works produced by subjects identifying themselves, and identified by the viewer, as artists – not the least because we tend to attribute a particular kind of individualism to artists. Thus, while Merleau-Ponty's model of intersubjective relations can be applied effectively to *any* imagery, it has a different structure in relation to mass cultural images, which are more likely to be connected to the identity of the people depicted (especially if they are celebrities) than to those who made or took the pictures.

4 The chiasmus intertwines the interpreting subject in the objects she views and judges. In doing so, it definitively collapses the subject/object distinction upon which Kant's notion of disinterested judgment (meant to solve the problem posed by supposedly universalizing judgments that are subjective from the get-go) is predicated. See Merleau-Ponty's "The Intertwining – The Chiasm," in *Visible and Invisible* (1964), trans. Alphonso Lingis, ed. Claude Lefort (Evanston: Northwestern University Press, 1968), pp. 130–55. For a different – deconstructive – critique of this aspect of Kantian theory see Jacques Derrida's "Parergon," in *The Truth in Painting* (1978), trans. Geoff Bennington and Ian McLeod (Chicago: University of Chicago Press, 1987), pp. 15–147.

5 See Judith Butler, "Sexual Ideology and Phenomenological Description: A Feminist Critique of Merleau-Ponty's *Phenomenology of Perception*," and Iris

Marion Young, "Throwing Like a Girl: A Phenomenology of Feminine Body Comportment, Motility, and Spatiality," in *The Thinking Muse: Feminism and Modern French Philosophy*, ed. Jeffner Allen and Iris Marion Young (Bloomington: Indiana University Press, 1989), pp. 51–70, 85–100.

6 Merleau-Ponty, *The Structure of Behavior* (1942), trans. Alden L. Fisher (Boston, 1963); cited by Martin Jay in *Downcast Eyes: The Denigration of Vision in Twentieth-Century French Thought* (Berkeley, Los Angeles, London: University of California Press, 1993), p. 306. Sartre's *Being and Nothingness* retains this abstracting impulse, as well as a residual Cartesianism and a privileging of vision as inexorably victimizing and, ultimately, a disembodiment of intersubjective relations. See especially Part 3, "Being-for-Others," of *Being and Nothingness* (1943), trans. Hazel Barnes (New York: Washington Square Press, 1956), pp. 301–556. Judith Butler stresses this distinction by noting that, with his late work, Merleau-Ponty argues for an "ontology of the tactile" to replace Sartre's "social ontology of the look"; see Butler, "Sexual Ideology and Phenomenological Description," p. 97. On Sartre's Cartesianism, see also Judith Butler, "Sex and Gender in Simone de Beauvoir's *Second Sex*," *Yale French Studies*, no. 72 (1986), the section on "Sartrean Bodies and Cartesian Ghosts," pp. 37–40.

7 In particular in his essays "Cézanne's Doubt" (1945), "Indirect Language and the Voices of Silence" (1952), and "Eye and Mind" (1961), all of which are collected in *The Merleau-Ponty Aesthetics Reader*, ed. Galen Johnson (Evanston, Illinois: Northwestern University Press, 1993). Johnson writes a useful, extended "Introduction" contextualizing and analyzing each essay and pointing to Merleau-Ponty's investment in visual art and the visual imagination. Johnson cites Merleau-Ponty's argument that both phenomenology and painting exhibit "the same kind of attentiveness and wonder, the same demand for awareness," in order to explain the philosopher's attachment to visuality (he is citing Merleau-Ponty from *Phenomenology of Perception* (1945), trans. Colin Smith (New York: Humanities Press, 1962), p. xxi; cited by Johnson, p. 4). For Merleau-Ponty, visual images *immerse* the subjects of making and viewing in another world – he is particularly taken by Cézanne, whose remark "[t]he landscape thinks itself in me, and I am its consciousness" is cited by the philosopher several times (Johnson, p. 11). The appeal of Cézanne's remark, and his practice in general, for Merleau-Ponty is in the applicability of the case of Cézanne to the philosopher's attempt to theorize and enact a phenomenological kind of reversibility of the artist and the world he or she is a part of and labors to recreate in visual form. Ultimately, he argues (in "Eye and Mind," his last essay on painting) that an interrogation of painting "looks towards th[e] . . . secret and feverish genesis of things in our body," enabling a theorization of how the embodied subject relates to the world: the art of painting "is always within the carnal," marking

vision as "the means given me for being absent from myself, for being present at the fission of Being from the inside"; in "Eye and Mind," from the version translated by Carleton Dallery, in Merleau-Ponty, *The Primacy of Perception*, ed. James M. Edie (Evanston, Illinois: Northwestern University Press, 1964), pp. 167, 186. For my purposes, however, Merleau-Ponty's interest in visual art and creativity per se, which, among other things, tends indirectly to reinforce romantic conceptions of the artist, is less of interest than his general philosophical arguments regarding visuality and embodiment from *Phenomenology of Perception* (1945), trans. Colin Smith (New York: Humanities Press, 1962), and "The Intertwining – The Chiasm."

8 Merleau-Ponty, "The Intertwining," p. 131. This paragraph cited here was inserted, one assumes by hand, on the manuscript of Merleau-Ponty's text, which was incomplete when he died. The ellipses are Merleau-Ponty's.

9 This equivocation is clear throughout "The Intertwining," where Merleau-Ponty refuses to allow any settling into the categories of "subject" and "object" to occur – "he who sees cannot possess the visible unless he is possessed by it, unless he *is of it*" (pp. 134–5); "Where are we to put the limit between the body and the world since the world is flesh?" (p. 138). That is, there is no "division" between the seeing (touching, etc.) subject and that which he sees (touches, etc.) – the division that would allow subjects to oppose themselves to objects simply does not exist.

10 Ibid., p. 146.

11 This is not to say that Merleau-Ponty is absent from other kinds of Anglophone cultural discourse or from philosophy during this period. I have already noted the important work of Butler and Young; see also the work of Vivian Sobchack in film theory; see especially her book *The Address of the Eye: A Phenomenology of Film Experience* (Princeton: Princeton University Press, 1992).

12 As I discuss at length in my book *Body Art/Performing the Subject* (Minneapolis: University of Minnesota, 1998), other more accessible theorists of embodiment also became popular among artists and art theorists during this period. In 1959, for example, the US sociologist Erving Goffman published a popular book discussing the self as a performance in relation to others, a negotiation involving complex intersubjective cues and behaviors; see Goffman, *The Presentation of Self in Everyday Life* (Garden City, New York: Doubleday, 1959). Kate Linker discusses Acconci's interest in the work of Merleau-Ponty and Goffman in *Vito Acconci* (New York: Rizzoli, 1994), pp. 30, 46–7; Morris's interest is discussed below. Interestingly, the fascination with phenomenology seems to have been largely gender-based. As Carolee Schneemann has noted to me, it was the "guys" who were obsessed with reading, citing, and discussing Merleau-Ponty and Wittgenstein in the 1960s; she approached issues of embodiment, power, and representation viscerally, without an explicit intellectual basis (interview with the author, November, 1992).

13 Sartre's impact can be felt in texts from Harold Rosenberg's "The American Action Painters," *Art News* 51, no. 8 (December 1952), pp. 22–3, 48–50, to Goffman's 1959 *The Presentation of Self in Everyday Life.*

14 In addition to those authors engaging specifically with Minimalism, Cindy Nemser opens her important early article on body art – "Subject–Object Body Art" (*Arts Magazine* 46, no. 1 [September–October 1971], pp. 38–42), with a quotation from Merleau-Ponty's *Primacy of Perception* and goes on to deploy loosely phenomenological ideas to discuss the body art works of Acconci, Nauman, Dennis Oppenheim, and others.

15 Michelson articulates a convincing, appreciative analysis of Morris's Minimalist sculptures with reference to Merleau-Ponty's conception of perception as rendering "oneself present to something through the body," in "Robert Morris: An Aesthetics of Transgression," *Robert Morris* (Washington, D.C.: Corcoran Gallery of Art and Detroit: Detroit Institute of Art, 1969–1970), see pp. 43, 45. Michelson makes clear that Morris expands sculpture in this Merleau-Pontyian direction in antagonism to Greenberg's conception of sculpture as moving in the direction of a reduction to pure visuality; see pp. 45, 49. See also Morris's collected writings, *Continuous Project Altered Daily: The Writings of Robert Morris* (London and Cambridge, Mass.: MIT Press, 1993), and Maurice Berger's brief mention of Morris's interest in Merleau-Ponty in *Labyrinths: Robert Morris, Minimalism, and the 1960s* (New York: Icon Editions, 1989), pp. 11, 12, 65.

16 Fried focuses particular ire on the phenomenological claims of the sculpture and writings of Donald Judd and Morris; see "Art and Objecthood" (1967), reprinted in *Art and Objecthood: Essays and Reviews* (Chicago and London: University of Chicago Press, 1998), pp. 148–72. I critique Fried's argument, which precisely pivots on the foreclosure of intersubjectivity and an antagonism to the vicissitudes of embodiment, in my essay "Art History/Art Criticism: Performing Meaning," *Performing the Body/Performing the Text*, ed. Amelia Jones and Andrew Stephenson (London and New York: Routledge Press, 1999), see esp. pp. 39–55.

17 Rosalind Krauss, "Richard Serra: A Translation," *The Originality of the Avant-Garde and Other Modernist Myths* (Cambridge, Mass., and London: MIT Press, 1985), pp. 260–74. Notably, these "Merleau-Ponty-ites" were closely connected at the time: Krauss's book is dedicated to Annette Michelson and Krauss studied briefly at Harvard under Greenberg in the late 1960s with Michael Fried.

18 Krauss, ibid., pp. 261, 263, 268; she is quoting *Phenomenology of Perception*, p. 304. One caveat arises for me in relation to Krauss's use of Merleau-Ponty's ideas: there is a startling tendency in this essay for her to lapse into metaphysical or, more simply, formalist concepts that, in my view, are incompatible especially with the proto-poststructuralist late Merleau-Ponty. Another

caveat relates to the fact that, in his later work, Merleau-Ponty explicitly rejected the idea of the body as "preobjective" (and it is indeed arguable whether this is what he was arguing in *Phenomenology of Perception*). In "The Intertwining" he makes it scrupulously clear that the body enacts the subject but is also experienced by both its "subject" and by others for its weighty object-ness (it is *never* experienced as "preobjective ground" for some cognitive experience layered on top).

19 See Krauss's *The Optical Unconscious* (Cambridge, Mass., and London: MIT Press, 1993).

20 See in particular Shiff's "Cézanne's Physicality," in *The Language of Art History*, ed. Salim Kemal and Ivan Gaskell (Cambridge: Cambridge University Press, 1991), pp. 129–80; and "On Passing Through Skin: Technology of Art and Sensation," *Public* 13 (1996), pp. 14–31. I am indebted to Shiff's general philosophical approach, his insistence on attending to the embodied aspects of making and viewing art, and his scholarly generosity in sharing this work with me.

21 See also Alex Potts's recent *The Sculptural Imagination: Figurative, Modernist, Minimalist* (New Haven, Conn.: Yale University Press, 2000), in which he discusses Merleau-Ponty's work in relation to minimalism in the section "Merleau-Ponty and the Viewing of Art," pp. 224–34.

22 Merleau-Ponty, "The Intertwining – The Chiasm," p. 138.

23 Not symmetrically because the "visibles" are not subjects in the same way I am. That is, the work of art is not "equivalent" to me in its relation to subjectivity, and yet it "is" (or implies) a subject.

24 Merleau-Ponty, "The Intertwining – The Chiasm," p. 138.

25 For an excellent and much needed critique of the notion of "context" as a kind of catch all historicizing corrective see Mieke Bal and Norman Bryson, "Semiotics and Art History," *Art Bulletin* 73 (June 1991). To this end, I would depart definitively from T. J. Clark's (albeit 28 year old) claims, *vis-à-vis* Courbet, for the possibility of "revealing the relation of the artist to his public" in order to determine the work's meaning; Clark, *The Image of the People:* Gustave Courbet and the 1848 Revolution (London: Thames and Hudson, 1973), p. 12.

26 As Foucault defines it, the author-function is not "the author as an individual" but is defined through "the singular relationship that holds between an author and a text"; it is signaled by the author's name, which serves to "characterize the existence, circulation, and operation of certain discourses within a society." See Foucault, "What is an Author?" (1969), in *Language, Counter Memory, Practice*, trans. Donald Bouchard and Sherry Simon (Ithaca: Cornell University Press, 1977), pp. 115, 124.

27 In the most moving passages of "The Intertwining," Merleau-Ponty argues as much about our relationship with any other "flesh": "With the first . . . contact,

the first pleasure, there is initiation, that is, . . . the opening of a dimension that can never again be closed, the establishment of a level in terms of which every other experience will henceforth be situated" (p. 151). See also p. 142, where he writes eloquently of "bring[ing] a vision that is not our own into account," bringing out the "limits of our factual vision." His insights could thus expand our conception of how productively to negotiate racial, sexual, and class otherness, as well as our understanding of how we relate to visual or other works of art.

28 I have made this argument regarding disinterestedness in more detail in my essay " 'Every man knows where and how beauty gives him pleasure': Beauty Discourse and the Logic of Aesthetics," *Aesthetics in a Multicultural Age*, ed. Emory Elliott (Oxford: Oxford University Press, 2002), pp. 215–39.

29 The identity-politics oriented Whitney Biennial of 1993 marked the high point of the tendency to connect images with the identities assumed to be attached to their making subjects. The vitriolic responses to this exhibition and catalogue (Elisabeth Sussman et al., *1993 Biennial Exhibition* (New York: Whitney Museum of American Art and Harry N. Abrams, 1993), exemplify the tendency within the more conservative art critical establishment to paint those who address identity as somehow betraying the true meaning of the works of art, which (so the argument goes) transcend the identities of individuals.

30 Fried, "Courbet's 'Femininity'," *Courbet Reconsidered*, p. 43.

31 He describes *Woman with a Parrot* in the following loaded way: "Her breasts are full, her hands and feet (as always in Courbet) are delicate, her upside-down mouth opens in a smile that reveals a row of perfect white teeth, and her great shock of tawny hair spreads outward from her head in burnished snakelike waves," in "Courbet's 'Femininity'," p. 49. It is the painting *Sleep* that he describes as "more ravishingly than any other painting in Courbet's oeuvre, . . . represent[ing] the limits of Courbet's 'femininity'," p. 52; so at least he can be lauded for acknowledging this "limit"! He uses the terms "dazzlingly" and "sensuous" on p. 51.

32 Nochlin, "Courbet's Real Allegory: Rereading 'The Painter's Studio'," *Courbet Reconsidered*, pp. 31, 32.

33 This is not to say that she does not have a broader reading of Courbet elsewhere, as in her crucial survey book *Realism*, written before her public conversion to feminism (Harmondsworth, England: Penguin Books, 1971).

34 She implicates herself quite dramatically in the earlier part of the essay; see, for example, her noting of her "distress" and "annoyance" in viewing the *Painter's Studio*, her feeling of being shut out of its production of meaning; in "Courbet's Real Allegory," p. 21.

35 Fried, "Courbet's 'Femininity'," p. 52

36 Thus Nochlin argues that the artist in Courbet's *Painter's Studio* "is definitively gendered, and this gendering is underlined by the position of his opposite

– his would-be object included in the image: the female model"; "Courbet's Real Allegory: Rereading 'The Painter's Studio'," p. 31.

37 I discuss this dynamic of a woman's anatomy looking back at length in relation to Marcel Duchamp's *Étant donnés*, which I compare to Courbet's *Origin* in "Re-Placing Duchamp's Eroticism: 'Seeing' *Étant donnés* from a Feminist Perspective," in my book *Postmodernism and the En-Gendering of Marcel Duchamp* (New York and Cambridge: Cambridge University Press, 1994), pp. 191–204.

38 Merleau-Ponty, *Phenomenology of Perception*, p. 149. See also his extended discussion of the master-slave dialectic in relation to the gaze and the body on pp. 166–7.

39 Sartre's model pivots around his description of a voyeur looking through the keyhole and suddenly realizing that he himself is being seen from behind and is thus, for the moment, an object rather than subject of the gaze. See his "Being for Others," in *Being and Nothingness*. Lacan's model is notoriously complex and stresses the alienation of the subject in relation to a gaze that is everywhere; the alienation is fundamental – we never "own" our bodies, which tend to be abstracted in his theory. For Lacan, the subject can only "look" but is gazed at from all sides; see his essays in the section "Of the Gaze as *Objet Petit a*," in *The Four Fundamental Concepts of Psycho-Analysis*, ed. Jacques-Alain Miller, trans. Alan Sheridan (New York and London: W.W. Norton, 1977), pp. 67–119. See also Kaja Silverman's extended discussions of Lacan's model of the gaze and the look in *The Threshold of the Visible World*, esp. chs. four, five, and six.

5

Art Works, Utterances, and Things

Alex Potts

Voices of Silence

Merleau-Ponty is usually seen as important for thinking about the visual arts because of his conception of visual perception as an embodied, kinaesthetic activity. His theories on the subject, as elaborated in *The Phenomenology of Perception*, a major study published in French in 1945 and translated in 1962, had a significant impact at the moment in the 1960s when artists and critics were looking for alternatives to purely ocular models of how a viewer engages with a work of visual art.[1] What concerns me here, however, are issues raised in his later writing when he was exploring the relation and distinction between the operations of language and thought and those of visual perception. He addressed these issues most fully in a complex and densely argued, and little read essay titled "Indirect Language and the Voices of Silence." Partly written in response to André Malraux's grandiose survey of world art history in *Voices of Silence*, it came out in 1952 in the journal on which he and Sartre were then collaborating, *Les Temps Modernes*, and was republished in 1960 just before his death in a book called *Signs* which contained other essays concerned with processes of signification.[2]

What makes the essay particularly interesting is the way it exposes a fault-line in Merleau-Ponty's otherwise almost excessively poised and carefully modulated thinking. Here he engages in a sharp critique, more reminiscent of his political than his philosophical writings, of what he saw as inflated claims being made for the communicative power of art works and their ability to give immediate access to the outlook of past cultures.

Whereas he often seems to arguing for the value of the primordial, purely visual level of awareness he saw embodied in art, to the point of seeming to privilege it over the linguistic and conceptual, in this essay he almost takes the opposite view. Here he writes: "painting seen in its entirety (as in a museum) presents itself . . . as an aborted effort to say something that always remains to be said"; and he concludes his critique of André Malraux's dithyrambic meditations on the mute expressivity of visual art with the comment "Finally, language says something, and the voices of painting are the voices of silence."[3]

Merleau-Ponty's essay had two very specific motivations. Most immediately it was a riposte to, more than a review of, Malraux's recent repackaging of his influential ideas on the imaginary museum in the book *Voices of Silence*.[4] The riposte was not just directed against the conception of art Malraux was promoting, but was also political. Malraux, an erstwhile communist sympathizer and radical, had recently become an active supporter of de Gaulle and a prominent member of his right-wing nationalist party, the Rassemblement du Peuple Français. From the perspective of Sartre's politically engaged and Marxist-orientated journal, *Les Temps Modernes*, of which Merleau-Ponty was political editor, de Gaulle's phantasies about restoring the lost glory of the French nation were ludicrously yet also potentially dangerously reactionary.[5]

Soon after publishing his essay "Indirect Language" in 1952, Merleau-Ponty left *Les Temps Modernes* because of his disagreement with what he saw as Sartre's increasingly extreme left stance. However, he remained ethically and intellectually committed to Marxist thinking, and a sharp critic of the noisily espoused renunciations of Marx in the period of the Cold War by intellectuals such as Koestler who previously had close connections with the communist party.[6] The preface to *Signs*, the book in which he republished the essay "Indirect Voices" in 1960, began on a very political note, commenting on "the extraordinary disorder in which industrial society (in the third world) is developing. Capitalism randomly grows huge branches, puts the economy of a nation at the mercy of a dominant industry which devours its roads and towns, destroys the classic forms of human establishment." He reserved his particular ire for recent developments in France and de Gaulle's taking power as supposed saviour of the French nation,[7] which had again brought Malraux to prominence. As the new Gaullist administration's intellectual heavyweight, and faithful follower of the general, he had just been rewarded with the newly created position of Minister of Cultural Affairs.

The essay, though, was also occasioned by factors internal to Merleau-Ponty's thinking as a philosopher, as is evident from the fact that Malraux's name only occurs after a ten-page theoretical introduction. This addresses problems that had been preoccupying him since he published his two early books, *The Structure of Behaviour* and *The Phenomenology of Perception*, concerning the nature of signification as played out both at the level of language and of gesture and visual apperception. He developed his ideas on the subject further in a book he was writing at the time of his death, the incomplete manuscript of which was published posthumously under the title *The Visible and the Invisible*,[8] as well as in one of his best known essays on the visual arts, "Eye and Mind," which came out in 1960.[9]

In the theoretical introduction to "Indirect Language," he sought to elucidate the ways in which the seemingly higher levels of thinking embodied in language were grounded in a material praxis that had affinities with our sensory, physical engagement with the material world. First he insisted on the dependence of thought on language as itself a material phenomenon, with its own density and opacity, which signified, and here Merleau-Ponty followed Saussure, by virtue of its internal operations, "the lateral relation between sign and sign which renders each of them significant."[10] Secondly, he argued that a tacit sense, one not fully defined by the pre-given articulations of language, was lodged in the very fabric of our utterances in the same way that a tacit, implicit sense or meaning emerged from our non-linguistic, behavioural and sensory interactions with the world.[11] A modernist critic might take this to be the most significant level at which language signifies – but not Merleau-Ponty, just as he refused claims for the mute communicative power of visual art as somehow more resonant than consciously articulated designations of meaning. It is important to keep these complexities in mind when a hushed poetic tone infuses his discussion of art and seems to endow it with a primordial significance. The calmly modulated flow of his prose often has the effect of smoothing over the very real tensions and negations that shape his thinking.

Retreating into the realm of art's voices of silence was conceived by Merleau-Ponty as a thought experiment, not as a passageway to some deeper level of being, as in so much soft phenomenology and existentialism of the period. He was exploring how painting could generate mute sense through gesture and visual apperception so as to gain a more precise understanding of the signifying capacities of language:[12]

If we wish to understand language in its originary operations we need to feign never to have spoken and submit language to a reduction without which it would again escape us by leading us back to what it signified to us. We need to *look* as the deaf do when they look at those who are talking, compare the art of language to the other arts of expression, and try and see it as one of these mute arts. It may be that the meaning of language has a decisive privilege, but it is by trying out this parallel that we shall perceive what makes it perhaps impossible in the final analysis. Let us begin with the understanding that there exists a tacit language and that painting speaks in its own way.[13]

Merleau-Ponty's analysis shifts markedly in register from this measured adumbration of a complex problematic when sharp misgivings about the signifying power of art emerge in the latter part of the essay.[14] This happens when works of art are being considered, not in the abstract as mute non-linguistic forms of expression, but as auratic objects in a modern museum, supposedly embodying a significance that transcends the specificities of the culture that produced them. My aim here is twofold, I wish to show how these misgivings about the status of art in relation to language were prompted by concerns specific to the cultural politics of the moment when Merleau-Ponty was writing and to his own particular conceptions of art and language. At the same time, I want to indicate how the problems he addressed have a larger historical reach. In many ways he prefigured misgivings that were to become much more acute soon after his death, first about the institutionalization of art in museums and the cultural reifications this entailed, and secondly about the limits of the signifying capacities of art as compared with language – what some have called the art and language problem. This became a key issue with the conceptualist reaction against modernist assumptions that were shared by Merleau-Ponty, about the essentially visual level at which works of art should operate.

The Imaginary Museum

Merleau-Ponty's profoundly negative response to Malraux's conception of art gave his discussion of the visual arts in the essay "Indirect Language" an unusual complexity and critical edge. He was particularly opposed to Malraux's idea that art existed in a sphere apart from people's everyday interactions with the world, and testified to a higher capacity of the human

spirit to confront and transcend its mortal destiny. Artistic style, the seemingly coherent formations within which the art of a culture articulated itself, was seen by Malraux to transcend the contingent particularities of that culture. The history of art envisaged as a history of artistic form or style gleaned from the image bank of the imaginary museum – which in effect meant the decontextualized images that presented themselves in photographic reproductions and museum displays – thus constituted a higher history of the human spirit. Such a history was made accessible through the imaginative affinities being established between our own artistic universe and that of past cultures, usually led by modern artists looking to other cultures for creative inspiration.[15]

This conception of art was based on a neo-Nietzschean, quasi-existentialist image of the true artist as an isolated individual heroically facing up to the black void of death, and momentarily transcending his mortal limits. For Malraux, the essence of art was only fully realized by the modern artist, cut loose from the collective cultural structures and non-artistic purposes that in previous ages had framed artistic creation and who could realize an art that was entirely individual and subjective in character, and independent of the objective realities of the world in which the artist lived.[16] Merleau-Ponty throughout his career had a constitutional aversion to the kind of radical gesturing this implied, and doubly so in the case of Malraux, for whom a quasi-mystical vision of art as the locus of the isolated individual's confrontation with death was allied with the politics of de Gaulle's mystic sense of the destiny of the French nation.

Merleau-Ponty insisted that art was to be seen as embedded in the artist's everyday interactions with the world.[17] Thus the measure of transcendence art achieved, the way an art work, and the artist's process of bringing it into existence, could point beyond what was objectively given, was enacted within the fabric of a commonly shared material world. Artistic creation's apparent capacity to surpass its immediate circumstances operated by modifying these rather than rising above them to enter a higher realm. It had nothing mystical about it. It was an

> overtaking on the spot, which is the only irreversible surpassing. If we put ourselves in the position of the painter and participate in that decisive moment where what is given to him as corporeal destiny, personal adventures or historical events, crystallises on the "motif", we recognise that his work . . . is always a response to these givens, and that body, life, landscapes, schools, mistresses, creditors, police, revolutions, which can suffocate

painting, are also the bread out of which it makes its sacrament. To live within painting is to breathe this world again – above all for anyone who sees in the world something to paint, and every person is in part such a one.[18]

The stylistic affinities that the modern museum and its imaginary counterpart, the books of high quality photographic reproductions, prompted the modern viewer to see between the art of very different times and places, was not the result of some spirit of art that transcended the limits of time and place. Rather it was to be explained by those basic bodily and sensory interactions with things shared by all cultures and which were the basis of artistic creation – the everyday processes of viewing and tracing responses to this viewing that works of art enacted.[19]

The history of art derived from the spectacle of objects in Malraux's imaginary museum traced the shifting character of the styles that seemed to be embodied in these objects' form. But this, in Merleau-Ponty's view, far from offering new insights into the nature of art, or the nature of the human condition, as Malraux would have it, gave the works a "false prestige" as revered objects, and obscured their "true value," "detaching them from the accidents of the milieu out of which they were born and making us believe that certain fatalities had guided the hand of artists since time immemorial." The reverence associated with their being immortalized in a museum was a fake one. Going into a museum sometimes "makes us feel as if we are robbers. The idea occurs to us from time to time that these works were not for all that made to end up among these morose walls, for the pleasure of Sunday promenaders and Monday intellectuals." The historicity embodied by the museum was at odds with what Merleau-Ponty saw as the living, internalized history enacted by artists responding to the work of their predecessors, that "non deliberate, involuntary" history traced by art as a human activity. A museum kills "the vehemence of painting just as the library, according to Sartre, transforms into 'messages' writings which were originally the gestures of a man. It is the historicity of death," not the history of some heroic human absolute that transcends death, as Malraux would have it.[20]

Merleau-Ponty's internal history of art, even as it is contrasted with Malraux's "official and pompous history," invokes a humanistic, individualist conception of art that in some significant respects is similar to Malraux's. The artist as Existential hero facing the void is recast in another, less confrontational, role, where he is dedicated to immersing

himself in and responding to the non-human world of things. According to Merleau-Ponty, the painter constitutes a "historicity of life," of which the external objective history of the museum "offers only the failed image," as he

> weaves together in a single gesture the tradition that he takes up and the tradition he founds, the tradition that reunites him at once with everything that has ever been painted in the world, without his having to leave his place, his time, his blessed and accursed work, and which reconciles paintings with one another in so much as each expresses the entirety of existence, in so much as they each succeed – instead of reconciling them with one another in so much as they are finished, as so many gestures carried out in vain.[21]

This living history shares something with Malraux's history of art in so much as it is felt intuitively, even if it is not a matter of pure consciousness but is bound up with a material praxis. Both writers set historicity center stage, and yet imagine an encounter with the work of art where an awareness of the specific conventions and ideological inputs that might have shaped its conception seems to be excluded.

That Merleau-Ponty was uneasy on this score, however, is suggested when, in arguing against the implications of Malraux's ideas on the historical value of the art museum, he saw fit to deny to visual art, and to painting in particular, language's capacity to articulate its own historicity. In the final analysis, he concluded, a work of art was unable to embody an historical awareness. Being a discrete physical object, "self-sufficient and closed in upon its own intimate significance,"[22] it could not effect the interweaving of past, present, and future played out in language. Moreover, its immediately apprehensible forms, while giving the illusion of making the inner life of a past culture directly accessible to us, were unable to convey the dense array of meanings that constituted the actual fabric of that culture, and which texts could articulate. The visual immediacy of the art work's apparent triumph over the passage of time was a hollow one:

> A painting installs its charm straight away in a dreamy eternity where, many centuries later, we have no difficulty rejoining it, even if we knew nothing about the history, the costume, the furniture, the utensils, the civilization of which it carries the mark. Writing by contrast only delivers

its most durable meaning across a precise history about which we need to know something . . . this immediate access to something lasting which painting relegates to itself, it pays for this curiously by being subject, much more than writing, to the movement of time. A pleasure of anachronism mingles with our contemplation of pictures, while instead Stendhal and Pascal are entirely in the present. To the extent that it renounces the hypocritical eternity of art, that it bravely confronts time, that it makes time evident rather than evoking it vaguely, literature emerges victorious and endows time with a significance. The statues of Olympia, which do so much to draw us to Greece, nevertheless nourish, in the state in which they have come down to us – whitened, broken, detached from the whole work – a fraudulent myth of Greece. They cannot resist time as a manuscript does, even when it is incomplete, torn, almost illegible. Heraclitus's [fragmentary] text throws out illumination as no statue broken into pieces can, because . . . nothing is equal to the ductility of the word.[23]

This leads to the indictment quoted above: "In the end language says [something], and the voices of painting are the voices of silence."

In certain cases, when we lack any documented information about the beliefs, ritual practices and visual iconography of a culture from which a work derives, we have little more than our immediate visual impressions to go on when we speculate on its meaning – such cases might include the vivid depictions of animals in the prehistoric cave paintings at Lascaux, for example, or the impressive giant stone Olmec heads from Vera Cruz in Mexico. This, however, is not the case for most art we look at, particularly art of the recent past. Neither Merleau-Ponty nor Malraux considered how when viewing a work of art we will often alternate between what might be called pure looking and the decipherment of language-like, culturally specific signs and formal conventions. Even when viewing works where almost no traces of original context exist, such as the Olmec heads, we envisage their significance in terms of visual formats they seem to embody which were current in artistic traditions more familiar to us, and which we pick out because of rituals of viewing basic to our own culture – such as the attitude of sustained attentiveness invited by a work's status as a major art object or a significant image in what Malraux called the imaginary museum. Merleau-Ponty sharply parted company with Malraux, however, when he insisted that works of visual art did not convey a more immediately accessible meaning than texts, and argued instead that they simply did not have the capacity to articulate meaning in the way language or a language-like system of signs could.

Art and Language

Merleau-Ponty's verdict on the limitations of art's "voices of silence" also needs to be understood in relation to his more general ideas on art and language and on seeing and speaking. In his theory of language, a Saussurian view of how meaning is generated through the internal relations between signs combines with a very un-Saussurian emphasis on the inaugurating role of utterance or speech act in signification.[24] In Merleau-Ponty's view, language distinguishes itself from visual art by virtue of operating a complex system of signs that exists at a different level from the phenomena they designate. At the same time, a painting is like an utterance in that it is an expressive act, a gesture that points beyond itself and is not immediately subsumed within a practical activity.[25] There is communality then between language and painting at the level at which painting is gesture and language utterance.

However, there is a difference too. While we apprehend an utterance in the very fabric of the words it deploys, the gestural act of the painter is not made immediately present by the visible aspect of a painting we view, but has to be inferred by interpreting marks traced out on the canvas. A further complication in Merleau-Ponty's idea that a painting is analogous to a verbal utterance arises from his model for relating the painter's act of creating a painting, and by implication the viewer's act of apprehending it, to everyday processes of visual apperception. Far from being a straightforward expressive act on the part of the painter, painting is envisaged by him as a multi-layered, if still intuitive process, in which the painter sees a motif and responds to it and then generates a gestural act of painting out of this embodied response, an act which is then traced onto the world so it can be viewed. The viewer, seeing the painter's marks, supposedly gains an intuitive sense of the painter's response to the motif. Merleau-Ponty thought of this symbiosis between viewing and painting as echoing that in our everyday activity between looking at and moving around in or acting on our physical environment:

> The artist's movement tracing his arabesque in infinite matter amplifies, but also continues, the simple marvel of self-directed movement or of gestures of grasping. In the gesture of designation, not only does the body itself project out into a world, the schema of which it carries within itself: it possesses this world at a distance more than being possessed by it. All the more reason then that the gesture of expression [the painter's marking the

canvas], which undertakes to draw or designate itself and to make extern-
ally apparent what it has caught sight of, will recuperate the world. [26]

Because of these different levels at which painting has to operate, painting
cannot quite be equivalent to speaking, and certainly not so for the viewer,
a situation summed up succinctly when Merleau-Ponty insists that "man
does not paint painting" in the same way that he "speaks utterances."[27]
Because language is the common currency of communication and the basis
we have for articulating and reflecting on our ideas, we are constantly
involved in a symbiosis between speaking or writing on the one hand, and
listening or reading on the other, to the point that the process of uttering
usually seems identical with the fabric of the utterance. When viewing a
painting, however, what we see in it as object or visual phenomenon can
easily strike us as being quite distinct from any sense we might have of the
painter's gesture of painting, and of her or his response to the motif being
depicted. This threat of breakdown in the symbiosis between painting
seen as object and painting seen as gestural process surfaces in the anxiet-
ies Merleau-Ponty expresses at several junctures as to how museums tend
to represent works of art as self-contained, objectified things rather than
as quasi-utterances.

If painting could not be envisaged as an everyday practice in the way
speaking was, the process of identifying things visually and orienting our-
selves in our physical environment certainly could be. Merleau-Ponty was
thus at pains to emphasize the interplay between our processes of making
visual sense of the world around us, and the processes of painting. That
painting involved a dialogue with other paintings as much as with the
visible world was rather downplayed by him, though he did acknowledge
this from time to time when discussing the painter's act of creating a
work. It was there, rather than in the viewer's response, that an interplay
occurred between the formation of a particular painting, the viewing of
things in the world, and the viewing of other paintings.[28]

For all his concern with processes of viewing, Merleau-Ponty was not
interested in enquiring into how our viewing of works of art might be
distinct from our viewing of other kinds of object and visual phenomena.
The particular way in which we look at paintings only concerned him in
so much as their being displayed in museums seemed to create a situation
where we saw them as autonomous objects isolated from the circum-
stances that generated them. In other words, Merleau-Ponty's thinking
about the phenomenology of viewing paintings was limited to considering

the effects of Malraux's museological viewing of works of art. At the same time he was articulating something very important, that befitted his commitments as Marxist attuned to the reifications of process occurring in modern culture. He was drawing attention to how the institutional framing of the modern museum and art reproduction privileged a way of viewing of art works in which they were seen as things whose material substance somehow embodied an auratic value, thereby occluding their genesis as gestures and as processes of engaging with and acting on the material world.

The particular arguments Merleau-Ponty puts forward to register his unease about the grandiose claims made for visual art in an artistic culture enamored of the imaginary museum, however, are mostly quite technical and philosophical in character, having more to do with his ideas about the interface between the linguistic and the perceptual than with considerations specific to the visual arts. It is worth pausing to consider these arguments because they do have a bearing on questions relating to art and language that were to assume a large importance for the art world in the decade or so after Merleau-Ponty's death in 1961 as a conceptualist reaction developed against the idea of an art purged of linguistic conventions.

Merleau-Ponty could be said to have staked out the territory of later debates about art and language when he maintained that the mute forms of art could not convey any of the conceptual awareness made possible by the signifying power of language. The visual arts, as he put it, appeared to be "aborted efforts to say something that always remained to be said."[29] However, it is important to remember that he was speaking here as a philosopher, anxious to claim some value for the systematic thinking that language made possible. He had concluded the preface to his book *Signs* saying

> While literature, art, the exercise of life, which are conducted with things themselves, with the sensory world even, even with beings, can, except at their extreme limits, have and give the illusion of remaining within the realm of the habitual and constituted, philosophy, which paints without colours, in black and white like engravings, does not permit us to ignore the strangeness of the world, which men confront as well as if not better than it, but as in a semi-silence.[30]

The main point in Merleau-Ponty's argument concerning the special status of language by comparison with mute forms of expression relates to a very

basic idea prevalent in discussions of language since the Enlightenment about how the arbitrary relation between sign and referent in language enabled it to be more creative and flexible than gestural or iconic forms of expression. Language, he argued, was able to reconstitute the world within itself because it was relatively self contained, operating independently of the phenomena it designated and not immediately embedded in these. Utterances gave one the sense that things were being evoked directly without being refracted by the materiality of the words uttered. Language thus distinguished itself from other gestural forms of utterance in that it seemed to be transparent to the phenomena it designated, even if, in the final analysis, this transparency was an illusion. Indeed, it was because of the illusion we had in the immediate course of making or attending to an utterance that things were being conjured up as they truly were that language could be the medium for articulating thought and a conscious awareness of things. At the same time, language was still mired in the material world. Without this materiality the thoughts embodied in it would neither exist nor have any purchase. There was a basic level at which language functioned like other mute "expressive operations," such as visual art, with "meaning . . . implicit in the edifice of words rather than being designated by them."[31]

There is in Merleau-Ponty's phenomenological analysis an interesting interplay between his own generation's understanding of language and a later poststructuralist one which is worth pondering today partly because it is not locked into the insistence on the deceptions of referentiality prevalent in recent semiotic theory. He focuses on the shifting apperceptions we have of linguistic utterances as, on the one hand, seemingly transparent designations of things and, on the other, as self-activating operations embedded in the stuff of language, arguing that this splitting is fundamental and allows of no dialectical resolution.[32] By highlighting an alternation between apparent transparency and material opacity within language, he could also be seen to be offering a suggestive model for thinking about issues preoccupying theorists of visual art. Discussions of painting, particularly in the 1960s and 1970s, made great play of the interplay between the opticality or transparency of painting and its materiality as stuff applied to a flat canvas – the way we both see through a painting and see a painting for what it literally is. Radically abstract work of the immediate post-war period, such as Jackson Pollock's, rendered particularly acute the shifting sensations to be gained from looking at a painting between seeing it as a field of optical effects evocative of a sense of space and depth, and

seeing it as a sedimentation of opaque coloured materials applied to a flat support.

In Merleau-Ponty's critique of the auratic significance Malraux attributed to the voices of silence emanating from art objects, one further general issue concerning the distinctive nature of texts and linguistic utterances played a key role. He argued that a linguistic utterance was able to rework and transform, rather than simply repeat or reinvent, the currency used in previous utterances, to a degree that was not possible in other forms of expressive act. He was not denying that an artist, just as a speaker or writer, could only fashion something significant by redeploying, or visibly departing from, possibilities inherent in previous work of the kind he or she was producing, and that as a result the process of making a work of art inevitably internalized something of the past history of art.[33] However, he did insist that such an internalized historicity was much more fully played out in linguistic utterances.

Following Saussure, he envisaged an individual utterance as having implicit in it the system of differentiations and articulations between signs comprising a language. It was by virtue of being integrated into this system of signs that a particular utterance became comprehensible, in a way that was not true of painting.[34] In making an utterance, we did not have to choose between reiterating word for word something that had been said before and deploying an entirely new "idiom, which like a painting, was self-sufficient and closed itself in upon its own intimate signification."[35] An utterance was automatically integrated within the totality of previous utterances while not merely repeating them. A painting, by contrast, had to be more self-contained. It was not embedded in a elaborate system of articulations that integrated it in the same way with earlier paintings. As such, it would either be copying something that had been done before, or had to deploy its own original language or style.

In his view then, a text or utterance had an internalized, self-reflexive sense of its own historicity in a way that a work of art did not. We might have the illusion that an art object from the distant past, such as a fragment of ancient Greek sculpture, could communicate something to us directly in a way that no ancient text could. We had to decipher a text. But in doing so we were made aware of the historicity of language – not only because we had to face up to how different our language was from the language being deployed, but also because our decipherment made us cogniscent of how the text's meaning was closely bound up with previous usage of the same language. By contrast, the sense we had of directly

apprehending the significance of a work of art was a false one, an effect of the ahistorical immediacy of its physical presence as self-contained object.[36]

The qualitative distinction Merleau-Ponty sought to make between art and language in this respect is not entirely convincing even in its own terms, particularly as it seems to contradict arguments he advanced elsewhere about the historicity of painting. To understand why he took this hard line we need to be aware of the force of his disagreement with Malraux's ideas on the status of the work of art. Merleau-Ponty was not talking about art as such so much as about what works of art became as items displayed in a museum or in a museum-like array of photographic reproductions. Museum culture reified works of art as self-contained objects with a significance that inhered in their visible qualities, and constituted their historicity in equally reified terms, as a history of abstractly conceived styles directly emanating from the spectacle they presented when arranged in chronological order. The point then was not so much some qualitative difference between art and language, or between art objects and verbal utterances. At issue rather was the particular objectifying logic of modern museum culture, and the tendency to envisage art works, because they were so literally things, as statically conceived, self-contained objects or images. By contrast a text seemed more process-like, its meaning and its historicity enacted by way of utterance rather than then given as fact.

In putting forward this argument, however, Merleau-Ponty singularly failed to address one important issue, namely that there is no inherent quality of texts that inevitably makes them less reified or objectified than art works. Subsequent poststructuralist theorists of language, such as Derrida, have been at pains to underline this and to stress the objectified, material qualities of linguistic utterances, to the point of critiquing the privileging of the spoken word for being more spontaneous and process-like even than written texts. At the same time, Merleau-Ponty's phenomenological approach does have the advantage of drawing attention to working assumptions about the difference between visual images or art works and verbal utterances or texts that are deeply engrained in modern culture.

A Coherent Deformation Imposed on the Visible[37]

Merleau-Ponty's views on art and language were clearly embedded in particular modernist conceptions of visual art prevailing in intellectual circles at the time when he was writing. He envisaged the modern work of art as

above all a creative painterly depiction of the kind exemplified in the late work of Cézanne, where apperceptions seemed to be embodied directly in the act of painting. This symbiosis between things seen in the world, and the configurations and visual effects painted on the canvas, could incline more in the direction of abstraction, as in the case of Klee, where a recognizable motif emerged out of the activity of mark making, or it could be more straightforwardly depictive, with the artist working from life, as in the case of Matisse or Giacometti.[38] Within the terms of this model, the work of art became an expressive act. As a response to the visible world traced back directly onto it, however, it could not fully articulate meaning or sense. The latter could only exist as a mute implication emanating from the "coherent deformation [it] imposed on the visible."[39] With language it was a different matter, as Merleau-Ponty made clear in his critique of Malraux's ideas on visual art's "voices of silence": "When one then compares language to mute forms of expression – to gesture, to painting – one needs to add that it is not content, as these are, to trace on the surface of the world certain directions, certain vectors, a 'coherent deformation', a tacit sense."[40]

As we have seen, Merleau-Ponty's model of visual art as expressive act takes little account of the viewer's response, effectively confining it to identifying at a corporeal, empathetic level with the artist's process of creation. This, combined with his conception of visual art as a process of painting the artist's perceptual responses to the world, would seem to leave little space for a whole variety of modern art forms. Nevertheless, the implications of Merleau-Ponty's analysis of art have a much broader reach than this would suggest, and I wish to conclude by underlining such features of his thinking that have specifically to do with the questions he raised about the relation between art and language.[41]

The comments quoted above about the status of art as a form of positing that at the same time remains at the level a "coherent deformation imposed on the visible" rather than being a fully articulated utterance, are a good case in point. Firstly, to think of the art work as a quasi-utterance rather than as a thing or object is very suggestive for works of art that are not conceived as traditional painterly compositions or depictions, but as objects that interact with the viewer. A ready-made may be indistinguishable from an ordinary object if we envisage its significance as being lodged entirely in its visible properties as object. But the situation changes radically if it is seen, as it inevitably is when represented in a photograph or displayed in a gallery or even just described in words, as something that

has been posited and to which one is as a result prompted to direct one's attention. It stands out from the world of mere things as a kind of utterance that does not articulate anything in particular but seems to imply something nonetheless, what Merleau-Ponty might have described as "an aborted effort to say something that always remains to be said."[42]

A lot of minimalist work could be seen as operating in this way. There are no complex compositional articulations within the work to give one the illusion that it is defining some unspoken meaning. But once the work is seen as an entity placed before one to be encountered, as an intervention in the relatively empty arena one shares with it, then it functions as a kind of utterance and acquires a certain significance as a result. Merleau-Ponty may use the term "expressive act" to describe this generic form of utterance, but we could equally well call it "positing" as he does not envisage it as expressing an artist's inner feelings, but as a gesture destined to convey a meaning or sense of some kind. The gestural utterance enacted by the art object, though, is still qualitatively different from a verbal utterance in Merleau-Ponty's scheme of things because it is immersed within the world of mute things. It is less a fully articulated expressive act than a "coherent deformation imposed on the visible," as he put it. This would nicely describe the way in which work such as Serra's operates by intervening in and reshaping the environment where it is placed.[43]

When Merleau-Ponty envisaged our viewing of a work of art as momentarily immersing us in a pre-linguistic universe that existed purely at the level of the visual and tactile, he would seem to be advocating a somewhat outmoded conception of art. This mind-set, however, is not without its later resonances. A host of alternative forms of art practice emerged in the 1960s which took the quasi-phenomenological line that the art work should operate entirely at the level of bodily gesture and physical experience, in an attempt to escape or get beyond the dominant ideologies encoded in the symbolic systems of language.[44] Such a libertarian privileging of the bodily and of immediate bodily feelings and perceptions over the linguistic and conceptual is however at odds with the status granted to language by Merleau-Ponty. His complex conception of the interplay between art and language would offer little support to the romanticizing of the bodily as an escape from the oppressions of articulated utterance found in many later, quasi-phenomenological apologias for various forms of process and performance art.

At the same time, if Merleau-Ponty often seems to be making a clear-cut distinction between the realm of language and the visual and sensory

realm of art, he also argues against objectifying this distinction. This is not just because he is aware that our seeing is inevitably inflected by our simultaneously being language users, but also because he sees the making of meaning and the articulation of self-awareness achieved in language as sharing something with the implicit sense and mute awareness produced in our physical and kinaesthetic engagement with the world. If a verbal utterance for him is not quite Robert Smithson's "heap of words," it is an "edifice of words" as much as it is the articulation of a thought. It too exists as a physical phenomenon, as in a way a "coherent deformation" imposed on the substance of the material world. In his view, thinking about how an implicit meaning is conveyed in visual art helps to draw attention to such operations of language. But if he thinks it important to dispel the illusion we sometimes have that thought and verbal communication exist in a realm above brute materiality, he is not quite saying that becoming immersed in a purely physical interaction with things constitutes an alternative way of being, purified of the constructs and cultural codings of thought and language.

Modern abstract art for him did not distinguish itself from traditional, representational art by liberating itself from the objective world and becoming pure subjective utterance, as Malraux maintained, any more than he thought of it as operating at a purely optical level that excluded non-visual forms of engagement with things. As he put it, "Modern painting, like modern thought generally, obliges us to admit to a truth which does not resemble things, which has no exterior model, no predestined instruments of expression, but which nevertheless is truth,"[45] a truth which has to do with the everyday empirical world, with as he put it our "mediocre experiences," however autonomous it might seem to be. The arena of experience in which it involves us is not some stark encounter between our subjective awareness as isolated individuals and an inhuman, objectively given world of things. Sensory apperception is no less intersubjective than language.

Retreating to a world of individual bodily and sensory experience would not enable us to escape the political degradations of our culture. Even at this most basic level, we inhabit an intersubjective world, not one stripped bare of the effects of human interaction. As Merleau-Ponty expressed it in the preface to his book *Signs* where he republished his essay "Indirect Language," the political distempers of our times are "born within this tissue which we have woven between ourselves, and which suffocates us," and which constitutes the very fabric of our most private-seeming experiences.[46] The situation, though, is not to be seen as one of damnation, any more

than our aspirations to move beyond it are glimpses of some possible route to salvation that lie beyond it. The very real sense we have of being able to surpass and move beyond our immediate circumstances is generated within the fabric of the intersubjective, material world we inhabit: it is nothing less and nothing more than an intensely activated aspect of its continual self-transformation. Art works, those "coherent deformations" imposed on the physical world, those things functioning as utterances that never quite yield a definable meaning, provided Merleau-Ponty with a model for envisaging a pattern of thinking basic to his conception of philosophical reflection – the incessant process of projecting beyond while necessarily remaining immersed within the given material substance of things.

Notes

1 See A. Potts (2001) *The Sculptural Imagination* (New Haven and London: Yale University Press), pp. 207–34; S. Melville (1998) "Phenomenology and the limits of hermeneutics," in M. A. Cheetham et al. (eds.), *The Subjects of Art History* (Cambridge and New York: Cambridge University Press), pp. 143– 54; J. Meyer (1998) "The Uses of Merleau-Ponty: Fried, Michelson, Krauss." In C. Metzger and N. Möntmann (eds.) *Minimalism* (Stuttgart: Cantz Verlag), pp. 178–89.

2 M. Merleau-Ponty (1960) *Signes*. Paris: Gallimard (cited henceforth as *Signes*). Translated as (1964) *Signs* (Evanston: Northwestern University Press).

3 *Signes*, pp. 99, 101.

4 A. Malraux (1978) *The Voices of Silence* (Princeton: Princeton University Press). First published in French in 1952 and in English in 1953. An earlier version of part one on the imaginary museum had appeared as a separate volume in 1947. On Malraux, see H. Lebovics (1999) *Mona Lisa's Escort. André Malraux and the Reinvention of French Culture* (Ithaca and London: Cornell University Press).

5 An article by Merleau-Ponty in *Les Temps Modernes* in 1947, which ridiculed Malraux's Gaullism, prompted Malraux to put pressure on his publisher Gallimard to discontinue producing the journal. O. Todd (1998) *Albert Camus: A Life* (London: Vintage, p. 293).

6 *Signes*, pp. 11–21. The essay on Koestler, "The Yogi and the Proletarian," which first appeared in French in 1948, was included in M. Merleau-Ponty (1964) *The Primacy of Perception* (Evanston: Northwestern University Press), pp. 211–28. On Merleau-Ponty's political trajectory, see S. Kruks (1981) *The Political Philosophy of Merleau-Ponty* (Brighton: Harvester); and Potts, A. *The Sculptural Imagination*, pp. 211–13.

7 *Signes*, pp. 8–9.
8 M. Merleau-Ponty (1964) *Le Visible et l'invisible* (Paris: Gallimard) (cited henceforth as *Le Visible*). English translation (1968) *The Visible and the Invisible* (Evanston: Northwestern University Press).
9 M. Merleau-Ponty (1964) *L'Oeil et l'esprit* (Paris: Gallimard) (cited henceforth as *L'Oeil*). English translation (1964) Eye and Mind. In Merleau-Ponty, *The Primacy of Perception*, pp. 159–90. His other well-known essay on art, "Cézanne's Doubt," first came out in French in 1948. An English translation was published in *Sense and Nonsense* (1964) and, together with his other two main essays on art, in G. A. Johnson and M. B. Smith (eds.) (1993) *The Merleau-Ponty Aesthetics Reader: Philosophy and Painting* (Evanston: Northwestern University Press).
10 *Signes*, p. 53.
11 Ibid., pp. 95–7.
12 Ibid., pp. 56–7.
13 Ibid., pp. 58–9.
14 Ibid., pp. 99–103.
15 Malraux, *Voices of Silence*, pp. 44–6, 65–9, 189–91, 630–42. On Malraux's use of images in his presentation of the imaginary museum, see H. Zerner (1998). Malraux and the power of photography. In G. A. Johnson (ed.), *Sculpture and Photography. Envisioning the third dimension* (Cambridge and New York: Cambridge University Press).
16 See particularly Malraux, *Voices of Silence*, pp. 591–602.
17 *Signes*, pp. 70–2.
18 Ibid., pp. 80–1.
19 Ibid., pp. 84–6.
20 Ibid., p. 78.
21 Ibid., p. 79, see also pp. 75, 77 and *Oeil*, pp. 92–3.
22 Ibid., p. 99.
23 Ibid., pp. 100–1. Merleau-Ponty is directly attacking Malraux's (*Voices of Silence*, pp. 74–5) discussion of Greek sculpture.
24 *Signes*, pp. 53–4, 82–7.
25 See *Oeil*, p. 87 and *Signes*, p. 104.
26 *Signes*, pp. 83–4. See also pp. 82–3, 85–7.
27 Ibid., p. 100.
28 Ibid., p. 73.
29 Ibid., p. 99.
30 Ibid., p. 31.
31 Ibid., p. 103, see also *Le Visible*, p. 203.
32 *Signes*, p. 103, *Le Visible*, pp. 202–4.
33 *Signes*, 73, 79, *Oeil*, pp. 92–3.
34 *Le Visible*, p. 201.

35 *Signes*, p. 99.
36 Ibid., pp. 100–1.
37 Ibid., pp. 97, 101.
38 *Oeil*, pp. 75–6.
39 *Signes*, p. 97.
40 Ibid., p. 101.
41 Merleau-Ponty's understanding of visual apperception has significant affinit-
 ies with later understandings of a viewer's interaction with three dimen-
 sional work (Potts, *The Sculptural Imagination*, pp. 216ff). Recent writing
 on painting has highlighted how the complex processes of viewing a work
 that is in any sense representational involves a symbiosis between our seeing
 its formal substance and recognising in this what is being depicted. See M.
 Podro (1999) *Depiction* (New Haven and London: Yale University Press),
 esp. pp. 5–28.
42 *Signes*, p. 99.
43 It then seems not illogical that attempts to describe the impact made on the
 viewer by Serra's work have so often drawn on Merleau-Ponty's phenomeno-
 logical analysis of visual apperception, despite the very different form of
 visual art Merleau-Ponty had in mind when writing on the subject.
44 Think of Kaprow's notion of a happening and Morris's conception of process
 art, for example (Potts, *The Sculptural Imagination*, pp. 252).
45 *Signes*, p. 72, and also p. 65.
46 Ibid., p. 47.

6

Art and the Ethical
Modernism and the Problem of Minimalism

Jonathan Vickery

The most characteristic examples of minimal art from the mid-sixties are non-compositional, pre-planned, repetitive, and made of uninflected pre-fabricated industrial materials. Donald Judd's symmetrical metal boxes, Robert Morris's quasi-geometric plywood structures, and Carl Andre's rectangular formations of firebricks, exhibit few artistic "qualities" and lack an explicit relation to the traditional genre of sculpture. Since Rosalind Krauss's innovative essay, "Allusion and Illusion in Donald Judd" of 1966,[1] minimal art has become paradigmatic for contemporary art theory and celebrated as the final death-blow to modernism and the values of modernist aesthetics. As Hal Foster suggests, however, minimal art was not anti-modernist as such, it was modernism in another guise; or more accurately, it was the aporetic finale of modernism itself: it fulfilled the high modernist aspiration for pure autonomous form and at once re-vealed the internal contradictions and thus terminal decline of this very aspiration.[2]

Krauss and Foster offer convincing arguments in defence of minimal art. My contention in this essay concerns the way the concept of modern-ism has since been misconstrued by less sensitive critics. The overem-phasis on "form" and the objective characteristics of the artwork has been misleading, and the commonplace equation of modernism and formalism has obfuscated the historical complexity of central concepts like "form," "autonomy," and "aesthetic." In this essay I suggest that modernism is

more helpfully understood from the vantage point of the subject, as an ethical venture, the nature of which is most vividly expressed in one central part of the debate on minimal art between 1966 and '67.

In 1966 Robert Morris published in *Artforum* the first of a series of essays entitled "Notes on Sculpture" defending minimal art, or "unitary forms" as he called them.[3] At the time his essays were the most convincing and theoretically informed defence of minimal art. According to Morris, minimal art provided an opportunity for heightened reflective awareness of the structure of human perception (embodied in what Morris called a "gestalt" sensation). In *Artforum* the following year, critic Michael Fried launched a memorable attack on minimal art, contrasting Morris's "gestalt" experience to aesthetic experience proper, that is, to the experience of modernist art. Minimal art was, for Fried, indicative of a potentially corrosive trend toward blurring the categorical distinction between aesthetic experience and the specular experience of ordinary empirical objects. Michael Fried's critique was entitled "Art and Objecthood";[4] some of his main observations can be summarized as follows:

(i) Before 1960 the risk, or even the possibility, of seeing works of art as *nothing more than* objects simply did not exist. Hence modernist art needed to demonstrate explicitly something which had only previously been manifest implicitly: its unique medium of shape. Shape is the "essence of the pictorial" and the means by which it would defeat art's objecthood – the ever more emphatic literal nature of its material support.

(ii) Minimal art is a "literalist" art: it refuses to defeat its objecthood and claims its obdurate literal non-differentiated wholeness as the locus of its aesthetic value.

(iii) Literalist art has "presence" – as opposed to the *presentness* of modernist art. Like brute objects, literalist art engenders a powerful physical immediacy, yet because of their human scale and hollowness they simulate the presence of another person, albeit a mute, identity-less person.

(iv) The literalist object demands an utmost seriousness, yet the spectator is reduced to a state of unquestioning awareness. The spectator stands in an open-ended, indeterminate and wholly passive relation to the object as a detached subject: interaction, engagement, and response – the characteristics of aesthetic experience – are turned into isolation, passive reception, and domination.

(v) Literalist art creates a "theatricality of objecthood": an over-awareness of the situation in which the object stands, and a heightened sense of the object as an obdurate entity.

(vi) The experience of literalist art is one of indefinite duration or endlessness; there is no meaningful dimension to the work which stimulates a momentary epiphany of understanding within our experience of it. Modernist art, conversely, is characterized by its "instantaneousness": its meaningfulness is made wholly manifest in our momentary experience of it.

Fried's concerns were more than just local issues in art criticism; his argument has endured because it involved categorical claims about the nature of art and cognition. Moreover, the stakes were the future of modernism itself – artistic practices capable of resisting the "theatricalization" of contemporary culture: a broad degeneration of cultural sensibility where the desire for the sensational was overwhelming the need for the value-laden experience of quality in the individual arts. What at root was being threatened or lost for Fried? Why did the qualities of experience offered by modernist art embody such significance? Fried never offered an extended account of the cultural and philosophical issues evidently raised in his critique. My objective here is to outline a broader framework within which we can understand what I take to be his central concept: "presentness." As one of the most misunderstood terms in Fried's critique it is worth exploring, despite the fact that many of its cognate terms – the vocabulary of Modernist criticism – are now largely anachronistic. For guidance we can turn to his intellectual interlocutor, the philosopher Stanley Cavell.[5] For Cavell, Modernist art preserves distinctive modes of human expression gradually eroded by the rationalization of modern society; aesthetic experience embodies something of the suppressed ethical structure of human life. In this essay I will attempt to identify what is, or was, *ethical* about Modernist aesthetic experience, and with this amplify the importance of the artworks' "presentness" as facilitated or enabled by its "shape." This paper is thus largely expository and will not consider arguments since marshalled against Fried, save, that is, to counter the ever persisting myth that Fried was advocating a belief in metaphysical aesthetic value embedded in a pure optical experience of the artwork's form.

For Cavell the primary cognitive or existential characteristic of modern culture is *separateness*: the loss of an experience of presentness to ourselves and each other, and an absorption into nature.[6] "Separateness" in Cavell

functions to signify both the state of autonomy and of alienation of persons and institutions in modern society, and his concept of Modernity resembles the many post-Weberian accounts of the dissolution of the authority of tradition and the transcendental certainties provided by religion and Christian metaphysics. The crux of the problem, for Cavell, is our concept of knowledge. Modern epistemology has attempted to regain a sense of cognitive certainty by redefining knowledge as pure facticity: clear indubitable concepts, verifiable empirical data, logical theorem and so on. It is the ancient figure of the skeptic, however, who embodies the aporetic condition of this move: the skeptic (rightly, for Cavell) denies that knowledge (defined as "certainty" or facticity) can give us what we need to know of the reality of the external world, of myself and others in it. The "world" of certain knowledge, that is, is not "our" world of everyday existence – the world of "fact" is the world stripped of everything which pertains to our individual, specific, particular, subjective experience. The skeptic therefore (wrongly, for Cavell) concludes that knowledge *as such* cannot exist at all.

For Cavell, separateness must be conceived as a condition of the task of knowing – and knowledge in the absence of certainty is achieved by *acknowledgment*. He remarks: "What we forgot, when we deified reason, was not that reason is incompatible with feeling, but that knowledge requires acknowledgment."[7] We can never have *certain* knowledge of the world, that is, pure generalized knowledge apart from our claims, agreements and expressions of it; the task is thus to demonstrate that knowledge defined as certainty misconceives the nature of its own aspirations.

Acknowledgment honors the very impulse of cognition: to know what is *other*, as other, on their own terms. Knowledge of the kind the skeptic is worried about is only made possible by acknowledgment; and the possibility of acknowledgment is latent in the modes of human reciprocity common to all forms of communication and expression. Acknowledgment is as much about experience as understanding; it unites what epistemology has torn apart – the particular and general, sensual and conceptual, subject and object. And for Cavell, art is an exemplary vehicle demonstrating the nature and potential of acknowledgment. The function of art in modern culture is to interpret and reinterpret the skeptical problematic – the availability of knowledge of the external world, of myself, and others in it – redefining knowledge as acknowledgment, in terms of individual experience as much as general concepts.

Thus for both Cavell and Fried, modernist artworks are not primarily objects of social or cultural analysis. Rather, they rehearse modes of

cognitive activity unavailable in other regions of social life. This is not to preclude the possibility of art being defined as social document, ideological code or cultural commodity, but art's significance – in fact, why it is even a candidate for such powerful social or cultural roles – lies in its visual efficaciousness, or the way it can empty itself of non-aesthetic meanings. Art articulates the suppressed truth of the nature of knowledge: that *knowing* is a kind of ethical praxis grounded in the intersubjective nature of human communication. In what follows I will attempt to explore this conception of modernism.

As Stanley Cavell observed in his early essay "Music Discomposed" (1967),[8] viewing modernist art involves rehearsing many of the basic emotional modes of apprehension and interaction common to our relations with other people. Works of art move us; we treat them in special ways, and "invest them with a value which normal people otherwise reserve only for other people – *and* with the same kind of scorn and outrage."[9] The indeterminate marks on a flat modernist canvas have the power to make a "claim" on us. Mere paint and colour on canvas can hold us with the force of an obligation and demand that we acknowledge it, holding our attention without explanations or concepts. The modernist painting, like another moral human agent, is an end in itself. It can sustain our attention before it by its sheer presence; it can inspire conviction and make us sure that it is worthy of a unique attribution of value. We use terms to describe works of art which are appropriate for human character: we say they express feeling, have authority, are fraudulent or dishonest, inventive or profound. Yet modernist art, being "abstract," is intrinsically hermetic and absent of all explicit content. It therefore requires attentiveness and an attitude of trust; it must, in turn, honour that trust; or betray it. And we cannot understand *what* it is, as an entity, apart from *how* it is, and the reasons it gives for that. It does not offer verifiable fact or any permanent truth about the world, but a temporal and changing experience of a relationship.

Art, for Cavell, is an analogue of the ethical "other"; our experience of the other is only made possible by our willingness or ability to make it present by recognizing its otherness or radical separation from ourselves. Cavell states: "It is only in this perception of them as separate from me that I make them present. That I make them *other*, and face them."[10] Perceiving art as separate is to acknowledge the conditions and experience the modes of being which are distinctive to it – the conventions of expression

by which it addresses itself to our sense of vision. The extent to which we can allow it to *abstract us* from ourselves, our cognitive compulsion to explain by fixing general concepts onto specific objects, is the extent to which we begin to understand the terms and conditions of our relationship with it – *its* form of reality. "It is in making their present ours, their moments as they occur, that we complete our acknowledgment of them. But this requires making their present *theirs*."[11] The radical fact of the separation of the other can be made present, and *this experience of separateness itself*, remarks Cavell, is the unity of our condition. This unity can be acknowledged or denied. We can acknowledge what the encounter expresses about the intentions of the other – be it a person, artwork or text – or fail to acknowledge it. Conversely, the other might fail or refuse to present the conditions for acknowledgment.

In a short excursus, "Some Modernist Painting," Cavell extends this meditation. Our encounter with the other is animated by a reciprocal act of revelation and self-revelation. One "primitive" fact acknowledged by modernist painting concerning its own condition, he states, echoing Clement Greenberg, is "flatness"; "flatness" is not an empirical characteristic of painting so much as a condition of expression: everything to be known about a painting is, and must be, available to our eyes.[12] It is "*totally there*, wholly open to you, absolutely in front of your senses, of your eyes, as no other form of art is."[13] Modernist art has no explicit content, and the canonical forms of traditional representation or symbolic value which once guaranteed art a sure identity and an intrinsic meaning are no longer available. It is wholly abstract, and perhaps not genuine art at all. It has to convince me of its identity and meaning through my viewing alone, that is, I can only acknowledge *it* if it reveals something true of me – the fact that I can see it *as* a painting. In this I have to explore my own capacity to accept its demands, and take leave of my own, and with it encounter my own ability or even willingness to judge, discern, describe, assert, protest or interrogate. Thus the conditions of the painting become my conditions of viewing. I make its world my world, and despite its separation from me I share in something of its reality. Acknowledgment is the only response to acknowledgment, and the aesthetic "content" of the artwork is the ways in which I can relate to the object and the pleasure or pain of that experience.

Given its extreme abstract appearance, we might say that art interrogates *our* capacities for perception, which is equivalent to our interrogating our own capacity for response, necessarily engaging everything we know about

art in general. Aesthetic experience in this sense is like a dialogue, and has the moment-by-moment temporal quality of a dialogue. For Greenberg, our experience of modernist art is characterized by a concentrated or punctuated sense of time, an interruption of our normal sense of temporal duration. The abstract painting is there all at once, "like a sudden revelation."[14] The "at-onceness" of the work demands an untrammelled concentration: "You become all attention, which means that you become, for the moment, selfless and in a sense entirely identified with the object of your attention."[15] For Cavell, the artwork's "total thereness" is a similar visual event of simultaneity, "an event of the wholly open."[16] The work is "open" in the sense of the instantaneousness of its "thereness"; it must be capable of maintaining the "haecceity" (sheer "that-ness") of a brute material object. Yet it is not merely a material object; it has a life of its own, it exists independently of me, "it must be complete without me, in that sense *closed* to me."[17] It is like a good actor – denying our awareness of him *as actor* in order to bring the character of the play to us. If for a moment my awareness of the actor becomes a determining factor in his performance, then to that extent the power of his characterization will diminish, and the actor will merely be exhibiting himself.

Drawing on these basic remarks, we can understand the metaphor of "stage presence" Fried uses to describe our experience of minimal art. Minimal art is like the paradoxical presence of an actor minus a "character": it maintains a physical presence, but is lacking an identity and thus empty of meaning (or the kind of meaning his identity – as dramatic character – demands of him). Modernist art, in contrast, is not merely present, but has *presentness* – it is like the presence of another person, where my experience of their physical proximity is inseparable from my understanding of who they are and what they are saying, and where the "meaning" of this interchange is as much lodged in my response as their act of communication. *Presentness* indicates that the art in question allows me to acknowledge it by providing the conditions for a response. Any meaningful response is mediated by specific conditions of intelligibility – what I need to know in order to understand something. For abstract modernist art in particular, the object must declare to me that it is art in a way which engages with the "grammar" of art, a grammar which allows me to identify it and assess its meaning and the value or significance of that meaning.

Modernist art's visual appearance facilitates my vision in a way that "its" meaning becomes as much the truth about myself – my own capacity

for reflection and judgment – as about itself. On this level, we can perhaps see why Fried's concern lies purely with our visual experience of the art-work and not the status of the art object as cultural commodity or ideo-logical code. To be sure, a work of art is a manufactured object, like any other object, and there are many sociological or cultural facts which would be relevant to describe this object *as* an object: a cultural commodity. The object's significance, however, is that its meaning and validity stand or fall on its ability to divest itself of its object-status, that is, to transcend its own objecthood by engaging me in a way no other object can. We could say it prompts a cognitive reorientation of the way my visual apprehension of objects is normally governed. It seems for Fried that art's only intrinsic value is its cognitive function – its ability to mediate a certain kind of self-awareness, and by extension reveal to us something the nature of cogni-tion itself (ie the nature of acknowledgment). If it fails in this, regardless of any "innovative" appearance it may have, it is no more aesthetically significant than luxury wallpaper or designer furniture.

We need to understand more about art's "cognitive" function and how it is produced. Cavell's use of the concept of "intention" is important here.[18] Modernist art, for Cavell, supplies its own meaning and the condi-tions of its interpretation via its "intentionality." Intentionality in art, as countless accounts of the "intentional fallacy" have shown, is not a psy-chological phenomenon: it does not refer to the causal relation between an idea in the mind of the artist and the appearance of an external phys-ical object. Moreover, to say that a work of art is fundamentally intentional in character does not mean that every part of its form or structure was consciously intended. Intention, for Cavell, can be described as the artwork's "purposive" appearance as it is manifest in its form. The "form" of the work is not synonymous with its empirical compositional structure, or its physical contour, but refers to the "shape" of our perceptual relation with it.

Modernist art is not merely an arbitrary optical device geared only to elicit our attention or stimulate fascination; it must engage our optical capacities in a way which convinces us that *it* is engaging with what we count as art and that it successfully stakes out its claim to significance in relation to the history of that art. For both Cavell and Fried, there are no *a priori* conventions for producing modernist art or criteria for establish-ing what will count as art. Conventions must be discovered in the process of construction. Intentionality in art is like the way one's intentions are embodied in acts of communication – we may communicate something

specific, but we do so by utilizing conventions, a "grammar" of speech or gesture that is held in common by all; similarly, art's specific or unique appearance is only intelligible if it engages with the conventional grammar of our concept of "painting" or "sculpture." The grammar of the genre never prescribes what is made; it has power to affirm what we know about art, yet reorientates that knowledge, that is, we do not see the work in terms of what we know of art, but reconfigure what we know of art in terms of our specific experience of the work.

The implication that art only finds a meaningful identity by expressing intentionality embodied in form – engaging with a "grammar" common to the history of the genre – has led to accusations that Cavell's concept of modernism is narrowly "formalist" and prescriptive. Minimal art, in contrast, is liberated from the confines of the traditional genres. Cavell is not a formalist in the sense that for him there is no understanding of an art object available without understanding the terms and conditions by which it addresses, and is understood by, the beholder. His concept of form may seem "traditional" as it obviously presupposes composition of some kind, or at least an arrangement of discrete parts. Modernism of the kind Cavell celebrates, however, no longer retains even the conventions of composition. Meaning is purely constructed out of an "arrangement" or "juxtaposition" of visual elements. Cavell's concept of form is equivalent to "syntax": the words in a sentence or the notes on a musical score obtain meaning only through the *relation* between individual elements, plus their force of contrast or mutual affinity. It is the syntax of our speech or gestures, for example, from which meaning is produced: the semantic value of each of our words is wholly relative to the pragmatic ways in which we string words together for specific purposes in certain contexts. Intentions are expressed in our syntax. With regard to minimal art, its single-unit structure would be the equivalent of a single word, or single musical note, repeated perhaps, but with no *syntax* with which to exhibit meaning. To say art must have a syntax, and that syntax is only constructed in relation to a relevant grammar, can hardly be prescriptive, but it does signify the presence of "limits," something we will consider in the next section.

One of the paradoxes of minimal art is that, despite its apparent meaninglessness it has prompted a considerable quantity of "theory" or speculative criticism. For Cavell, if we have to supply an explanation or a theory for the artwork to become intelligible, then either it, or we, have failed. Rather, the act of description is the way I register the work of art's intelligibility. Cavell remarks: "Describing one's experience of art is itself a

form of art; the burden of describing it is like the burden of producing it."[19] We might observe that minimal art, as non-descript single geometric forms, eschews syntax and meaning, thus divesting viewers of their powers of description; for Cavell, without description, interpretation becomes a matter of abstract speculation, replacing what should have counted as a meaningful experience.

So far I have attempted to outline some of the characteristics which would inform a rudimentary phenomenology of presentness. We have observed that a Modernist work of art's identity and meaning, unlike other objects in the world, is not derived from general characteristics or properties it shares with other objects of its kind, but is secured by the kind of response-relation it facilitates with the viewer. This response-relation is characterized by a certain temporal quality of instantaneous-ness, and this is engendered by the work's "intentional" structure. We can thus describe the work as having "presentness." The significance of presentness, it seems, is that is re-structures our experience of time, of the everyday temporality which conditions our experience of objects in the world. It does so according to the temporal nature of intersubjective communication – dialogic time – thus defeating the arbitrary authority of routine or "clock-time," or the rationalized temporality by which our everyday cognitive involvement with objects in the world is formed. Our relationship with the artwork, like our relation with another subject, is formed through understanding and responding to the way the other's intentions are manifest. Intention, observes Cavell, is something which modernism exhibits more nakedly than ever. Why is this?

For Cavell, modernism is the need to construct meaning without the authority of tradition, or more accurately, to construct meaning out of a perpetual critique of conventions refined by recent practice – conventions of colour, line, form, space, etc. – which have become ossified by encoded meanings or plain cultural familiarity. Modernist art purges itself of these outmoded or extraneous conventions, "abstracting" itself from the arbi-trary authority of routine and established norms, and seeks in perpetuity to explore "the limits or essence of its own procedures."[20] "Essence" here means the way a work of art exemplifies an *identity* as "painting" or "sculp-ture" – in an age in which art can end up being nothing more than an object – demonstrating, as Fried would say, the "essence of the pictorial": shape. But it does this through exploring the "limits" of formal possibility: creating new conventions. Not to explore these limits, we may infer, is to

fall into aesthetic banality, or anachronism; to go "beyond" these limits is to collapse into objecthood or arbitrary visual effect.

Cavell, like Fried, celebrates Anthony Caro. Caro's work confronts all our received assumptions and expectations of what sculpture should look like – sculpture as a self-enclosed object shaped by carving or modelling, placed on a pedestal, and so on. He deploys the conventions of sculpture in ways that has redefined the concept "sculpture" in that his work is characterized by none of the accepted conventions, yet at the same time his work defines itself in relation to the great sculpture of the past. The work engages with what we expect and understand by the concept of sculpture, yet reveals that these conventions are outmoded by producing new ones. Caro demonstrates that *figuration* is no longer necessary for compelling contemporary sculpture; in fact, it is a hindrance to it. He succeeds in making sculpture which, paradoxically, exemplifies what past (figurative) sculpture was, but without the anachronistic conventions of figuration.[21]

Caro is authentic modernism. For Cavell, the unique historical condition of modernism – the absence of normative procedures – creates the perpetual risk of fraudulence. This is hardly a startling observation, but an emphatic opposition between authenticity and fraudulence plays an important role in Fried's criticism and has earned him a reputation as a reactionary.

Moreover, Fried was also convinced that "no more than an infinitismal fraction of the art produced in our time matters at *all*."[22] His evident unconcern for any artist other than the epoch-making genius coupled with his adeptness at identifying the fraudulent has unsurprisingly attracted charges of elitism and dogmatism. The charge of elitism can often point toward interesting sociological aspects of art; for example, the way an otherwise radical concept of modernism can indeed (did indeed) become institutionalized and prescriptive; elitism is a less interesting concept in the context of aesthetics. The charge of dogmatism is likewise often misplaced, but it will provide us here with cause to explore a central feature of Fried's concept of modernism.

For Fried and Cavell, strictly speaking, there are no established principles or normative conventions to be dogmatic about. The object must convince us through experience that it is significant, and no amount of justification, theoretical or otherwise, can accomplish this task for it. Art must (can only) inspire "conviction," that is, modernist art only finds a confirmation of its own authenticity by convincing me personally that this

is meaningful art – the sanction of experts, aesthetic theories or institutions will not suffice. Modernism acknowledges the radical dissolution of all forms of unquestioned normativity and authority; there is no other form of validation to which these objects can appeal than the experience of an individual. In his essay "A Matter of Meaning It" (1965), Cavell explains why pop art fails to convince him. He states:

> This is not painting; and it is not painting not because painting *couldn't* look like that, but because serious painting doesn't; and it doesn't, not because serious painting is not forced to change, to explore its own foundations, even its own look; but because the *way* it changes – what will count as a relevant change – is determined by the commitment to painting as an *art*, in struggle with the history which makes it an art, continuing and countering the conventions and intentions and responses which comprise that history.[23]

Modernism is the attempt to perpetually redefine art in the absence of any prescriptive normativity or tradition, and radical change is its hallmark. Yet pop art, for Cavell, is not a radical change. It does not change anything, that is, it does not acknowledge and transform the limits and perceptions of what painting is, or can be. Change in art must be immanent – it is the visual demonstration that art no longer needs the confines of previous conventions, and it is wrought through changing those conventions themselves. The issue of "conventions" is pivotal here, and is often the root of charges of dogmatism. In *The Claim of Reason*, Cavell states the following:

> If it is the task of the modernist artist to show that we do not know a priori what will count for us as an instance of his art, then this task, or fate, would be incomprehensible, or unexercisable, apart from the existence of objects which, prior to any new effort, we do count as such instances as a matter of course; and apart from there being conditions which our criteria take to define such objects. Only someone outside this enterprise could think of it as an exploration of mere conventions. One might rather think of it as (the necessity for) establishing new conventions. And only someone outside this enterprise could think of establishing new conventions as a matter of exercising personal decision or taste. One might rather think of it as the exploration or education or enjoyment or chastisement of taste and of decision and of intuition, an exploration of the kind of creature in whom such capacities are exercised. Artists are people who know how to do such things,

i.e. how to make objects in response to which we are enabled, but also fated,
to explore and educate and enjoy and chastise our capacities as they stand.
Underlying the tyranny of convention is the tyranny of nature.[24]

To say that art's identity and meaning is to be continually re-created
through a critique of convention is to say there are no available objective
principles or standard criteria by which art can attain a meaningful iden-
tity; art has to be re-constructed from the (always outmoded) conventions
of the medium alone, and conviction (the experience of authenticity) is
the only validation it can offer. As Caro demonstrated, conventions are
maintained, not as principles, techniques, established procedures, or even
visual characteristics, but as the necessary conditions of intelligibility from
which experimentation proceeds.

Yet pop painting, like Caro's sculpture, strikes us as both intelligible
and radically different in appearance from anything that has gone before.
Why is pop fraudulent? We previously noted that all art is radically bereft
of tradition and thus validation and meaning, and can only create a mean-
ingful identity for itself by acknowledging the limits and essence of its own
procedures; failure to do this will result in either banality/anachronism or
objecthood. We might accuse pop of being the former: its artistic conven-
tions, often a pastiche of traditional naturalism or abstract expressionism,
are retrograde. Yet this is not what Cavell argues. *Anything* not modernist
is fraudulent for Cavell. Modernism is not a style but an historical condi-
tion. Ignoring it is one thing; feigning it is another. Artists happily using
traditional styles or materials, producing art for pleasure, cannot be said to
be feigning modernist art. Pop art, because of its radical newness, *appears*
to be demonstrating the limits and essence of painting, and appears to be
redefining convention. Pop, like minimal art, feigns radical change.

Cavell engages with no particular artworks in his essays; his claims can
thus easily appear as unfair blanket condemnations. We can, however,
clarify his remarks. Firstly, when Cavell talks about art convincing me
by "experience" alone, he is not talking about a pure empirical mode of
perception. "Aesthetic" experience is the way the object – by the force of
its appearance – effectively dismantles and reconstructs my conception
of what painting or sculpture is – my expectations, attitudes, assumptions
concerning what it looks like or how it works – and consequently my
understanding of the history of that practice. A successful artist, like Caro,
would accomplish a paradigmatic shift in the whole concept (and thus
perception) of sculpture. This process could take some time, and involve

many different viewings and perhaps even debates, and is as much a sensible education (learning to see differently) as a conceptual education (learning new ways of thinking and talking about this process).[25]

The word "convention" in its ordinary sense denotes the publicly accepted use of something, a binding treaty, or a public congregation. The semantic breadth of this term is important as it emphasizes that a cultural practice like art is not a matter of personal proclivity, or equally not constructed from principles impervious to historical change, but constituted (and revised or reconstituted) by a collective activity or shared, publicly available experience. This does not mean that what counts as art is determined by common subjective preference or subjective agreement; authentic art may be rejected wholesale for many non-aesthetic reasons, or fraudulent art embraced for non-aesthetic reasons (perhaps by collective misunderstanding). Art's conventional identity is constituted out of, by extending, the grammar of an already socially established practice: the grammar of the genre. There is nothing a priori that specifies how this genre is to be continued – the genres painting or sculpture have no "a-historical" essence – but for Fried they do have a trans-historical essence; that is implied, in part, by the continuing use of the generic concept of "sculpture" or "painting" for objects of radically changed appearances. The concept of sculpture as a genre is intimately connected with what Fried calls "shape": the essence of the pictorial. But what does that tell us? We might attempt a definition of sculpture as "three-dimensional shape," or painting as "two-dimensional shape." But these definitions cannot offer us substantive meaning, or even imply some basic descriptive terms as to what sculpture or painting is; and there are no standard characteristics defined by tradition left. We might say there are no general descriptive concepts which apply to these kinds of object. Only a work of sculpture itself can "give us" the concept of sculpture. Knowledge of sculpture – unlike our knowledge of other objects in the world – is only available by experience, or *as* experience, and this experience, as we have noted, is as much a reflexive engagement with ourselves as with the object.

But what is the grammar of the genre as such? This is a not a phrase used by Fried or Cavell, but serves to remind us that though Caro's sculpture signifies radical change (is anti-traditional) it draws upon deep historical resources. At the same time, it (if we are to agree with Cavell and Fried), speaks in a grammar we already possess: the grammar of bodily movement and gesture. For the historical practice of sculpture always revolved around our understanding of the human body, or more accurately,

our experience of the body (both others and our own) as a medium of expression and communication. Cavell often uses the term convention in a way that emphasizes its *non-arbitrary* nature, that is, the way conventions of meaning and expression and are bound up with our "human nature" or the exigencies of conduct and feeling we all share – socially established agreements as to what constitutes meaningful expression. We could say that art's conventions acknowledge *our* essence and limits, the conditions of our identity and the meanings we make: the way our bodies have a comparable scale, certain physical aptitudes, a repertory of movements, certain optical capacities, and the way all these together constitute the nature of our perception and thus the way we think and speak. These aptitudes or potentialities do not operate according to "rules," they function according to common social conventions of communication; and they cannot be said to be "restrictions" as such, yet their potential is indeed relative to physical restraint.

Art's conventions are therefore bound up with our conventions of thinking and speaking and embody physical constraints as much as cultural or social constraints. Authentic art will acknowledge its present conditions of aesthetic possibility as they are conventionally mediated, which is to say it acknowledges the conditions of contemporary cultural sensibility in general – what it takes for us to relate to it as art. In this sense we can see the logic of Cavell's disapprobation of pop art: to say that pop is not modernist is to say it does not address the limits and essence of what art is, which is at one with saying it does not address the current conditions of perception. And addressing the current conditions of perception is at once to challenge and reveal the ossification of our perception under current cultural conditions. For Cavell, pop art's offence is, paradoxically given its subject matter, an obliviousness to its cultural conditions.

The broad implication of Fried's critique of minimal art is, similarly, that objecthood is art without acknowledgment, oblivious to the cultural conditions of perception, or what counts as meaningful identity in a culture increasingly seduced by the theatrical. What is theatricality? It is the experience of art as a brute object, in a world (an experience of reality) constituted not by relations between people but by relations between things, objects of specular fascination and consumptive pleasure perhaps, yet which remain impervious to the needs or possibilities inherent within our subjectivity, unresponsive to our need for acknowledgment. And without acknowledgment there is no knowledge. What kind of knowledge does acknowledgment make possible? Self-knowledge: the ways in which my

human nature is also culture and the extent to which my subjectivity is also intersubjectivity, how my body and mind are inseparable, and the act of expressing individuality is a collectively and conventionally mediated experience.

I have attempted in this essay to elaborate on what I have called the ethical structure of aesthetic experience as defined by Stanley Cavell in so far as it pertains to Michael Fried's criticism of minimal art. Despite the tiresome familiarity that talk of modernism often evokes, it is all too often mis-construed. This represents but one dimension of Fried's argument, and summarizing some of Cavell's ideas as schematically as I have is bound to misrepresent their depth and complexity. In this essay the concept of "presentness" was central. As Fried maintained, art maintains presentness through "shape." There is a sense in which "shape" simply denotes an artwork's formal coherence – the way its composite elements are unified in our perception of it. Greenberg often referred to the dialectical unity of the "depicted" and the "literal" dimensions of the artwork to describe the way it overcomes its empirical status as "literal" entity, or, in Fried's terms, "defeats" its physical objecthood.[26] Yet it is more than this for Fried. Shape is an analogue of subjectivity (or more accurately, individual subjectivity as intersubjectively or dialogically mediated). The subject is more than a dialectic of body and mind. A person is an embodied subject in which the body and mind are ever combined and activated by expressive commun-ication; and communication (even with oneself) is always contextualized in a chain of response and counter-response, always in and through the other. The "presentness" of the art object is the way it is present to us like another person, not merely another object. Moreover, our experience of shape is "instantaneous." The temporal structure of our experience is like the way human subjectivity is manifest: momentary, yet "wholly," revealed in the course of a person's communication or expression.

However, Fried was right to take minimal art seriously. Robert Morris, for example, self-consciously continued modernism's exploration of the nature and limits of perception through shape. However, minimal art's shape was literal; it was art stripped of convention, that is, art aspiring to fulfil a cognitive role without the complexities of expression and acknow-ledgment. In production, creation was replaced by planning, and in recep-tion, criticism by theory. In a sense, minimal art is an analogue for the traditional epistemological ideal of knowledge: clear indubitable concepts, abstracted from all subjectivity and contingency, offering more direct

access to the nature of reality. For Morris, minimal art provided a more direct experience of the nature of perception. Modernism was redefined as a quasi-science of practical phenomenology.

Notes

This essay was written during a generous research fellowship awarded by The Henry Moore Foundation.

1 Rosalind Krauss, "Allusion and Illusion in Donald Judd," *Artforum*, vol. 4, no. 9 (May 1966), pp. 24–6.

2 Hal Foster, "The Crux of Minimalism," in *The Return of the Real: The Avant-Garde at the End of the Century* (Cambridge, Mass.: MIT, 1996), pp. 35–68.

3 Collected in Robert Morris, *Continuous Project Altered Daily: The Writings of Robert Morris* (Cambridge, Mass.: MIT, 1998), pp. 1–70.

4 Michael Fried, "Art and Objecthood," reprinted in *Art and Objecthood: Essays and Reviews* (University of Chicago Press, 1998), pp. 148–72; for a recent exploration of this essay in the context of the history and theory of modern sculpture see Alex Pott's exemplary study, *The Sculptural Imagination: Figurative, Modernist, Minimalist* (Yale University Press, 2000), pp. 178–206 and *passim*.

5 This is not to conflate their respective ideas, but Cavell (as did Fried) often made reference to their mutual indebtedness; see "The Avoidance of Love," in *Must We Mean What We Say: A Book of Essays* (Cambridge University Press, 1994), pp. 267–353, p. 333, note 16; "Excursus: Some Modernist Painting," in *The World Viewed: Reflections on the Ontology of Film* (Harvard University Press, 1979), 108–18, p. 239, note 40.

6 See "The Avoidance of Love," pp. 322–4, and *passim*. Cavell's work is notoriously difficult to simplify or abstract from his various philosophical contexts; what I attempt to offer here is merely a collection of apposite remarks. Of interest on these issues is Stephen Melville's *Philosophy Beside Itself: On Deconstruction and Modernism* (University of Minnesota Press, 1986), ch. 1, pp. 3–33.

7 Ibid., p. 347.

8 "Music Discomposed" in Cavell, *Must We Mean What We Say*, pp. 180–212.

9 Ibid., p. 198.

10 "The Avoidance of Love," p. 338.

11 Ibid., p. 337.

12 "Excursus: Some Modernist Painting," p. 109.

13 Ibid.

14 Clement Greenberg, "The Case for Abstract Art" (1959), in John O'Brian (ed.), *Clement Greenberg: The Collected Essays and Criticism* (vol. 4) (University of Chicago Press, 1993), 75–84, p. 81.

15 Ibid.

16 "Excursus: Some Modernist Painting," p. 111.

17 Ibid.

18 "A Matter of Meaning It" in Cavell, *Must We Mean What We Say*, 213–37; see esp. pp. 225–37.

19 "Music Discomposed," p. 193.

20 "A Matter of Meaning It," p. 219.

21 Ibid., pp. 215–18.

22 Stated in Michael Fried's contribution to a symposium at Brandeis University, published as *Art Criticism in the Sixties* (New York: October House, 1967) (unpaginated).

23 "A Matter of Meaning It," p. 222.

24 Stanley Cavell, *The Claim of Reason: Wittgenstein, Skepticism, Morality and Tragedy* (Oxford: Clarendon Press, 1979), p. 123.

25 See Krauss, "Allusion and Illusion" for a defense of Donald Judd's work in similar terms.

26 For example, Clement Greenberg, "Collage," in *Art and Culture* (London: Thames & Hudson), pp. 70–83.

Does Art Think?
How Can We Think the Feminine, Aesthetically?

Griselda Pollock

For many years, the model of art history in which I worked rigorously examined the relations between art and its social conditions of production and circulation, mediated through the work of ideology.[1] This approach served well but was often in conflict with equally compelling pressures and questions that arose from emerging feminist investigations of the repressed question of gender posed to both art and society. Into this dilemma, through my work with and on several contemporary artists, the cultural appropriation of psychoanalysis brought new possibilities that have not displaced the obligation to think historically and produce socially grounded accounts of artistic practices. Instead, a further dimension of investigations into "aesthetic practices" (a term borrowed from Julia Kristeva) was opened that concentrated not just on socially and ideologically manufactured *gender* relations, *gender* identities, and *gendered* practices. I wanted to explore the constitution of subjectivity, sexuality, and fantasy under the psychoanalytical term, *sexual difference*.

This, in turn, raised problems as well as possibilities. For some, the continuing attention to *sexual* difference tends to reinforce our thinking about everything through the prism of heteronormative phallocentric divisions into masculine and feminine, male and female, men and women. What about sexuality and difference in terms of gay and lesbian identities/ subjectivities, in relation to cultural difference in postcolonial worlds, in relation to complex configurations of the still most powerful division, class? Alert to these dangers, I still would want to argue that precisely

because our thinking and our cultural practices are so saturated with heteronormative and phallocentric structures, even when dealing with non-sexual differences, that we must for a while at least, pose the question of a feminine sexual difference conceptualized and represented *beyond* the phallic structuring. Can you accept: "The difference of the feminine is inaugural of its own space and is originary; it is not deduced from the masculine or male"?[2] This is very far from Sigmund Freud's concluding remarks on femininity in 1933:

> That is all that I had to say about femininity. It is certainly incomplete and fragmentary and does not always sound friendly . . . If you want to know more about femininity, inquire within your own experiences of life, or turn to the poets, or wait until science can give you deeper and more coherent information.[3]

I'll take you up on that, Sigmund. Drawing on my own experience, I shall turn to artists rather than poets, and see what the development of psycho-analytical thinking beyond your 1933 "signing-off" can offer.

The most promising place to begin might be this statement:

> Discussing art in a psychoanalytical context is inseparable, to my mind, from debating sexual difference, since we enter the function of art by way of the libido and through extensions of the psyche closest to the edges of corpo-*reality*.[4]

What is suggested here is that we cannot think about art without thinking about sexual difference because the psychic *roots* and *routes* of that which lines the aesthetic dimension with affect and that which drives the repetitious act of making art itself emerges onto the human plane at the point at which sexual difference also is generated. Where is that? Lacanian theory locates this in an archaic space between "trauma and phantasy" that is, between the events of the body that have as yet no sense-making mechanism and their inscriptions, transformed, in the psychic apparatus as phantasy. Between this space and thought lies a further complex construction that both generates and requires signifiers to drag the archaic traces up through the registers of subjectivity to the plane of language. Art, like hysteria, trembles in this relay between body and language: the question is what the relay might be if we could actually think sexual difference.

In this essay, therefore, I want to explore the triangulation of feminist theory, artistic practice and psychoanalysis. But, this leads to another

question: can we think about sexual difference if we do not have the relevant signifiers through which to know a difference *from* the feminine, rather than a difference *attributed to* the phallocentrically defined other, which as Luce Irigaray has argued is only the other of the Same, the One?[5] If that is the problem, we have then to ask: what artistic practices might enlarge the signifying scope of the Symbolic so that it is not only this formulation:

Symbol = Signifier of signifiers = Phallus
Symbolic castration = phallic inscription = any passage to the Symbolic?[6]

What role have artistic/aesthetic practices made by "women" – subjects positioned in the feminine both within the existing Symbolic and in relation to its foreclosed other, feminine difference – had in pushing the limits of philosophical reflection by finding, initially visual, forms or imaginary holes for traces of dimensions of the corpo-Real that a phallocentric Symbolic firmly forecloses? Are there grains of sexually specific corpo-realities that can be gleaned through art on behalf of culture in general? Can women think at all "in, of and from the feminine" if we do not have an alliance between a poetics/aesthetics of the feminine and new theoretical pathways in thought?[7] Working with a radical psychoanalytical framework that posits a non-essential, and non-reductive relay between corporeal events, sensations and intensities and their psychic transformation/inscription through the registers of the *imaginary*, Bracha Lichtenberg Ettinger follows Piera Aulagnier by introducing an archaic level of *representation* that further mediates this relay between body and language, corporeal intensities and thought, namely the pictogram. Pictograms are "traces of the unviewable, unsignified *Thing* . . . archaic sensorial events . . . [produced by the] primary process[that] uses the *images of things*."[8] Thus without falling into any of the former dangers of reductive anatomism, we can psychoanalytically posit a way in which a sexual difference that can be theorized of and from the non-phallic, non-Oedipal feminine – retroactively conceived because of the later coming of the psychic apparatus in which this "event" finds subjective meaning – can filter into the realm of images and words, fantasy and thought.

> In the realm of subjectivisation through phantasy, sexual difference and artistic creation, [we can] draw a borderspace in several mental fields: the *real* (emphasising links to *feminine bodily specificity*); the *imaginary* (exposing matrixial beyond-the-phallic phantasies, for both men and women); and in

the *symbolic* (displaying matrixial contributions to subjectivity, art and culture) . . . If we go on the return journey between body and language, I suggest that any relation between *the I* and *the non-I* produces not only records in each psychic space, which can be formulated by metaphor and metonymy, but also a different kind of inscription: *metramorphosis* as a mental trace off a fourth space of ontogenetic "memory" of transmissions and transformations. To the co-existing idea (thought), the "figurative mise-en-scène" (phantasy) and the pictogram, I add, then, a matrixial ontogenesis, understood in terms of the aesthetic: continual readjustments of sub-symbolic elements as meaning-producing psychic events which do not stay *pre-symbolic*. *Sub-symbolic* elements . . . push their remains towards the primary process to produce phantasies and towards elaboration of the secondary process. Alternatively we may say, at the same time as an experience is organised according to the logic of discourse, it is both subjugated to the concealed or repressed "logic" or "aesthetic" of phantasy, and echoes both its pictograms and its network of transforming relations.[9]

It is this combination of a theory of sexual difference from a differently theorized feminine – the matrixial as a site of a network of sub-symbolic relatings and transformations, and a theory of the aesthetic as a subjectively affecting process of relatings and transformations that allows us to posit a significant relation between feminist theory, psychoanalysis, art and thought: the necessary site at which these processes that happen and affect us can be understood and taken up for philosophical, political, ethical and analytical expression.

Readings in Art and Theory

My method for exploring these questions involves creating a small archive of readings from a range of texts. I make no apologies for lengthy quotations, for this text itself is a kind of weaving of many thoughts on art. These are the sources for my reflections not just on the impact of certain theories or philosophies on art or art history, but on the role of artistic practices in enlarging the very range of things we can think about, and in generating the means, terms, and signifiers through which to shift what we think, which is to say, to change the world. What we can think, is what we can know. What is unthinkable – because it lacks signifiers in the Symbolic – remains unknowable, foreclosed is the technical term, although it is not inoperative upon our psyches. Julia Kristeva explains the odd way in which earlier phases of subjectivity, nonetheless, play their part:

Psychoanalysts acknowledge that the pre-Oedipal stages Melanie Klein discusses are "analytically unthinkable" but not inoperative, and, furthermore, that the relation of the subject to the signifier is established and language-learning is completed only in the pre-genital stages that are set in place by the *retroaction* of the Oedipus complex (which itself brings about genital maturation.) Thereafter, the supposedly characteristic functioning of the pre-Oedipal stages appears only in the complete, post-genital handling of language, which presupposes, as we have seen, a decisive imposition of the phallic.[10]

Julia Kristeva here makes clear the paradoxical logic of psychoanalytical time: that the earlier, generative phase becomes itself active in its distinctive manner, in the *retroactive* effect of that which it precedes. In phallic logic, however, this serves to subject all anticipatory, pre- or sub-symbolic psychic events or processes to its domination and definition. What if its retroaction were not exclusive and sovereign? What if some kinds of historically generated artistic possibilities have been pointing to other relays?

Kristeva further argues, however, and very usefully, that art is the antithesis of psychosis because it is a way of thinking and it offers an access to what lies beyond thought.

In other words, the subject must be firmly posited by castration so that drive attacks against the thetic will not give way to fantasy or psychosis but will instead lead to "second-degree" thetic, i.e. a resumption of the functioning characteristic of the semiotic chora within the signifying device of language. This is precisely what artistic practices, and notably poetic language demonstrates.[11]

Art is, therefore, a second-degree passage between its archaic sources and a means of signifying a relation to them for subjects in a symbolic. It repeats the journey of the subject which, as we have seen, is never one way. The subject is the effect of the perpetual play and movement between its component registers, each tracing itself in the other by means of specific mechanisms and processes in constant relays and overdeterminations. Thus the subject is the configuration of all its constituent levels, which are, however, held in different kinds of signifying systems – conscious/unconscious being the advanced division. In order for us to know things about the most archaic dimensions of subjectivity, which border corporeal, sensory zones full of pulsions, energies and non-verbal intensities that are not yet patterned or shaped and disciplined by linguistic systems and ultimately

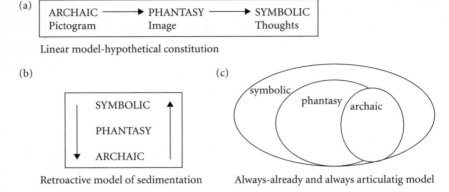

Figure 7.1

mortgaged to the signifier, we need filters both appropriate to each level, and a signifier in the Symbolic that can open this whole transactional passageway both forward and backward between the place where we can say, think and know, and those places of which we might want to say, think, and know something else.

The coming to meaningfulness passes through several states: archaic characterized by meaning as pictograms[12], phantasy characterized by images, and the Symbolic characterized by thoughts. The phallus as signifier in the Symbolic allows into thought those pictogrammic representations and phantasies corresponding to its organization of meaning around the binary, the cut, separation, presence and absence. Any other dimension of archaic experience or phantasy not in accord with that phallic model is excluded from thought, excluded from enabling us to think about, for instance, relations to the other that are not lined with ambivalence and anxiety, any form of trans-subjectivity that imagines subjectivity beyond the boundaries of the discrete individual facing/opposed to its menacing or alluring other. Without a signifier in the Symbolic, archaic pictograms of "severality" as opposed to unity remain condemned to hover as delusional, hallucinatory, psychosis-inducing remains.

An easy misunderstanding of my project might arise because the term "feminine" is a negative term within phallic thought, the other-thing-nothing against which the masculine assumes a position of meaning. In a phallic model, the feminine is what is beyond the human: death, beauty, the Thing, which is desired because lost or sadistically destroyed because

mutilated. It has no meaning and nothing to contribute to what is considered the human. In a matrixial theory of subjectivity, beyond (but not instead of) the phallus, the feminine will be the term for a "different difference," beyond that phallic ordering of sexual difference as plus/minus, man/non-man, a difference that arises before and more archaically than the phallic, from "the invisible sexual specificity of the feminine" (Bracha Lichtenberg Ettinger) that has nothing to do with the phallic binary masculine/feminine orchestrated around the presence/absence, the having/being of the phallus. This feminine produces a sexualizing and subjectivizing difference from the specificity of its structure as a borderspace of encounter that trails a connectivity between never quite become and never completely lost unknown partners. I shall be exploring a major contribution to the re-thinking of aesthetic practices and sexual difference offered by the painter and thinker Bracha Lichtenberg Ettinger, whose work I shall place in context with other feminist theorists of this interface of art and difference.

In the first major text presenting her theory in English, published in 1992, Bracha Lichtenberg Ettinger suggested that:

> Artists continually introduce into culture all kinds of Trojan horses from the margins of their consciousness; in that way the limits of the Symbolic are transgressed all the time by art. It is quite possible that many work-products carry subjective traces of their creators, but the specificity of works of art is that their materiality cannot be detached from ideas, perceptions, emotions, consciousness, cultural meaning and that being interpreted and reinterpreted is their cultural destiny. This is one of the reasons why works of art are symbologenic.[13]

Here the artist-thinker advances the idea that works of art can generate new signifiers that then allow into culture other subjective traces than those currently permitted to filter into culture by the existing signifying system. Thus artwork transgresses and, in a sense quite close to some of Julia Kristeva's theses about the role of the semiotic in language, renovates and even revolutionizes, i.e. moves culture.[14] This passage is also important for the way in which Bracha Lichtenberg Ettinger insists that the materiality of art cannot be detached from ideas, perceptions, emotions and consciousness, as well as cultural meaning. Something is articulated across many levels by this subjectivized materiality that is art – not just a beautiful object but one that carries human meanings for subjects – that provokes discursive engagement, incites responses that take the form of ideas, words,

thinking. Art can thus generate thought, not because it is intellectual, but because it conjugates the relations between the corporeal, sensory, perceptual, affective, and cognitive dimensions of the subject.

A year later in the catalogue of her exhibition at the Museum of Modern Art in Oxford, in 1993, Bracha Ettinger wrote this even more clearly:

> The work of art does not illustrate or establish theory; theory can only partly cover – uncover – the work of art. Sometimes the work of art produces seeds of theory from which, upon elaboration, art slips away. The seeds should be sown elsewhere.[15]

Thus the artist paints and reflects upon her art work through other kinds of work, writing in her notebooks, linking words and ideas and responses until they find an echo in some form of thinking that can elaborate these insights and perceptions in a known form of thought, in a theoretical system hospitable to them. Thus, Bracha Lichtenberg Ettinger found, while exploring historically conditioned but not exclusive forms of trans-subjectivity and inter-generational transmission of trauma and phantasy, while also practising as a clinical psychoanalyst, that the covenant between the paintings and the theory of subjectivity offered by psychoanalysis could develop. In becoming theory, however, the art dimension of its revelation/donation may slip away, yielding itself to another form, another mode of circulation and effect that does not kill the art or lose it. It simply allows another processing of its freight to deliver its insights as thought. This relation, called a covenant, is itself matrixial; there is differencing but there is not an either/or situation. Psychoanalytical insights can flow back through the thinking subject who is also the painting subject. Psychoanalysis would, however, only be receptive to what the art work "discovered" if the historical, ideological, phallic limits enshrined within that theoretical discourse would allow themselves to be permeated by what was clearly happening in the work and through the artworking.[16] As both exhibitor and theorist for one of the most important exhibitions to confront the question of the feminine in twentieth century art, *Inside the Visible: an Elliptical Traverse of 20th century Art in, of, and from the feminine*, curated by Catherine de Zegher in 1996, Bracha Lichtenberg Ettinger expanded upon theory/practice, art/thought:

> Theory does not exhaust painting: painting does not exhaust theory. Painting produces theory and kernels that can transform it; theory does not alter

painting in process; it can draw stalks out of it and translate them into its own language. While painting produces theory, theory casts light on painting in a backward projection. Yet sometimes theory seeps in and anticipates approximations of what will become a future painting – an instigation that will be retroactively revealed . . . The touch in painting changes the thought and goes elsewhere; the thought alters and returns to the touch. Painting and theory illuminate each other asymmetrically when adjacent but their temporalities are different.[17]

Key terms here are the "backward projection," anticipation of a future painting, retroactively revealed to be instigated by what called it forth. In addition, there is the idea that thought and touch are in a kind of mutually transformative relay, where a material gesture or stroke, a materialized act creating an active material can solicit thinkings, yet the touch also implies the play of affect through materialities like color, mark and gesture that, none the less, resonate either in the mind, the understanding, or in the emotions of the subject. Thus there is a relay between the subjectivized space of the art-work and the subjectivized space that lies between it and its viewing subjects.

The artist-thinker continues and proposes an "inter-range" between the "Real of the psychic id, the act of painting and the Symbolic," so that painting and theory are not different but represent different levels of working. The important space is this "with-in-ter" the two.

My next quotation moves sideways to an important but strange text by Julia Kristeva that links "sexual difference: women" with three major figures of modern, secular dissidence: the rebel, the writer, and the psychoanalyst. Julia Kristeva concludes,

> For true dissidence today is simply what it has always been: thought. Now that Reason has become absorbed by technology, thought is tenable only as an "analytic position" that affirms dissolution and works through differences. It is an analytical position in the face of conceptual, subjective, sexual and linguistic identity.[18]

Thought is identified with the analytical position, with psychoanalysis, in so far as identity is proposed as subjective, linguistic, sexual. Thus thought is not abstract, neutral, universal and transcendent, disembodied and objective. It is marked by that which psychoanalysis revealed to us, the unconscious, the drives, desire, and difference. It is in this same essay that Julia Kristeva situates the problematic of sexual difference and artistic

creation in relation to the repression of the mother. Citing Mallarmé's question: "What is there to say concerning childbirth?" which Julia Kristeva finds even more poignant than Freud's famous: "What does Woman want?" she locates woman's particularity in her sexual specificity that can only be thought in relation to reproduction as threshold, between nature and culture, between sociality and its destabilization. Thus she concludes:

> Under these conditions, female "creation" cannot be taken for granted. It can be said that artistic creation feeds on an identification, or rivalry, with what is imagined to be the mother's jouissance (which has nothing pleasant about it). This is why one of the most accurate representations of creation, that is of artistic practice, is the series of paintings by de Kooning entitled *Women*: savage, explosive, funny, inaccessible creatures in spite of the fact that they have been massacred by the artist.[19]

But could a woman have made such paintings, Kristeva asks? This is not a silly question, for it contains within it the important question of what relation there is for the woman-subject to the Other-*Woman*. Bracha Lichtenberg Ettinger writes in her turn:

> Femininity, in Freud's conception is femininity in and for men, and men reflect the feminine for women. When the artist, James Joyce (for Lacan), Leonardo (for Freud) materialises/realises "woman", his creation is a poetic writing or a painting. He exposes/creates a symbolic relation the like of which has hitherto not been known. And [what happens] when a woman artist orients questions in/of/from the feminine toward an Other-woman and realises/incarnates "woman" in writing or in painting?[20]

That would involve, according to Julia Kristeva, "dealing with her own mother, and therefore with herself, which is a lot less funny. That is why there is not a lot of female laughter."[21] Locked into a Hegelian duality between her status as a subject and her status as this constitutive Other and threshold between nature and culture, Woman for Julia Kristeva is limited to the mother or the phallus. She endorses a critical feminist practice, therefore, that sees woman as a non-identity, as an exile from the illusions of identity, dissenting from the culturally allocated and theologically endorsed idealizations built upon an uncritical fantasy of the great and good mother that threatens feminism itself when it fails to take on the tragic vision of subjectivity proffered by psychoanalysis. Kristeva warns feminism above all against religion, against Christianity's virgin mother

secularized into the fiction of an identity called Women. Yet she importantly insists that we have to think the relation between maternity and female creation, analytically, if we are to get beyond this lure. So she puts the issue on the theoretical agenda firmly in relation to the question of artistic creation.

This relation has been poetically posed by Hélène Cixous in her major manifesto for women's writing, "The Laugh of the Medusa," a text that insists that there is a potential for feminine laughter, precisely coming from the open mouth of western phallocentric culture's most monstrous image of the feminine, the petrifying/castrating Gorgon's head, the snake-haired Medusa whose gaze can kill. Condensed and displaced image of the yawning cavity of the female genitals, fetishistically reinforced with a forest of phalloi for pubic hair, the Medusa eroticizes and desolates the visual rapport or relay. Hélène Cixous writes:

> *The Dark Continent [what Freud called female sexuality] is neither dark nor unexplorable.* It is still unexplored only because we've been made to believe that it was too dark to be explorable. And because they want to make us believe that what interests us is the white continent, with its monuments to Lack . . . They rivetted us between two horrifying myths: Medusa and the abyss. That would be enough to set half the world laughing, except it is still going on. . . . Too bad for them if they fall apart on discovering that women aren't men or that the mother does not have one. But isn't this fear convenient for them? Wouldn't the worst, isn't the worst in truth, that women aren't castrated, but they have only to stop listening to the Sirens (for the Sirens were men) for history to change its meaning. You only have to look at the Medusa straight on to see her. And she's not deadly. She's beautiful and she's laughing.[22]

Powerful as this invocation is, moving and inspiring as it is, there is a touch of an idealization of the maternal feminine in this text. The appeal of the text for women, however, lies precisely in the voice it gives to a feminine passion, a desire for the Other-woman, once phantasized but kept by phallocentric culture in the realm of archaic, the monstrous, the inhuman and, the non-humanizing that can only be accessed by an inversion. The monstrous becomes carnivalesque. Perhaps the most famous passage in Cixous's essay concerns *écriture féminine*, women's writing, as a writing in *white ink*, the whiteness being the metaphor for the mother's milk, itself linked with "the first music from the first voice of love which is alive in every woman."[23] Cixous is trying to articulate the sense of the

feminine in woman that comes not as the disillusion of her discovery of lack, but as the loss of a certain maternal-feminine as rhythm, voice, sound, movement, proximity. But Cixous does not allow this vision to collapse into some collective being or fantasy. The purpose of this invocation of the maternal Other is to allow at last each woman artist her singularity.

Both these important writers and their influential texts take us to the threshold of theoretical renovation, but find themselves hinged again to the phallic concept of the mother as lost object, as figure of fantasy and aggression, lodged in the archaic or pre-Oedipal, associated with the lost part-objects: the breast, the gaze, the voice. Bracha Lichtenberg Ettinger's theses radically transform this evident desire to show them our "sexts" and "let the priests [of phallic discourse and society] tremble" before a daring to speak of feminine difference. In order to make this plain, I shall offer a digression into perhaps more familiar aesthetic theory, to a moment in 1926, when the arch-formalist Roger Fry wondered about what art could learn from and teach to psychoanalysis. This will bring us back to Freud himself and his theses on the uncanny, from which Bracha Lichtenberg Ettinger poses her radical theses.

The Aesthetic Emotion: Formalism and the Uncanny

Two contradictory views dominate twentieth-century aesthetics.

a) Art lies outside the Symbolic, defying it with its non-verbal, aesthetic, affective transmissions.
b) Art is now transformed into a conceptual, strategic questioning of meaning, itself becoming the site of philosophy.

Stephen Melville articulates the second, historically pertinent position of art as thought in a recent catalogue of an exhibition, *As Painting*. First, he asks:

What is it that art is thinking across all this? At one level, it's thinking whatever is evidently to be thought – things like who we are, how we are together, what it is to face or turn away from one another, what it is for the gods of nature to have or not have a shape and so on. At another level, it is always thinking (thinking through, finding new articulations for) what it is to think at all: how it is that this activity takes place in the world and is

clothed in its stuff, in sounds and marks and gestures and so on, and so also what kinds of barriers or limits this worldliness imposes on the work of thinking. Over its longest haul, the sustained episode of art takes us from the apparent arbitrariness of language to a recognition of its transparency as pure thought now able to discount or abstract itself from its material envelopment. This entails the notable Hegelian thought that art comes to an end, indeed has come to an end, and does so – has done so – as philosophy.[24]

Building on this Hegelian tradition of art's place within a history of human thought, Melville then argues:

> To persist with art, the making of it or the caring about it, in the wake of Hegel is to take it that there is no need to end the dealing with the materiality of our thought and so equally to take it that there is no place thought comes simply to rest within this materiality. . . . *As Painting* thus explores the terms of visual practice in a field for which language is an ineradicable given; in doing so, it aims at a visuality not so much supplanted by language as possessed of an articulation or thinking internal to it. This would be what it means to speak in terms of a "theoretical practice" or a "theoretical object". Theory would here be less something a critic or a historian brings to the work . . . than something traced in it, and writing would belong to such work as a part of its unfolding, a continuation of its conditions of appearing.[25]

This is not a recipe for conceptual art at all. Indeed there are some clear echoes here of Bracha Lichtenberg Ettinger's position that there is no clear line of demarcation between art and thought, but that in a movement of unfolding that runs from the specific ways in which art "thinks" to the different way language "thinks," we can allow art to contain and generate reflexive meanings that can relay across distinct but co-operative domains.

To consider the first position again, I want to go back to 1926 to find the counter-argument when the British artist and art writer Roger Fry, who had organized in 1911 and 1912 the landmark exhibitions that introduced French modernist art to the British public, lectured to a newly formed group of Freudian psychoanalysts. The lecture provided the occasion for the presentation of Fry's distinctive aesthetic thesis on significant form as a counterpoint to what he feared was crass psychobiographical readings of artworks as reflections of the artist's mind or personality. To this end, he called upon his audience to accept a fundamental division between two types of artist. One is "preoccupied with creating a

fantasy-world in which the fulfilment of wishes is realised. The other is concerned with the contemplation of formal relations."[26] The former can easily confirm psychoanalytical assumptions, since they concern the psyche of the artist, not the effect of art upon a viewing/making subject. Thus Fry proposes a radically autonomous activity that cannot be reduced to what might appear in the early understanding of psychoanalytical theories as a reduction of the impulse to make art to something more primary, such as "sexual instinct." Fry is talking about reading art for its affective effects: something that happens between artwork and its maker or viewer.

> But in art, there is, I think, an affective quality which lies outside that. It is not mere recognition of order and inter-relation: every part, as well as the whole, becomes suffused with an emotional tone. Now, from our definition of this pure beauty, the emotional tone is not due to any recognisable reminiscence or suggestion of emotional experiences of life; I sometimes wonder if it nevertheless does not get its force from arousing some very deep, very vague and immensely generalised reminiscences. It looks as if art had got access to the substratum of all emotional colours of life, to something which underlies all the particular and specialised emotions of actual life.[27]

Indeed Fry here elaborates what could be called a theory of sublimation perfectly in accord with Freud's thinking itself, when he argues that whatever the physiological or even sociological *origin* of an organ or an activity, what is important is what it has become: how it is changed by its passages through various levels and registers. Thus, Fry argues, if you want to understand art, you must study it in its advanced, and most rarefied form, in which the project of modernist art takes precedence over the many other manifestations of aesthetic elements. Thus Fry admits aesthetic components to dress, advertising, and other visual practices including a great deal of art that he does not consider rises to this level of aesthetic dedication. The archaeology of the modern itself becomes significant for this psychoanalytical investigation.

What is the aesthetic? For Fry, it is an emotion, but an emotion purely about *form*. To be more precise, in certain people the recognition of purely formal relations give rise to these specific emotions. Access to these formally induced emotions is often obstructed by the clutter of other kinds of emotion inducing association, memories and responses that can occur in relation to a familiar piece of music, for instance the National Anthem, or to an image of something itself thought of as beautiful. Fry associates

these equally powerful but not purely aesthetic forces with the external world as opposed to the internal, formal relations within the work of art. Fry then proceeds to lay out his case against what he presents as the Freudian view, that the artist seeks some kind of wish fulfilment through his art, creating a fantasy world, a world akin to the dream which appears to make extensive use of symbolism. In such readings of art, Fry perceives the typical tendency to read art for the image that serves as a translator of ideas. Thus Fry makes what might appear as a familiar modernist argument that the true artist or art lover responds not to the *what* of representation but to the *how*, giving examples of the banality of some of Rembrandt's, Cézanne's or Chardin's subjects and the aesthetic profundity of emotion often felt before the materiality of their *paintings* of *signs*, apples or carcasses. Finally, Fry insists that the aesthetic emotion cannot be linked with any forms of psychic motivation because is it pre-eminently objective and disinterested.[28]

None of this is strange to those familiar with the modernist, Kantian position proposed by Roger Fry. It is his apparent relenting in the final paragraphs of his essay that I want to take up here.

> But in art, there is, I think, an affective quality which lies outside that. It is not mere recognition of order and inter-relation: every part, as well as the whole, becomes suffused with an emotional tone. Now, from our definition of this pure beauty, the emotional tone is not due to any recognisable reminiscence or suggestion of emotional experiences of life; I sometimes wonder if it nevertheless does not get its force from arousing *some very deep, very vague and immensely generalised reminiscences*. It looks as if art had got access *to the substratum of all emotional colours of life,* to something, which underlies all the particular and specialised emotions of actual life. It seems to derive an emotional energy from the *very conditions of our existence* by its revelation of an emotional significance in time and space. Or it may be that art really calls up, as it were, *the residual traces left on the spirit by the different emotions of life,* without however recalling the actual experiences, so that we get an echo of the emotion without the limitation and particular direction it had in experience. (19–21)

Thus the arch formalist Fry's critique of a reductive psychoanalytical theory of the image, none the less, admits of a relation between the seemingly extenuated art *form* and the affectivity it can arouse, a relation that depends upon notions of reminiscence, trace and memory that "somehow" link this sophisticated plastic activity with something which "underlies all

the particular and specialised emotions of life." He is virtually admitting to a relation between the affectivity of art and that which lies beyond repression, very deep, that which can only be registered as an echo, residual traces, at the borderlines that post-Lacanian psychoanalysis will finally theorise in a much more sophisticated and sustained way than Fry's musings.

This would link the argument to the key Freudian exploration of aesthetics, that *traverse of* long-lost sights/sites of emotional intensity, shock and even trauma, and recurrence, namely, the uncanny/*das Unheimliche*. Freud stresses the ambivalence in the word itself: *heimlich*, the word for home, meaning familiar becomes das **unheimliche**, indicating that its strangeness derives from what was once familiar, a home of some sort. Freud takes over the definition of the uncanny from Schelling as "something which ought to have remained hidden but has come to light." The uncanny is anxiety associated with the breach of primal repression. *Urverdrängung* is a hypothetical process described by Freud as the first phase of the operation of repression that cannot be known or analysed but is, nonteheles, traceable in its distant, removed, and attentuated effects.

Freud's text on the uncanny posits at least two primary sites of uncanniness. Anxiety marks the return of the primal repressed: that which must be repressed for us to become subjects at all. Hence the threatening nature of the anxiety that can undo us. Freud's first psychoanalytical example of the uncanny is significant:

> It often happens that neurotic men declare that they feel there is something uncanny about the female genital organs. This *unheimlich* place, however, is the entrance to the former *Heim* (Home) of all human beings, to the place where each one of us lived once upon a time and in the beginning. There is a joking saying that "Love is home-sickness;" and whenever a man dreams of a place or a country and says to himself, while he is still dreaming: "this place is familiar to me, I've been here before," we may interpret this place as being his mother's genitals or body.[29]

In his general thesis, as exemplified in the article on the Uncanny by a discussion of Hoffmann's tale of "The Sandman," Freud associates the uncanny with castration anxiety, linking it back to the primal fantasy and the primal scene that form foundational hypotheses for the Freudian system. But we must attend to this first exemplification of the dreams of home and then the casual but theoretically significant statement: "The

state of affairs is different when the uncanny proceeds from repressed infantile complexes, from castration complex, *mutterleibsphantasien*, phantasies of the mother's body";[30] It is Bracha Lichtenberg Ettinger's contention that subsequent repressions in psychoanalytical discourse have silenced these clear references in Freud's text, collapsing the invocations of the psychic significance of the mother's body, what Bracha Lichtenberg Ettinger will name the invisible specificity of feminine sexuality, into the later and distinct structure of castration.

Firstly, we must grasp that " 'Castration', which is a sexual notion even while the 'phallus' is considered neutral, is treated typically as the prototype for *any* separation from the bodily-archaic partial dimension, of any loss and absence that leads to an inscription in the Symbolic, and the intra-uterine fantasies are not referred to in any different way nor do they serve to indicate another function."[31] But is it here that Bracha Lichtenberg Ettinger wants to reveal a certain and critical difference:

> I suggest that while curving the unconscious object into aesthetic mysterious splendour, Freud did *separate* the *castration complex* and the *maternal/womb/intra-uterine complex*. I think that we can clearly separate these two kinds of archaic phantasy complexes . . . and that, when threatening to approach the subject in the Real, both of them become *different kinds* of sources of awe and strangeness, for the same class of "uncanny anxiety," the *Unheimlich*.[32]

Bracha Lichtenberg Ettinger wants to refuse the retroactive folding of what she now names the *matrixial* phantasy into the later castration phantasy, permitting them instead to co-exist, thus allowing us to plot distinctive psychic pathways and strata of subjectivity mounted in the different tracks created by these two phantasy systems.

> This leads, in my view, not only to the analysis of the particularity of what I call, after Freud's *Mutterleibsphantasie*: the *matrixial phantasy (-complex)*, but also to conceive of a different subjectivising stratum – (distinct from the phallic one) that I have called *matrixial*.[33]

The matrixial subjectivising stratum handles the key elements of subjectivisation – namely mastery (sadism), gazing (scopophilia), and curiosity (knowledge-seeking) – differently from the phallic stratum. In addition, because of its specificity, it also includes "*touching, hearing and moving*"

that are, unlike the phallic model, "not connected with particular 'erotogenic areas' or uniquely connected to body orifices."[34] Instead of an apparatus and an imago based upon the body, its zones, and parts, their presence/absence, wholeness/mutilation, we are beginning to imagine a supplementary relational economy precisely not dependent upon the image. The Matrixial proposes subjectivity as co-affectivity, as relational, as encounter and event, that donates meaning to us without ever quite entering the economy of the sign that is built upon the still effective, but not exclusive model of the phallus and castration. By its very character, the Matrixial does not displace, drive out, take over from, master, exclude. It supplements and shifts, causing possibilities within subjectivity simply by challenging the idea of only One signifier determining all meaning for the human subject. In positing such a possibility of supplementary signifiers in an expanded Symbolic, this theory gives a theoretical form to what many artists already sense and even Fry was trying to adumbrate, namely, a sense of a shifting that both recalled and created what, by being forgotten, was never known before, yet appears loaded with some emotional freight that is experienced as a kind of beauty. How can art be creative if it harks back to the subject's past? Because not all of that past finds its filters and signifiers. Artistic practices, however, that disown the service of ideology and fantasy and explore formal, material practices of relational colour, rhythm of mark and spacing, may liberate such "experiences" from their foreclosure, from an inflicted amnesia that denies us knowledge of these dimensions of ourselves. Paradoxically, it is the formalities and materialities of modernism that have opened up the possibility of an aesthetic pathway to these domains.

The thesis of a supplementary dimension of human subjectivity that arises in relation to the phantasies, the inscriptions in the psychic apparatus, of an encounter-event, rather than a sight or vision of mutilation or the play of absence/presence (as in the phantasy of the primal scene or the masculine interpretation of the sight of female external genitals) allows us radically to imagine and thus to think about a feminine sexual difference and its legacies within subjectivity and within aesthetics. The very idea is carefully policed into unthinkability by the challenge it poses to the singular sovereignty of the phallic model, a model that sustains the narcissism of the masculine subject in his possession of all the valuable organs and capacities. The phallic model is built on the binary presence/absence, and constructs the psychic apparatus in relation to cuts, losses and substitutions (fetishism being its best known version).

In terms of the uncanny, there is an important distinction. As Bracha Lichtenberg Ettinger points out, "while the *castration phantasy* is *frightening at the point of emergence of the original experience* before its repression, *the matrixial phantasy* becomes frightening only when the experience is repressed – but it is not frightening at the point of its original emergence." Any return of the repressed is "frightening" because of the disorder to the structuring of subjectivity upon the surfacing of these primal events and experiences. Thus any invocation of the Matrixial dimension is not to be mistaken for idealization of, or sentimentalization of pregnancy and uterine existence. Rigorously psychoanalytical in formulation, we are not talking about phantasies of fusion, symbiosis, nirvana, and thus not about the death drive. The Matrixial stratum concerns the theorization of that trace Freud readily perceived and regularly discovered in his subjects, of a certain kind of phantasy of space, a space that we must strictly understand as always already being a *borderspace* shared by mutually, co-affecting becoming, partial subjects, registering a minimal difference in the most intimate proximity imaginable, gleaning separateness-in jointness in a non-specular situation. Hence we are thinking about a partial subject-partial subject nexus, rather than the subject/object situation theorized as the condition of subjectivity in the phallic model. (To be a subject, the provisional "I" must distinguish between itself and an other who confronts it then as object = means of the gratification of the aims of its drives). This domain is, as others who dare to hypothesize both psychoanalytical and philosophical significance for it, precisely that of colour before light which again relates to the phallic model of situated, defined, separable objects.

In her brilliant feminist re-reading of Merleau-Ponty's essay "The Intertwining – The Chiasm" from *The Visible and the Invisible,* Luce Irigaray opens the field of vision and color to pre-birth dimensions in two passages. I would like to quote from an essay which philosophically insists that we must go back to the pre-discursive experience:

> Perhaps there exists, there is, a *foreseeing* where the maternal is concerned? Something that would make the child believe it is seen before it sees. That the invisible looks at it? And if the mother foresees her child, imagines it, she foresees it also in this sense that the feeling of it within herself is sometimes transformed into vision: a clairvoyance of, and within, the flesh . . . Sight reduces the invisible of things and of the look, their tissue, their clothing of seeing flesh, that nostalgia for a first abode lodged in and on them, which will be twice lost: in the coming to being of the seer and, even more, in the look's becoming vision . . .[35]

Are we pleasured in our relations to art not by seeing it as an object, but by being found in its visual domain? This is how Lacan radically retheorized the gaze as *objet a* in Seminar XI in 1964 when he presented a thesis on the gaze relieved from the Oedipal fantasies of mastery, and imagined a subject situated in a field of vision, longing to be seen, though always disappointed in the impossibility of being beheld by the gaze which was never a point of vision. Bracha Lichtenberg Ettinger elaborates this in relation to painting:

> Since the painter's internal dialogue with the gaze on the screen of phantasm is externalised onto the painting's screen of vision, something of the psychic gaze is always contained within the painting, waiting to affect us. But for Lacan, the viewpoint of the gaze, as *objet a*, is my blind spot, since I cannot see the point from which I am gazed at by the other, or from where I desire to be looked at. Thus when the gaze appears, the subject situates itself in the picture only as a stain. The painter seduces the eye of the viewer and offers it some imaginary food clearly visible in representation, but the viewer is solicited by the painting to lay down his gaze as one lays down one's weapons (Lacan, 1964, 98) . . . The painter's stroke does not originate in an acknowledged decision but concludes as internal unconscious stroke which resembles the move of psychological regression, but contrary to regression, in an act of painting, it creates – in a reversal of the course of time – a gaze, a product that is also a cause to which the painter's actual stroke becomes a *response*.[36]

Then in commentating on what Merleau-Ponty calls the "talisman of colour, this singular virtue of the visible that makes it, held at the end of the gaze, nonetheless more than a correlative of my vision," Luce Irigaray writes:

> Color? . . . That it pours itself out, extends itself, escapes, imposes itself upon me as the reminder of what is most archaic in me, the *fluid*. Through which I (male or female) received life and was enveloped in my prenatal sojourn, by which I was surrounded, clothed, nourished, in another body. Thanks to which I would also see the light, be born, and even see; . . . Color resuscitates in me all of that prior life, the pre-conceptual, pre-objective, pre-subjective, this *ground* of the visible where seeing and seen are not yet distinguished, where they reflect each other without any position having been established between them. Color bathes my gaze . . . Color constitutes a given that escapes from the subjective realm and that still and always immerses the subject in an invisible sojourn of the visible, a sojourn that cannot be mastered.[37]

There are radical and significant differences between this phenomenological argument and the post-Lacanian theses of Bracha Lichtenberg Ettinger, especially in terminologies that do not allow us to imagine the Matrixial dimension in terms of an organ – the womb as a housing, an interior alone – even if translated into the metaphor of a lost home, a space. Bracha Lichtenberg Ettinger is not talking about the pre-conceptual, the pre-objective, the pre-discursive, the pre-subjective based on a kind of phenomenological endorsement of the anatomy of human reproduction that places a "baby" inside a "mother's womb." Although her analyses of painting, vision, and embodiment do themselves draw on Merleau-Ponty,[38] she is following Freud and Lacan in plotting out the double relays upon which their notions of subjectivity are structured. Firstly, all psychoanalysis works backwards, from the most advanced point of sexed speaking subjects to the conditions of emergence and disturbance. This means that far from offering a developmental model, we are dealing with a structural one, layered and revised in constant reworkings of hypothesized potentialities retroactively reformulated as each new stage emerges, and finds itself re-articulated.

The theory of the Matrix is not about the pre-birth sojourn as source but as a long-term, retroactivated structuration. It is about the structural possibilities within subjectivity as encounter resulting from the double inscription of this encounter-event that is the intertwining of feminine sexuality/desire and fantasy because of an event within her person – the becoming mother, the person rendered mother by the encounter with the unknown other, who, in turn is a becoming subject-infant because of the encounter and impact of the becoming mother. This is not about Mother and Child, already phallically positioned as known and desired objects in a phallic relay. It is this complex series of co-affecting events and encounters between becoming Is and unknown non-Is that produce the psychic trace, or are produced as a psychic trace – later when such a psychic tracing apparatus emerges – of a borderspace that itself marks subjectivity, in some of its dimensions, by a primary *severality*. Thus the capacity to be moved by something radically other – like a painting – that subjectivizes me, affects me, that relies however, on that addition of me to its effectivity to become "art" as opposed to stained canvas, or bits of wood, relies upon this already trans-subjective capacity that we must name "of the feminine" since it is a tracing of a psychic potential generated by the invisible sexual specificity of the feminine body.

Put at its briefest, the theory of Matrixial dimension proposes subjectivity from its inception as several, from its beginnings, as a subjectivizing *encounter*. This is utterly distinct from the phallic model which proposes subjectivity only from the moment of severance, the cut, and requires the thetic gap, the distinction between subject and object, staged and incorporated as image in the mirror phase, and the interruption of the signifier.

Psychoanalytically informed aesthetics and uses of psychoanalytical theory in art and art history have so far built only upon the phallic hypothesis that subjectivity is thinkable only after the first cut: birth, and that the mechanisms of separations, while leaving their own hauntings and imaginary traces, are ultimately captured by and retroactively redefined by the all important event of castration complex, which places all subjectivity under the dominion of its signifier, the phallus. Thus film theory above all has worked with theories of fetishism, sadism, and the specular. All of this theory leaves femininity outside the door, except as it is imaged negatively by those phallic mechanisms, requiring us to teach generation after generation of artists and art historians, that sorry as we are it is such a bad story, this is it. Woman doesn't have it. Woman does not exist and does not signify anything: her image as the castrated other serves to keep the whole apparatus in place. The best we can do is play the masquerade and try and avoid the deadliness of permanent melancholia and unresolved mourning.

Bracha Lichtenberg Ettinger's ambitious and challenging readings of the threads that lie ungathered in the texts of Freud and the later teachings of Lacan offer not only the most radical retheorization of femininity to date, but a major contribution to aesthetic theory and to understanding the historic practices of art, especially as they emerged in the modernist project. It is here that her own paintings come into view, as a project that has critically resumed and redefined a place for painting, that has worked with the unharvested legacies of the highest of modernist painting, that has blown open the stalled feminist debate about sexual difference and artistic practices like painting, raising that debate from dire reductivism by the brilliance of the psychoanalytical returning of its elaboration at the theoretical level.

Having studied this *oeuvre* as it has developed through the decade of the 1990s, I want to suggest that it has moved steadily towards the painterly realm of colour and the gesture of its applications in a historic *après-coup*, *nachträglichkeit*, a re-transcription of a preceding moment of the most

intimate intertwining of subjectivity and painting signified by the Abstract Expressionists, notably in the work of Mark Rothko. Bracha Lichtenberg Ettinger shows that size must not be mistaken for scale and thus she recovers the intimacy of the visually perceived touch that allows painting to become an extimate encounter*. This dialogue with a difference – a deconstructive displacement – is leading to the progressive dissipation of the gesture as a mark separate from its ground. In Bracha Lichtenberg Ettinger's recent paintings since 1998, the classic relations of figure/ground, support/image, touch/gaze are so radically shifted as to precipitate us onto a novel aesthetic plane that is, at once, a radically new theoretical space.

A Matrixial aesthetic that founds itself upon a convergence of personal if historically forged necessity and timely theoretical innovation binds this painting to that historic project called and often misrecognized as "feminism." What her art has discovered in and through its own long gestation and creation, in its own routes of wandering, a discovery that has been transplanted to another theoretical terrain as the project of the analyst-theorist Bracha Lichtenberg Ettinger, is a historic breach of the hitherto total hegemony of phallocentrism, even within psychoanalysis and paradoxically within feminism. It is thus of the utmost importance for feminism and reveals at the same time the vital importance of feminist attendance to the potentiality of sexual difference.

The second feminist century has only just begun and our enormous task to challenge millenia-old structures of sexual difference still lies before us. Shall we allow the feminine to expand and realign our cultural imaginations and our social fantasies so that there is both acknowledgement of trauma and a means of imagining a way beyond and after it? Shall we allow a feminine difference that conditions for all of us, men and women alike, a psychic structure of subjectivity itself as encounter, to proffer a new way to think about the endgame of modernity? That is to say, can we use it to rephrase its dread of ambivalence and fear of the stranger, its exile of the other, and to come to terms with the traumas western culture still bears? The unassimilated traumas remain unknown

* Editors' Note: Extimate is not the opposite of intimate. It is the Lacanian term generated to explain those psychic phenomena that defy the inside/outside, self/other boundary and are thus both exterior and intimate at the same time. *Extimité* is connected with Lacan's theory of *objet a*, which is a trace in the psyche of that from which the subject has been cut away, like a negative shadow. It is thus the otherside of the subject, foreign and removed yet encapsulated within the psyche's most fundamental recesses.

and are so often repeated, precisely because that dread was played out on the plane of the social real between 1933 and 1945, opening the way to its recurrence and repetition in the horrors of attempted genocides worldwide with which the twentieth century so violently ended.

Why the work of a painter who is a woman is able to raise the question of the feminine to the potential to realign our aesthetic, but also our political and social imaginations, depends upon the exact convergence of the historical conditions of her painting as a prolonged reflection on a deeply personal and familial trauma of the Jewish experience of modernity with the theorized practice of feminist aesthetic creation mediated via Lacan and Merleau-Ponty. Between the gestural and anguished paintings that repeatedly discovered the figure of death and disaster emerging upon the bleached white desert of Europe's contaminated landscapes, titled chillingly, *After the Reapers*, and the mournful color-ladened tapestries of her latest paintings, the untitled series of 1998–9 and the long sequence from 1993–9 titled *Eurydice*, lies the historic moment during which the Holocaust emerged from decades of cultural forgetting and wilful dissociation finally to occupy the center of major intellectual research and cultural commemoration, what the artist names "la mémoire de l'oubli." The deepest aspects of a critical postmodernity fulfil Theodor Adorno's philosophical projection that we live now in a world that is defined by being not so much post-modern, as "after Auschwitz." In that space of the end of history, with its radical transformation of even our most intimate and singular property, death, we shall remain fixated, unless, beyond our present means of transport by thought, by art, by analysis, we track back towards another futurity. That move may, I suggest, aesthetically and theoretically, have to be "in/of and from the feminine." Might we not find in that encounter the potential for a future in the art of a painting woman who also has at her disposal a means of thinking both art and the psychic processes through her own radical transformations of psychoanalytical theory that she names Matrix and Metramorphosis?

Matrix is an unconscious space of simultaneous emergence and fading of the I and the unknown non I which is neither fused nor rejected. Matrix is based on feminine/prenatal inter-relations and exhibits a shared borderspace in which what I call *differentiation in co-emergence and distance in proximity* are continuously rehoned and reorganised by metramorphosis . . . created by and further creating relations without relating on the borderspace of presence/absence subject/object me and the stranger. In the unconscious

mind, the matrixial borderline dimension, involved in the process of creating feminine desire and meaning both co-exists with and alternates with the phallic dimension.

If the Matrix points to what is not reducible to the one and what does not yearn for the one then this is because it never was One. Its lost objects are partial and multiple; they never had a single value, and they do not stand alone in the Unconscious. It deals with multiplicity and plurality, partiality, asymmetry, alterity, sexual difference, the unknown, encounters of the feminine and prenatal in their passage from the sub-symbolic to the symbolic and processes of transformation of several elements in co-existence and continual retunings at borderlines and limits, and thresholds between partial subjects in co-emergence.[39]

Notes

1 See Fred Orton and Griselda Pollock, "Memories Still to Come," *Avant-Gardes and Partisans Reviewed* (Manchester: Manchester University Press, 1996), pp. i–xi.
2 Bracha Lichtenberg Ettinger, "Transsubjective Transferential Borderspace" in *Doctor–Patient: Memory and Amnesia*, ed. Marketta Seppälä (Porin: Taidemuseum, 1996), p. 68.
3 Sigmund Freud, "Femininity," *New Introductory Lectures on Psychoanalysis* [1933] (London: Pelican Books, 1973), p. 169.
4 Bracha Lichtenberg Ettinger, "The With-In-Visible Screen," *Inside the Visible: An Elliptical Traverse of 20th Century Art in, of, and from the Feminine*, ed. Catherine de Zegher (Boston: MIT Press, 1996), p. 92.
5 Luce Irigaray, *This Sex Which is Not One*, trans. Catherine Porter (Ithaca: Cornell University, 1985).
6 Bracha Lichtenberg Ettinger, "Matrix and Metramorphosis," *Differences* [Trouble in the Archives], vol. 4, no. 3, 1992, pp. 177–8.
7 For a fuller discussion of this concept "in, of, and from the feminine" see my "Inscriptions in the Feminine," in de Zegher, ed., *Inside the Visible*, pp. 67–88.
8 A pictogram is the representation of an originary psychic space (considered closest to the body); Piera Aulagnier, *La Violence de l'Interprétation* (Paris: Presses Universitaires de France, 1975). Translated by Alan Sheridan as *The Violence of Interpretation: From Pictogram to Statement* (London: Brunner-Routledge, 2001).
9 Bracha Lichtenberg Ettinger, "Metramorphic Borderlinks and Matrixial Borderspace," *Rethinking Borders*, ed. John Welchman (Basingstoke: Macmillan Press, 1996), pp. 126–7, 133.

10 Julia Kristeva, *Revolution in Poetic Language,* trans. Margaret Waller (New York: Columbia University Press, 1984), p. 50.

11 Ibid.

12 Pictograms are theorized by Piera Aulagnier cited in Bracha Lichtenberg Ettinger, *The Matrixial Gaze* (Leeds: Feminist Arts and Histories Network Press, 1995), passim. The pictogram is the most archaic form of meaning, based in simple but potent binaries, like on/off, presence/absence, pleasure/displeasure.

12 Kristeva, *Revolution in Poetic Language,* p. 50.

13 Bracha Lichtenberg Ettinger, "Matrix and Metramorphosis," *Differences,* 1992, vol. 4, no. 2, p. 196.

14 Initially this chapter detailed Julia Kristeva's well known theories of the revolution in poetic language, but since this work has been published and widely discussed in major texts, I refer to it only cursorily here. See Julia Kristeva, "Women's Time" and "The System and the Speaking Subject" in *The Kristeva Reader,* ed. Toril Moi (Oxford: Basil Blackwell, 1986), pp. 187–213, and 224–33.

15 Bracha Lichtenberg Ettinger, "Woman-Other-Thing: A Matrixial Touch," in *Matrix-Borderlines* (Oxford: Museum of Modern Art, 1993), p. 11.

16 This is the title of the most recent retrospective exhibition of Bracha Lichtenberg Ettinger, *Art Working 1985–1999,* curated by Piet Cousens and Paul van den Broek (Brussels: Palais des Beaux Arts, 2000), with essays by Brian Massumi, Christine Buci-Glucksmann, and Griselda Pollock.

17 Ettinger. "The With-In-Visible Screen," pp. 92–3.

18 Julia Kristeva, "A New Type of Intellectual: The Dissident," in *The Kristeva Reader,* ed. Toril Moi (Oxford: Basil Blackwell, 1986), pp. 299–300.

19 Ibid., p. 297

20 Ettinger, "The With-In-Visible Screen," p. 110.

21 Ibid., pp. 297–8.

22 Hélène Cixous, "The Laugh of the Medusa," in *New French Feminisms,* ed., Elaine Marks and Isabelle de Courtivron (Brighton: Harvester Press, 1981), p. 255.

23 Ibid., p. 251.

24 Stephen Melville, "Counting/As/Painting" in Philip Armstrong, Laura Lisbon, Stephen Melville *As Painting* (Cambridge, Mass.: MIT Press, 2001), p. 18.

25 Ibid., p. 19.

26 Roger Fry, *Art and Psychoanalysis* (London: Hogarth Press), 1924, p. 4.

27 Ibid., p. 19.

28 Ibid., p. 18.

29 Sigmund Freud, "The Uncanny," [1919] *Art and Literature,* Penguin Freud Library, Vol. 14 (London: Penguin Books, 1985), p. 368.

30 Ibid., p. 371.

31 Ettinger, *The Matrixial Gaze*, p. 7.
32 Ibid.
33 Ibid.
34 Ibid.
35 Luce Irigaray, "The Invisible of the Flesh: A Reading of Merleau-Ponty's *The Visible and the Invisible*, 'The Intertwining – The Chiasm,'" *An Ethics of Sexual Difference,* trans. Carolyn Burke and Gillian Gill (London: The Athlone Press, 1993), pp. 152–3.
36 Bracha Lichtenberg Ettinger, "Matrixial Gaze and Screen: Other than Phallic, Merleau-Ponty and the Late Lacan," *PS*, 1999, vol. 2, no. 1, pp. 12–13.
37 Ibid., p. 156.
38 Ibid., pp. 3–39.
39 Bracha Lichtenberg Ettinger, "Metramorphic Borderlinks and Matrixial Borderspace," *Rethinking Borders*, ed. John Welchman (Basingstoke: Macmillan Press, 1996), pp. 125–6.

What Was Postminimalism?

Stephen Melville

It's become more or less customary to think of 1967 as the year in which Minimalism becomes fully visible or secured as a distinct and crucial move-ment.[1] One of the reasons for this is undoubtedly that this year also sees the publication of Michael Fried's major essay "Art and Objecthood," an essay whose central focus on the specificity of the individual arts con-tinues to be for me an inevitable starting point for any effort to think about recent and contemporary art.

It's perhaps not too surprising that this should also be the time at which a range of work it is tempting to call "postminimalist" starts gaining some distinct visibility. Any decent history – which I have no intention of pro-viding – would certainly take note of Lucy Lippard's crucial critical and curatorial work around, particularly her "Eccentric Abstraction" show of 1966, and it would look also to the Whitney Museum's 1969 "Anti-Illusionism: Procedures/Materials." Further context of this kind – other evidences of the effort of a certain moment to take the measure of itself – might include such shows as "The Art of The Real," and "When Attitudes Become Form." I think what one can quickly take away from this sam-pling is a sense of there being something distinct in the air – I'd say more specifically and strikingly, a sense of there being work to be done – as well as a sense of uncertainty about what that thing, opportunity or demand ("postminimalism," one supposes) is.

The term "postminimalism" has not fared particularly well. While the adjective form survives as a loosely chronological way of picking out a range or even flavor of activity, textbooks and the like tend to reflect a sort of scattering of the substantive form into other labels – "land art" or

"body art" or "performance" or "process art" or "conceptual art" or "installation art." A part of what is at issue here is exactly how we are to name art-like things at a moment when neither style names nor avant-garde movement names seem adequate to the task, and I think this is a serious and interesting question this lecture means in some passing measure to address.

In 1977 Robert Pincus-Witten attempted to give "postminimalism" a strong and specific meaning by gathering together a number of his earlier essays on various artists and writing a general introduction characterizing what bound them together. The artists he included were Vito Acconci, Lynda Benglis, Mel Bochner, Scott Burton, James Collins, Jackie Ferrara, Eva Hesse, Barry Le Va, Bruce Nauman, Lucas Samaras, Richard Serra, Keith Sonnier, and Richard Tuttle. Like any such list, this exerts odd effects for those reading it some twenty years after its creation and something approaching thirty years after the beginning of the history it draws upon. One effect this one may have – it certainly has for me – is to stir the realization that we do – many of us anyway – actually have a sense of a distinctive postminimalism against which we test it. Many of you may have been not exactly surprised but caught slightly offguard by some of these names – some have simply dropped away from the histories we tell, become relatively unfamiliar (James Collins may be like this), some now have other contexts we're likely to think of first (Acconci and Benglis may, in different ways, be like this), and some may seem both familiar and oddly still unplaceable (Lucas Samara might be an example here). Some, surprisingly few, will seem just right, will seem capable of standing for postminimalism if anyone can: in this list, I think these would be above all Eva Hesse and Richard Serra. Some of you, I imagine, may feel the tug of Mel Bochner as well. My guess is that any names beyond those three will feel arguable, either in terms of importance or relevance. I make one more guess about this list: anyone in a position to have these kinds of responses to it will also have been struck, more or less consciously, by the absence of Robert Smithson's name (and, to do justice to Pincus-Witten, he is indeed a prominent figure all across the essays collected, although no single piece is devoted to him). Just as I suggested that Mel Bochner might figure in whatever core sense we do indeed have of a certain postminimalism, so some of you may likewise wonder about the further absence of the admittedly somewhat later Gordon Matta-Clark.

It's enough for me in this essay that one have some sense that there is some core sense to the term postminimalism that has roughly the scope

represented by the names Hesse, Serra, Smithson, and sometimes Bochner and Matta-Clark. It may also for you include some others from Pincus-Witten's list or elsewhere; all I want to do is tap this sense, not settle it.

As I've noted Pincus-Witten does also offer an overall characterization of what binds his artists together. In summary form this is:

> (1) the advent of the "pictorial/sculptural" mode; (2) the emergence of an abstract, information-based epistemology; and (3) its counterpoises, body art, and conceptual theatre.[2]

By "pictorial/sculptural mode" he means to indicate a certain revival of painterly expressiveness outside of painting, something he links quite strongly to feminism. He tends also to refer to the counterpoise of body art and theatre as "ontological." I have a certain amount of trouble with this characterization – partly in the features it chooses but more importantly in the kind of characterization it thinks is called for.

The kind of characterization I will be after is one that might also be called, in a distinctly Hegelian phrase, a "proving" of its object – as when Hegel writes, in the "Introduction" to the *Lectures on Fine Art*,

> Philosophy has to consider an object in its necessity, not merely according to subjective necessity or external ordering, classification, etc.; it has to unfold and prove the object, according to the necessity of its own inner nature. It is only this unfolding that constitutes the scientific element in the treatment of a subject.[3]

This is a difficult demand that nonetheless presides obscurely over both what I will eventually try to say about postminimalism and about the way I feel compelled to approach it. You should not be surprised if I end up arguing also that it is internally linked to the postminimalism I'll be offering.

That said, let me try to draw out at least one more intuition you might share about the fate of the term "postminimalism." It is, roughly, that the term is a kind of midstream, provisional marker of or first draft for what, in the fullness of time, we have come to call "postmodernism." It would thus indeed be a term we have no particular use for or interest in any longer.

This of course will not make much sense if you think, as many clearly do, that postmodernism in the visual arts is essentially a form or consequence of Pop Art, and there's nothing much I can do about that, at least

here. But for others this will be pretty much tantamount to saying that although Pincus-Witten's may be the most sustained and explicit attempt to name and define a discrete postminimalism, much of the interest in the work of the particular artists I've suggested are central to our sense of something specifically postminimalist arises from, perhaps is deeply formed by, the history of the journal *October* and the writers associated with it, Rosalind Krauss above all. I haven't attempted any census of its articles, but I imagine it would be an interesting exercise to track, say, Robert Smithson's appearances within its pages, from the extended two-part essay on *Spiral Jetty* and Thomas Pynchon's *Gravity's Rainbow* in its first two numbers through Craig Owens's "Earth Words" and on into the key discussions of postmodernism driven by Owens and Douglas Crimp. One might also want to weigh one's sense of how things hang together here with how the same things do and do not hang together in *L'informe*, Yve-Alain Bois's and Rosalind Krauss's 1996 show at the Pompidou Centre.[4] In this general context it would be notable about that exhibition both that it sidesteps any engagement with a presumptive postmodernism and that it grants a very substantial role to the work of artists plausibly called postminimalist as crucial elements within the revisionist modernism it attempts to render visible. Work by a cluster of artists very close to what I've offered as constituting the rough core of a postminimalism worth talking about amounts to approximately a quarter of the work shown, and the title, *L'informe* – *Formless* – for all its explicit reference to Georges Bataille, recalls also and inevitably Robert Morris's "Anti-Form," an essay that has much to do with how things were being sorted and resorted in the late sixties.[5]

Looked at from this distance, the yield from considering postminimalism as caught up in the trajectory of what comes to be called postmodernism is indistinct, but also interesting: if it turns out to be not entirely useful to think of postminimalism as a superceded first draft of something coming to recognition in the early '80s, it nonetheless does seem right or promising to see it as a place around which some of what may be at stake in distinguishing the modern and the postmodern effectively turns. This might be a reason to be interested in asking about, trying to characterize or prove, it.

It's probably time to move in closer. Robert Smithson was a notable presence at Cornell University in 1969. It's not particularly easy to lay hold of coherent accounts of what Smithson did at one or another particular place

– what exactly a given work is – and I haven't really tried to find out much about the *Cayuga Salt Mine Project*. The difficulty is built into the activities themselves in ways that scholarly documentation can't really help with that much, so in these pages I'm mostly interested in just wandering, rather casually, through the various things he did there, more or less under this title. I'll do this twice, in somewhat different ways.

First approach: In Ithaca Smithson evidently placed mirrors in various situations and photographed them and also took mirrors and materials, most notably salt, from some of those places, and made a number of gallery pieces out of them, displaying them in company with some of the photographs and related materials. This description, vague as it is, is perhaps already enough to allow us to begin asking what kind of work or activity this might be. Possibly we don't now feel this as a terribly pressing question – we're used to seeing galleries filled pretty much any way the artist wants and we're also used to being asked to appreciate things that cannot be seen at all or that can only be seen for a time or in some special and mostly inaccessible place and so on, and we tend to imagine that there are no general questions worth raising about this variety – but in 1969 it still made sense to ask such a question and it may be that it still does, both of the work we see now and perhaps especially of the work that seems to have made this current situation possible. In 1979 Rosalind Krauss produced what is still one of the best answers to this general question, and in producing it she was thinking not simply of Smithson but of a whole range of artists many of whom were clearly working in close intellectual and sometimes personal relationship to Smithson, which is to say that Krauss's answer to this question probably has some interesting and intimate relation to a view one might offer of postminimalism more generally.

Smithson is clearly one of a number of artists who, beginning in the late '60s, start doing things that happen in the places traditionally reserved to sculpture – off of the wall, on the floor or out of doors, and so on. But what they do there is not obviously sculpture: it makes little use of the techniques, traditional or modern, associated with sculpture, operates with scales and conditions of display foreign to our customary ways of grasping sculpture, and refuses the kinds of unity and relationship to a beholder that seem integral to what we usually mean by sculpture. In some instances, it would be entirely reasonably for a viewer to take them as bits of landscaping or architectural follies of some kind, and although this invites some possibly interesting comparisons, it seems implausible to claim a sudden revival of eighteenth-century interests and appreciations. Rather than try

to force some dubious narrative that would impose a pseudo-historical legitimacy on the material, Krauss is, in effect, content to take it that by about 1970, for whatever reason, it had come to be important to sculpture – its practice and its understanding alike – that it was neither architecture nor landscape. Once one makes this mental shift from looking at sculpture in terms of some set of irreducible features that would constitute its inner core (itself an image that markedly reinforces a certain imagination of sculpture), one will see that what we have become accustomed to call sculpture is simply one of its possibilities, the one keyed as it were to its autonomy, to its being neither architecture nor landscape. But one can imagine – and practice – something that might claim to figure more nearly as both architecture and landscape, just as one might imagine a practice locating itself between what is landscape and what is specifically not-landscape or between architecture and what is, equally specifically, not-architecture. Krauss lays this all out on what she usually refers to as a Klein group, a version of the Aristotelean table of oppositions and contraries that is also known as the semiotic or Greimasian square, and calls the resulting configuration "sculpture in the expanded field." Once we start thinking of sculpture as definable by its relation to an opposition that sets the conditions of its appearance, we see that its possibilities are multiple, structurally delimited, and irreducible to a single set of core properties. In

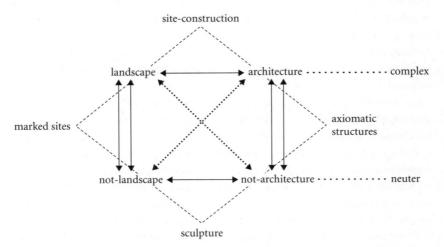

Figure 8.1 Rosalind Krauss's Klein group diagram of sculpture in the expanded field. First published in *October*, 8, Spring, 1979, p. 38.

the mid-seventies "sculpture" names the system in which axiomatic structures, marked sites, site construction, and the things we have always called sculpture are held in tension with one another and constitute a relational but not substantial whole.[6]

Although Krauss insists on this as simply a structural map, a synchronic analysis of the sculptural field at the moment of her writing, it responds well to a certain view of the history of sculpture, and if one asks why sculpture should, just then, find itself in an expanded field, the sensible short answer would be that it had, with the work of David Smith, gone so far toward making itself out of its own exteriority that it had nowhere to go except further out into that outside; Robert Morris's mirrored cubes of 1965 might seem usefully emblematic, and perhaps pivotal, in marking the passage from a sculpture that seemed still open to substantive definition because only tacitly neither architecture nor landscape to a sculpture that was explicitly neither and so obliged to an acknowledgment of its expanded field.

I think there's a lot to like in this account, both on its own terrain and in the implied or assumed history that subtends it. Not all of what I like in it is necessarily what Krauss would highlight, so I'll just run quickly through the features – apart from its general explanatory power – that particularly catch my interest. The first is that the semiotic square is, in effect, a interpretation of what in Hegel would be called "determinate negation," the mainspring of his dialectic, and the second is that something that once would have been called – that in Hegel is still called – "the system of the arts" is brought interestingly into view. And of course I am very much hoping you have already caught how closely this way of addressing sculpture resonates with Hegel's insistence on an "unfolding and proving of the object."

In many ways, it's as if Krauss, writing in the wake of and very much against what is generally seen as the strong, essentially reductive Kantianism of Clement Greenberg and Michael Fried, is finding a way to open up a certain contact with Hegel, thus both finding a way to address certain developments in contemporary art and implicitly fastening those developments to a difficult and crucial moment in the history of modern aesthetics. Looked at this way, the reductive, presumably Kantian, tendency in modern art spills with a certain inevitability over into something very different and to which Hegel would be an important guide. Looking at it another way, one might be tempted to say that the reductive tendency was in fact never quite what it appeared to be, which might lead one to start

noticing neglected threads in the writings of both Greenberg and Fried. Some of these might, finally, lead one to reconsider some of the rough patches in our received narratives: this might prominently include the ways we are accustomed to see minimalism as unfolding primarily in relation to a history of painting, the ways we have tended to understand the activity of David Smith and others as taking place within a certain dominance of painting – what's often put as the "pictorial" nature of such sculpture – as well as the implication of these things in the various pushes and pulls of nostalgia and desire in writings like those of Greenberg and Fried, especially where they border closely on a social thought or imagination that can seem at once crucial and elusive. I hope it's clear that there is a great deal more than might be said here, but it will have to be enough for the moment to simply mark the site.

There's also, of course, a difficulty or nest of difficulties with Krauss's scheme. Everything's very nice and tidy so long as we are content to take it on its own terms, but if we start asking either about what such anchoring terms as "landscape" and "architecture" themselves are – and presumably they too are relational things, caught up in structures like this one – we seem at the least to be looking at something of considerable complexity, and we may suspect that such complexity is not going to be handled adequately by making the diagram itself bigger and somehow multi-dimensional. We may also feel that the historical questions can be held at bay only so long, that sooner or later we're going to have to be able to say something more continuous about how "architecture" and "landscape" find themselves structuring sculpture's field; this is clearly not a permanent condition, and one can assume that the underlying logic cuts a bit deeper than the relatively good fit I suggested between David Smith's work and the expansion of sculpture's field. Michel Foucault, faced with questions of this order, appealed to mutations within the structure of the sign, and worried that in doing so he was merely repeating Hegel behind his own back. We probably inherit these worries if we want to work more fully with Krauss's analysis.

Krauss's own subsequent use of the Klein group follows a rather different track that has its own considerable interest.[7] Having employed it first to make visible the expanded field of one medium, she goes on in later work to use it to illustrate the internal exhaustion of another medium – painting. The structuring terms are significantly different – figure and ground as presumably irreducible dimensions of the visual – and the work of the analysis is to show that what has appeared to us a modernist history,

ground ——————→ figure
field of synchrony *serial repetition*
"visual as such"

imaginary relation *chance*

not ground *missed encounter* automaton
(part objects) *(figures of absence)*
"belong to me"

Figure 8.2 Rosalind Krauss's modification of Lacan's L Schema, in *The Optical Unconscious*, Cambridge and London: MIT Press, 1993, p. 75. Reproduced by permission of The MIT Press.

a certain kind of clarifying progress of painting, is in fact merely the repeated occupation of the various positions within a relational structure. This amounts to a demonstration of the closure of modernist painting, the visual punchline apparently given as the invitation to see a work like Frank Stella's *Hyena Stomp* as nothing more than the map of its own exhausted impulse.

But Krauss wants, I think, something else also out of this visual rhyme or pun,[8] and that is the thought that the diagram itself, in all its transparency, does not escape the conditions it claims to lay bare (it's probably worth noticing the relation between this view of the diagram's work and our standard phrasings of the modernist project). The diagram too is something that shows, and it is no more able to account for its own visibility than the painting whose closure it charts (as if we were now to read the diagram through the Stella rather than the Stella through it). She does this, in ways I won't attempt to go into here, by playing the diagram itself off against a Lacanian account of vision that entails recognizing that the diagram's clarity is the effect of a mirror "hidden" within it and supported elsewhere – the structure of what she then calls "the optical unconscious." The argument here is deeply interesting. Krauss's conduct of it seems to me somewhat uneven (although that may also be an effect of my wanting to push it harder in one particular direction than she wants it to go), and I can only hope I've sketched it well enough for you to have some sense of why the closure of modernist painting does not, in this case, lead toward some new thing one might call postmodern as much as it leads toward an attempt to rewrite the account of modernism in a way

Schema with two mirrors

Figure 8.3 Lacan's Schema with two mirrors. In "The Two Narcissicisms," chapter 10 of *The Seminar of Jacques Lacan*, Book I: Freud's Papers on Technique (1953–1954), ed. Jacques-Alain Miller, trans. John Forrester, Cambridge: Cambridge University Press, 1988, p. 124.

that places its claimed orientation to opticality, to a certain pure visibility, in active relation to the necessarily concealed support on which it none-theless depends. Krauss's immediately subsequent name for this, pushing through Lacan to Bataille, has been *l'informe*, and I've already suggested that work we may be strongly tempted to call postminimalist has a special place in relation to this.[9]

So this first turn through Smithson has, once again, an uneasy yield – a reasonable sense of the conditions under which it makes sense to call his work "sculpture," but also a sense of the embeddedness of those condi-tions in a considerably more complex situation that is harder to get a grip on and that, in effect, raises a bundle of questions about what we have actually gained with this sense. One of these might be – I assume it will be – about the relation between sculpture's occupation of its expanded field and Krauss's exploration of the closure or finitude of modernist painting, both taken as mediums being rethought in difficult adjacency to Hegelian kinds of thought – to determinate negation and the kinds of sense it makes.

Here's a second approach. It begins, like the first, by trying for a use-fully open way of getting some of Smithson's activity in front of us.

In Ithaca, Smithson evidently did some things that while they remained in place were available to be seen, and some of those things can now be borrowed and exhibited elsewhere and some cannot, and of the ones that are gone, there are photographs that have been understood primarily as documentation and have more recently been reunderstood as works on their own, and where some of these photographs exist as slides, they are now treated as original and non-reproducible works of art. Going beyond the *Cayuga Salt Mines Project*, we would certainly want to note that for many of his projects there also exist written reflections or supports, and that writing also appeared as a self-supporting activity of some sort of Smithson. The work was clearly friendly to this proliferation and blurring of its own identity or fixities, and Smithson's understanding of this openness itself seemed to shift over time, so that it became ever more explicitly an actual dimension of the work itself. In Ithaca there were mirrors placed within the abandoned Cayuga Salt mine and photographed there in ways that we will tend to call "documentary" and there were mirrors placed outside in the snow and photographed in ways that seem to merit their showing as something more or other than simple documentation. And in the gallery there were works with titles like "Eight Part Salt Piece" which may or may not still exist in some form – "Eight Part Salt Piece," for example, was reconstructed for a show, also at Cornell, some years later – or "Slant Piece," a 1976 reconstruction of which is owned by Oberlin College. One of the pieces shown in the gallery looks very close to a documented piece made in a nearby quarry (and presumably specific to that site), and both bear a marked resemblance to certain of Smithson's "Non-sites," although neither is directly supported by the cartographic or textual reference characteristic of those pieces, although photographs of the gallery show various photographs and diagrams on the wall that may have carried something of this function. All in all, it's a bit hard to tell what the *Cayuga Salt Mine Project* was or is and what its parts are or were.

Perhaps this just is an adequate description of the piece, a way of glossing Smithson's statement that "I'm using a mirror because the mirror in a sense is both the physical mirror and the reflection: the mirror as concept and abstraction; then the mirror as a fact within the mirror concept . . . Here the site/nonsite becomes encompassed by mirror as a concept – mirroring, the mirror being a dialectic."[10] Smithson had earlier described the site/nonsite works as "dialectical"; it was clearly a favorite word with him, which is far from saying that its sense was clear to him apart from the works he could apply it to. I take him as saying roughly that what once

had appeared to him dialectical – the relation of site and non-site, the referring of a gallery piece to an external site that is in some sense its source but which also is the site it is only because it is picked out by the nonsite in the gallery – all this now appears to him too simply built out of external relationships, so that the use of the physical mirror within the nonsite makes the displacement on which the earlier work turned answerable to a division within the nonsite itself.[11] While the piece may still register as a nonsite, the mirror subsumes that earlier moment under a tighter dialectic organized by the very idea of a reflection that is not, or is not entirely, a self-reflection. But of course the mirrors photographed in the salt mine and now appearing on the gallery wall are already extending and revising that dialectic still further, offering to subsume the mirror under the photograph just as the mirror subsumed the nonsite. The *Incidents of Mirror Travel in the Yucatan* takes this thinking as far as Smithson ever will: A car full of texts, notably including John Stephen's 1843 *Incidents of Travel in the Yucatan*, as it were underwrites Smithson's trip to Mexico, where he proceeds to place mirrors at a number of sites, photograph those mirrors in each of their sites, and then take those photographs up into a text, entitled "Incidents of Mirror Travel in the Yucatan," that is, in the end, all there is of the piece, and that understands itself explicitly as the last in a chain of displacements – of nature into mirror, mirrored nature in to photograph, photographed mirror into text, and into text which knows itself to be a displacement also of the initial text or texts that set the whole chain of incident into motion.

Dialectic is indeed a tempting word for this kind of movement; one of Hegel's favorite images of dialectic is of a circular movement in which things return always at a higher level. But Hegel's image is evidently of a spiral vertically oriented, holding itself to an axis running through its constant center, whereas Smithson's flat spirals turn variously in or away from themselves. In *Spiral Jetty* this is visible as its lateral spread, and it is also invisible as the movement that carries the structure of the salt crystals up through the jetty and into the path of the helicopter from which Smithson films it.

Displacement is a better word for what's going on here than dialectic, but seeing its real relation to dialectic is invaluable: one understands for example that this activity of displacement is, like dialectic, profoundly temporal, and one sees also that the time that is thus made internal to the work is, in contrast to dialectic, radically open. The questions we find ourselves having not only about where the work is but when it is – its

peculiar openness to a future built of removals, separations, and recon-structions – is part of what it is made of. Because it takes time as one of its dimensions it makes claims upon the time – say, the history – in which it figures. This would be integral to any capacity it might have to appear on some kind of cusp between modernism and postmodernism. And because it appears there by virtue of the way it takes time as displacement and thus as part of its structure, we cannot imagine this cusp as a marker of any-thing like a stylistic or thematic or formal change, however "deep," that simply happens in time; my word "cusp" is some kind of shorthand for a refiguration of art's time, and this refiguration is linked to the way the work makes itself, at every level, out of relation: it doesn't happen except by happening "as," where the "as" signals always a displacement apart from which the work collapses into nothing in particular – for example, some mirrors that were once in Ithaca or the Yucatan or New York.

And of course I am very much hoping that when you see how these mirrors both operate and are caught up in the work of displacement that is inscribing this "as" within the work, you are seeing also – glimpsing is probably better here – something I probably cannot put adequately into words, certainly not brief words, about what binds Krauss's explorations of painting, on the one hand, and sculpture, on the other, to one another.

This essay has proceeded to a high degree through a sort of marking of scattered sites, and I'm not going to try to pin down everything that is elliptical in it. Certainly one of the markers I've been trying to lay down with some regularity carries the name of Hegel, and to the extent that one sees fundamentally Hegelian forms still determining the way art history imagines change and sequence, periodicity and the possible shapes of its unity, Smithson's work of rewriting dialectic as displacement may well be consequential for one's sense of the limits and possibilities of the discip-line.[12] So I'm probably willing to say that this is an effort of sorts at doing art history in its expanded field. The Hegelian term here would probably be "speculative" (and I'm interested in calling it "objective").

One way of trying to hold these scattered sites in rough view of one another, of Smithson, and of the postminimalism I'm presumably aiming at, would involve thoughts along the following lines: Art is, for Hegel, an object that cannot finally be proved in the sense he insists upon. When one unfolds it fully, it turns out not to be there, becomes something else, gives over to philosophy. We've lately had a sustained revision of this from Arthur Danto, one that makes what one might be tempted to call the

postmodern more simply posthistorical, and the particular attachment of that revision to Pop Art may now seem notable.

Smithson, working on the other side of the complex difference the 1960s have evidently made to artistic theory and practice, seems to engage Hegel much more intimately. It will be hard to put this well in short compass, but much of it comes into relief if we focus on a couple of key Hegelian propositions. The first is that art most nearly proves itself, comes closest to actual autonomy and objectivity, as sculpture – this is both a historical and a systematic claim – and most nearly undoes that claim to autonomy from within as painting – again both a historical and a systematic claim. Painting is the moment of art in which it most fully acknowledges that the world escapes it, and painting's moment of historical primacy – our moment according to Hegel – occurs as a retreat from the claims of sculpture, a retreat that can be usefully thought of as a withdrawal from three-dimensional presence into a two-dimensional practice predicated on the absence, the unavailability to painting, of its own deepest thoughts and aspirations. Because the moment of painting's primacy is the moment of art's finitude and its turning toward its dissolution as philosophy, painting's primacy is itself limited; it knows as a part of its condition, a part of its withdrawal, that it is an art or a medium among other arts or mediums. The moment of its primacy is thus also the moment of the primacy of the dispersion of the arts, a dispersion that we can also think of – that Hegel does think of – as the coming into visibility of a system of the arts. Is it going too far to say – surely this is what I want to say – that Smithson's art knows all this in its bones? That it knows that art is now obliged to prove itself in and as its dispersion, that to be a work of art – to sustain itself in that place – entails a work of displacement that amounts to being responsible for its appearance always in and as a working of system and relation such that the very terms that grant it visibility as sculpture are also the terms that bind it irreducibly to painting?

This would be to say that the question of medium has not been simply set aside in the wake of minimalism, and that taking the effect of minimalism to be a direct giving of quasi-Duchampian permission for whatever is just too easy. In Smithson's work, the question of medium continues to go, as it did for Greenberg and Fried, all the way down. But the condition of that question has been profoundly changed. The work is now bound to assume it without being able to claim any support that would rely on the imagined interior of a self-supporting medium, and without being able to locate itself with reference to some stable system

through which the arts articulate themselves in advance of works that would then simply answer to it. Rather, the work just is the realized responsibility for, say the proving of, these things. And postminimalism would then be the name for the moment of the modernist's work's becoming explicitly responsible not simply for its medium but for what in that medium both divides and exceeds it, opening it to displacement. Because it is that, any general account of postminimalism will not consist in a list of shared features, but will have to pass through and make itself out of some particular body of work, some particular way of construing or reconstruing, taking responsibility for, the play of system and history apart from which nothing happens.

Coda

In 1967, where this paper more or less began, the action in the United States was clearly well away from painting. Having concluded a certain argument, I find myself wanting to add just a few words about some French painting of roughly the same era. Two figures in particular interest me.

The first is Simon Hantaï, a Hungarian who comes to France around 1950, largely under the sponsorship of André Breton and who starts, in the early 1960s, to make paintings by crumpling an unstretched canvas into a sort of large ball, painting the outside, and then stretching up the unfolded result. This simple method has opened, over the past forty years, into an extraordinary body of work, driven by a continuing effort to work through the full sense of this operation, the paintings both repeatedly revising their own understanding of what it is to make a painting of what is unpainted in them and moving into further material understandings of the operations of folding and unfolding – as, for example, their implication in such other practices as knotting and cutting. If there is a presiding master in contemporary French painting, it is undoubtedly Hantaï, who remains far too little known outside France.

In 1998 Simon Hantaï showed a series of works he called *Laissées* – leavings, leftovers, vestiges. These are works cut from a much larger pieces made some ten years earlier through systematic folding, knotting and unfolding, treated (so the story goes) as compost in the interval, and then displaced onto new canvas, stretched up and shown as paintings.

The other figure I want to pause over is Daniel Buren. Now a very prominent figure on the international scene, Buren early on was part of a

short-lived quasi-group that showed – sometimes by notably not showing – under the names of the four artists who constituted it: Buren, Mosset, Parmentier, Toroni. Olivier Mosset, who now lives in the American southwest, continues to show paintings, monochromes for the most part, in New York; Niele Toroni is a regular fixture in shows of conceptual and installation art; and Michel Parmentier, who died in the summer of 2000 – had a difficult and intermittent career of considerable interest and near perfect invisibility. In the cases of both Buren and Parmentier, the awareness of Hantaï is quite strong, although it is more visibly marked in Parmentier's folding pieces than in Buren's work. In 1967 and 1968 it's important to Buren that he paints. The work is extremely straightforward: pieces of printed fabric stretched up as canvases, with one or more of the white – that is, unprinted – stripes painted white. Buren's contribution to the 1971 Guggenheim Biennial was an immense token of painting slicing through – the cut remarked by a further banner hung across the adjacent street – a museum made out of a certain architectural aspiration to sculpture.

The earliest work Buren still takes as his (at least until recently), looked somewhat different from what has become his signature look – the white paint worked more to mask sections of the striped fabric and can thus suggest something of Buren's close relation to the *affichiste* Jacques Villeglé. Looking at Hantaï's work from just about that same time – for example, the series called "Meuns" – one may find one's self thinking a bit about the rather complex ways collage and cut-out, particularly as we find it in late Matisse, can seem to inform both bodies of work. There's obviously a good bit more that could be said about both of these figures, but this will have to do for the moment.[13]

Buren and Hantaï, as well as Parmentier, figured quite strongly in a show Philip Armstrong, Laura Lisbon, and I curated for Ohio State's Wexner Center for the Arts in the spring and summer of 2001. One way to put the goals of that exhibition, called *As Painting: Division and Displacement*, is to say that it attempted to discover in certain stretches of relatively recent American art conditions under which works like these might become newly visible – more particularly, it sought to tie their conditions of visibility to practices that lie outside painting as we normally conceive it.[14]

There's no historical sense in claiming either Buren's or Hantaï's work for "postminimalism," and I have in any case no interest in doing so. But I do want to claim that they figure among the fullest conditions of Smithson's visibility, opening out a system oriented to a certain play of excess and

reserve, relation and dispersion. These works too would be a part of this essay's attempt to prove its object – even as they exceed its terms.

Notes

The first version of this lecture was given at Cornell University in the fall of 1999 as the Ruth Woolsey Findley and William Nichols Findley Lecture. For a variety of reasons, that seemed a particularly appropriate moment to mark a debt both longstanding and continuing by dedicating these remarks to Rosalind Krauss, a dedication I renew here.

In revising these remarks for publication I have tried to undo their original heavy reliance on slides while still marking a strong place for the work itself; I have also tried to maintain a certain open play of "I" and "we" and "you" that I hope will continue to be interesting in the written text.

1 James Meyer has been particularly conscious of the ways in which most of our normal justifications for art historical labels – style, period, or movement – do not quite fit the minimalist case and call for some special accounting. See his *Minimalism: Art and Polemics in the Sixties* (New Haven: Yale University Press, 2001) as well as the edited volume *Minimalism* (London: Phaidon, 2000).

2 Robert Pincus-Witten, *Postminimalism* (New York: Out of London Press, 1977), p. 18.

3 G. W. F. Hegel, *Hegel's Aesthetics: Lectures on Fine Art.* Trans. T. M. Knox (Oxford: Oxford University Press, 1975), vol. I, p. 11.

4 See Yve-Alain Bois and Rosalind Krauss, *Formless: A User's Guide* (New York: Zone Books, 1997).

5 Robert Morris, "Anti-Form," *Artforum* 6, no. 8 (April, 1968).

6 See Rosalind Krauss, "Sculpture in the Expanded Field," in her *The Originality of the Avant-Garde and Other Modernist Myths* (Cambridge, Mass.: The MIT Press, 1985).

7 See Rosalind Krauss, *The Optical Unconscious* (Cambridge, Mass.: The MIT Press, 1993), esp. chs. 1 and 4.

8 Krauss puns similarly with Mary Miss's *Perimeters/Pavillions/Decoys* (1978) in "Sculpture in the Expanded Field." As I hope my remarks on *The Optical Unconscious* make clear, this punning, and the ultimately allegorical tendency it supports, is an integral feature of these essays; it should be seen as closely related to the claims Craig Owens makes for Smithson as well as the salience of notions of allegory in the claims for a specifically postmodern visual art that he eventually advances with Douglas Crimp. It is interesting and not at all irrelevant that Michael Baxandall also develops a pun-driven allegorical

writing for his way of doing art history as "inferential criticism." These prac-
tices make, I suggest, particular sense in relation to the Hegelian assertion
that the history in which art finds (and loses) itself is that of thought.

9 *Formless* now seems to have served as a way for Krauss to return to a trans-
formed version of the question of medium-specificity. See her *"A Voyage on
the North Sea": Art in the Age of the Post-Medium Condition* (London: Thames
& Hudson, 1999) as well as more scattered recent essays on Jackson Pollock,
James Coleman, and William Kentridge.

10 Jack Flam, ed., *Robert Smithson: The Collected Writings* (Berkeley: University
of California Press, 1996), p. 190.

11 Another way to put this would be to say that Smithson is determined that the
"site" element of the "Site/Non-Site" work not be reducible to "context." In
this he is very close to what I take to be one of the essential lessons of Michael
Baxandall's *Patterns of Intention: On the Historical Explanation of Pictures*
(New Haven: Yale University Press, 1985) – that "context" only ever counts,
when it does count, as composition.

12 It would do this in ways that closely parallel the effects of Bataille's mimicries
of Hegelian argument on one's more direct reading of Hegel.

13 See my "Marques – ce qui reste de Hegel, ou Daniel Buren comme peintre,"
in *La Part de l'oeil*, no. 17/18 (2001/2002).

14 See Armstrong, Lisbon, and Melville, *As Painting: Division and Displacement*
(Cambridge, Mass.: The MIT Press, 2001). The present essay attempts to
make good on a promise made in a footnote to my extended essay in that
volume (see fn. 20, p. 26).

Museum as Work in the Age of Technological Display
Reading Heidegger Through Tate Modern

Diarmuid Costello

Introduction: Tate Modern as a Work

What is the relation between works of art, public, and museum at Tate Modern? This is the question I address in what follows through an unorthodox recourse to Martin Heidegger's writings on art and technology: unorthodox, that is, so far as the standard account of the relation, or rather non-relation, between Heidegger's work and modern art goes. My purpose is to trouble the consensus surrounding Heidegger's philosophy of art through focusing on Tate Modern. This will strike those familiar with Heidegger as a highly unlikely example: that it is counter-intuitive will be to my purpose. My reasons for this approach are two-fold: reading Heidegger against the grain should demonstrate the relevance of his thought for contemporary artistic debate – a far from obvious fact – and open up a perspective on Tate Modern as a cultural phenomenon different to any that has emerged since its recent opening. This was accompanied by a near universal enthusiasm from public, press and critics alike, rare for an attempt to present high art to a mass audience. The question, of course, is what we should make of such popularity. Can it really mean contemporary art has

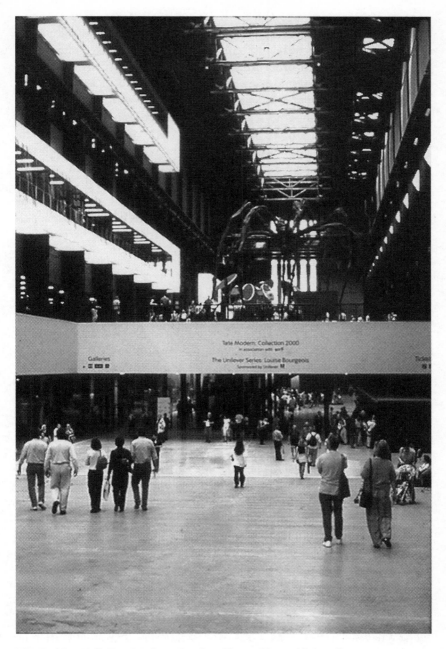

The Turbine Hall, Tate Modern, London. Photo: Diarmuid Costello.

become a subject of interest to the public at large? If not, does it suggest that Tate Modern's apparent popularity is more a matter of the passive consumption of "spectacle" or "culture industry" than a genuine participation in culture? In order to address these issues thrown up by Tate Modern's evident projection towards its public, but in a way that outflanks these rather tired alternatives, I entertain an outlandish proposal: I ask whether Tate Modern itself – by which I mean more than the building – as opposed to any of the individual works that it houses, might qualify as a work of art in Heidegger's distinctive sense. And given that calling something a "work" is for Heidegger a fundamental and an honorific claim, were we to conclude that Tate Modern is a work in his sense – or some modification of it – the depth of its cultural significance would be demonstrated against facile celebrations and dismissals of its popular appeal alike – though the nature of that significance would then be perceived differently.

Heidegger's Conception of the Work of Art

In his philosophy of art Heidegger sets out to contest our basic assumptions about art and "aesthetic experience" – assumptions so basic we are not even aware of them as assumptions – and this makes his account sound odd to the contemporary ear. For example, Heidegger thinks of art more as a kind of event than an object, and of its function as "founding a world," by grounding what will count as truth in that world, rather than as giving pleasure. Given the exegetical difficulties that a view of art opposed to the very idea of aesthetic experience throws up, when encountered from a standpoint that takes it for granted, I will proceed as follows. First I set out what Heidegger says about art, making his claims sound as plausible as possible without trying to reconstruct "fundamental ontology" from the ground up. Then I turn to Tate Modern in the light of that account in order to pose the following question: if Tate Modern "opens a world" in the sense Heidegger intends, then what kind of world is it that Tate Modern opens? More generally: if Tate Modern is a "work" in his sense, then what kind of work does that make it? It should be stated at the outset that such questions, posed here of a modern art gallery, will not engender an especially Heideggerian reading of Heidegger – by which I mean a painstaking exegesis of his own concerns as they emerge in "The Origin of the Work of Art." Nor is it my intention that they should.

What, then, does Heidegger say about art? Fundamental to Heidegger's view of art is his claim that it "opens a world." The idea of "world" has a technical sense in Heidegger's philosophy where it means an horizon of intelligibility. To take an example from *Being and Time*: it is only *within* the world opened by the carpenter's work-shop that the carpenter's tools, materials, and his projects themselves (i.e. what the carpenter does) take on a cohesive, mutually sustaining meaning – despite the fact that the carpenter need not thematize this fact to himself in order to go about his work. Indeed, were he to do so, it would prevent him from getting on with the job at hand. Instead, the world of the workshop is always presupposed as a backdrop, or horizon, of intelligibility that gives whatever is done within it its meaning and purpose.[1] In "The Origin of the Work of Art" the idea of world takes on a more radical significance, as the world of a particular historical-cultural people. Given this, Heidegger can claim that the temple-work opens the world of "the Greeks" in so far as it gives them a sense of themselves as a people by gathering their disparate and unthematized practices and beliefs, and setting them into relief in the world opened by the work *as* their beliefs and practices. Only given this function that the work performs, could the Greeks, or any other historical people, gain a conception of themselves as a people – by having their identity as a culture grounded in the world opened by a work. The temple, as Heidegger puts it: "first gives to things their look and to men their outlook on themselves."[2]

Moreover, the world opened by a truly great, or "epochal," work of art – and it is only such works that Heidegger is concerned with – is discontinuous with the world as it previously existed. This makes such works "origins" in the sense that they inaugurate new and incommensurable worlds. To adopt a vocabulary that is not Heidegger's own: one might understand the transition from one world to another as a kind of paradigm shift or in terms of the incommensurability of competing conceptual schemes.[3] Thus, although Heidegger later came to understand "world disclosure" in a more local and less radical sense of focusing emergent cultural practices – and thereby disclosing what *already* exists, albeit unthematized, anew – according to Heidegger's strongest claims for the stature of art, how we view what is as a whole will depend on the mode in which it is disclosed; a mode determined in eras of great art – i.e. eras unlike our own according to Heidegger – by the world opened by such works. This is what Heidegger means when he claims that with every truly great, or epochal, work of art – of which there will be correspondingly few

– a "thrust enters history" and a new epoch in the "history of Being" is inaugurated. Such epochs are governed by incommensurable ways of relating to everything that is, what Heidegger calls different "modes of disclosure." This can be seen in the transformations in self-understanding that depictions of Christ dying on the cross made possible at the dawn of the middle ages. By allowing Christ to appear as a suffering *human being* such images "opened a world" in which it became possible to conceive of human existence as a life of self-sacrifice and humility in the image of Christ – thereby transforming the Christian way of life and the kind of basic possibilities it offered.[4] This amounts to a transformation of world: it is the sense in which art "discloses" the truth or essence of what is, that is, the truth or essence of what is *for* that epoch, culture or people brought into being, or consolidated by, an epochal work of art.

But this is only half the story. For into this "world" opened by the work, according to Heidegger, the work "sets forth the earth" and that it does is necessary to its existence as a work of art. This is what a work of art does: it is part of what makes a "work of art" a *work* of art. As Heidegger puts it: "*The work lets the earth be an earth.*"[5] What Heidegger means by "earth," however, is more difficult to make clear. The idea has various meanings: from the literality of earth or (native) soil; through the denseness or opacity of matter and materiality in general; to what resists interpretation – but which is set forth *as resistant* – by being thrust into "the Open" of the work. What is clear is that a work of art, unlike an artefact, "sets forth" its materiality in a way that it allows the matter from which it is made to "shine forth" rather than being used up: the most memorable passages in Heidegger's account of the Greek temple describe the way in which it allows the rock from which it is made, and out of which it rises up, to shine forth, setting off the materiality of all that surrounds it, from the valley in which it is set to the sky under which it shelters. These two elements, "world" and "earth," are held in a state of constant tension within the work, where their mutually opposed natures struggle to overpower one another. The "world" opened by the work struggles to illuminate that which resists illumination, i.e. "earth": while "earth" struggles to drag down into its own opacity that which is essentially open, i.e. "world." A work of art not only opens a world and so founds a culture or people, then, but also sets forth the materiality, or earth, on which that world is founded and upon which that people depends. The work thus discloses earth to be the ground of the world: but only in virtue of becoming manifest as such, i.e. as earth, by being illuminated within a world. Their

extreme tension notwithstanding, the two exist in a kind of reciprocity: for only given their opposed natures can each raise the other to the self-assertion of its nature. In the last analysis, it is this "strife" between the two that constitutes art's work in the full sense – its "setting of truth into work."

By this Heidegger means the way in which a work discloses the fundamental nature of what *is* in general – what he calls the "Being of beings as a whole." This will be different for different epochs in the history of Being. In each, what is as a whole will be disclosed anew in a fundamentally different light – which is to say that, in each, what is a whole will *be* different. Hence the strong sense in which a work of art is an "event" for Heidegger is that it is an event of truth. Not truth as we mean it in the everyday sense of correspondence, or lack thereof, between a proposition and a state of affairs in the world; but rather truth as *a-letheia*, the Greek term for "un-concealing" that Heidegger adopts as the basis for his critique of the modern understanding of truth. It is not that the correspondence theory is wrong in any straightforward sense for Heidegger, but that it is derivative. It depends on *aletheia*, but that it does has been "covered over" by the philosophical tradition: it is an impoverished conception of truth. The sense in which a work of art is an occurrence of truth for Heidegger, by contrast, is that by illuminating the "Being of beings as a whole" for a given epoch, the work of art determines *how beings appear* in that epoch. Only once such beings have appeared as the beings that they are, are we able to make true or false claims about them in the everyday sense. But before this becomes possible they first have to be "disclosed," or "un-concealed," in some way by a work.

As must be apparent, this conception of what a work of art is, and what a work of art does, is a far cry from most modern theories of art. This is what makes it sound so counter-intuitive. Hegel, who had a similar view of art's lost foundational role in humanity's self-understanding, and a correspondingly dim view of aesthetics as an understanding of art's place in human existence, is the notable exception here. Indeed, in so far as Heidegger rarely talks about the artist, and never mere spectators, preferring to talk instead of "world," "earth," "Being," "Truth," and what he calls the work's "preservers," his is a theory aimed squarely at any account which understands art primarily as a vehicle for occasioning an aesthetic *experience* on the part of a perceiving subject: any account, that is, which might be held guilty of modern "subjectivism" as Heidegger understands the term. This is because there cannot be works in Heidegger's sense once

human beings understand themselves through the categories of modern subjectivity: there cannot because the modern subject understands its *own* representational activity to be the source of all "disclosure" of the world – thereby robbing art of its distinctive task.[6] This restricts Heidegger's strongest claims for the foundational, or "ontological," role of great art to the premodern period. In our own age, by contrast, our relation to works of art has been reduced to a *merely* aesthetic appreciation: a correlate of modern subjectivism which, if it testifies to anything at all for Heidegger, testifies to our inability to inhabit the truth of great works. If such works continue to exist, Heidegger believes, we have long ceased to hear – let alone respond – to their claim.

That said, the severity of Heidegger's requirements for calling something a "work of art" cuts both ways: and this is the problem for anyone trying to talk about Heidegger in the context of recent art. For if it is true that sheer magnitude of Heidegger's claims for art bar just about everything we would call art today from being taken as "works" in his sense, it is also true that the same fact makes it hard to see to what purpose, other than blanket condemnation, Heidegger's claims for great art can be put in the contemporary context. This is a fact that warrants as much caution in the face of Heidegger's nostalgia for the Greeks as it does scepticism about the achievements of recent art; but it does present a real problem for anyone trying to make Heidegger's account of the work of art *productive* for current artistic debate. Hence the outlandishness from a Heideggerian perspective of entertaining the thought that Tate Modern – nothing if not a product of our impoverished modernity – might be a work in his sense. Nonetheless, that it is such a work – albeit in a modified sense – is what I try to establish in the remainder of this paper. If the argument goes through, it should make certain Heideggerian insights available for debates about contemporary art and, in so doing, hold out the possibility of re-shaping the terms of such debate itself. That said, the project's counter-intuitiveness should not be understated.

Tate Modern as a Public Space

Given the grandiosity of Heidegger's claims for great art, and his pessimism about the fate of art in modernity, what basis is there for claiming that a modern art museum, of all things, might be a work of art in his sense? Unlikely as it seems, there is one, rather banal, fact that counts in the

proposition's favour: that is, the fact that Tate Modern is a building rather than an object. Moreover, given the *kind* of building it is, it opens a space in which something may happen: works of art, and the people who gather to see them, may themselves appear in a particular light. It is a building that opens a "public space", then, in a sense to be defined.

This is not a trivial point. In "The Origin of the Work of Art" Heidegger takes a painting of peasant shoes by Van Gogh and the temple at Paestrum as his examples. The latter is far more persuasive. Not only is a temple better able to meet the requirement of giving a people their sense of themselves; it also sits more comfortably within the anti-subjective framework of Heidegger's philosophy of art – a philosophy from which the artist, in the modern sense of the *particular* consciousness that shapes a given work, is notably absent. Given this, the art historian Meyer Schapiro has not received the credit he is due for pointing out that Heidegger misses something fundamental in the Van Gogh painting – namely, "the artist's presence in the work."[7] This criticism has been dismissed, though not answered, by various commentators, including Derrida, who seem convinced that the art historian has failed to grasp the philosopher's point.[8] But Schapiro's criticism, properly understood, suggests that Heidegger's use of the Van Gogh is ill-conceived. The fact that Van Gogh's paintings are stamped with a *distinctive* view of the world is hard to credibly deny.[9] How else can we make sense of the fact that many viewers are inclined to embrace or reject his *oeuvre*, and the sentiment that informs it, as a whole? What is it, if not this point of view onto the world that emerges from the works, which makes them do so? That Heidegger is opposed to the idea of a worldview, as a corollary of his antipathy for modern subjectivism does not excuse him from having to acknowledge this aspect of modern art. On the contrary, his opposition *requires* that he acknowledge it. Indeed, Heidegger may even be trading off this fact himself when he thematizes Van Gogh's romantic peasant pathos for his own ends whilst allegedly describing what his painting discloses of the peasant world. But it is much more difficult to attribute a subjective point of view to something as foundational as a Greek temple. The product of years, even generations, of anonymous collective labor, a temple, by contrast, obliterates whatever "subjectivity" – if one can still call it this – first brought it into being. This makes the temple a better example for Heidegger's purposes. I shall argue that the same holds true of Tate Modern.

So what is Tate Modern? The number of times it has been described in the press through religious metaphors – not least as a "cathedral of art" –

is striking. But what does this mean? Is it merely a reference to the building's proportions, or does it also imply something more? I believe it expresses, albeit vaguely, the general impression that Tate Modern offers a kind of *ersatz* religious experience for a secular modern audience. This experience, to the extent that it foregrounds the visual, abstracts from both the spiritual dimension proper to the experience of cathedrals, and the more variegated sensory experience afforded by those other "cathedrals" of popular imagination, the great railway stations of the nineteenth century. What remains constant is the building-as-dramatic-container, which figures prominently in all three. I would hardly be the first to note that it is the *building*, rather than the works within it, that is insistently – even aggressively – on display at Tate Modern. The works one encounters on leaving the "cathedral like" expanse of the turbine hall are dwarfed after the building's assertive self-presentation. Nor is this new: the same is true of Rogers' Pompidou Centre in Paris and Gehry's Guggenheim Bilbao; and it is even more true of the proposed waterfront Guggenheim in New York. Nonetheless, it does mark a consolidation of this trend.[10]

What gives Tate Modern such expansiveness is the shell of the converted power station it inhabits.[11] This has been secured by sacrificing a large proportion of its potential exhibition space to the retained vertical thrust of its original turbine hall. This is no small decision. It is spectacular: it might even be thought noble.[12] But given its consequences for the building's capacity as a space for exhibiting works of art it is remarkable that no-one has questioned it. Like the cathedral metaphors this is instructive; the fact that it has not even been raised suggests it is widely perceived that this is not really what is at stake in Tate Modern. So what is? The retention of the original turbine hall, spectacular though it is, suggests that a key goal of this project was to create a landmark building, an imposing structure which would ensure an unforgettable experience for the casual visitor – the visitor who, it is expected, will remember the building far more readily than the art which it houses. This goal has clearly been achieved, and in this respect Tate Modern is in perfect accord with its target audience. It is, as Serota has remarked of Guggenheim Bilbao, "an outstanding success as a 'visitor experience'".[13] But that it seems right to talk of "visitors" to Tate Modern is instructive: it suggests that one visits Tate Modern in much the same state spirit – typically a state of distraction – that one visits any other London attraction.

What is distinctive about the experience provided by Tate Modern, however, are the opportunities it affords its visitors to encounter themselves.

The turbine hall through which they enter functions as a backdrop against which the public encounters itself *as a public*, a public with characteristic ways of navigating the building, viewing the works, even characteristic technological accessories to maximize the yield of their visit. It is notable, for example, that throughout the spaces abutting the turbine hall, visitors are presented with a series of opportunities for spectating upon one another: whether looking up, from the floor of the hall, at the glass fronted corridors and viewing platforms above, or looking down, from these vantages, on the crowd below. This pervasive experience of spectatordom at Tate Modern was thematized and cannily subverted by the first installation of Louis Bourgeois' towers in the hall. These works allowed one visitor at a time to ascend, as if to a special vantage, only to find themselves – specimen-like – on display to other visitors looking down at them from viewing boxes immediately above, a fact reinforced by the huge, distorting mirrors encircling the towers' platforms. It is not surprising that Bourgeois' towers, which were commissioned for the hall, should engage with its space and ethos: but what works in the galleries – how does the public encounter them?

Tate Modern as World-Disclosive

If the scale of the building is the most salient phenomenological feature of Tate Modern, this question draws attention to its most salient ideological feature, the controversial first hang. Not unlike recent departures at The Museum of Modern Art, New York, the curators at Tate Modern have abandoned the chronological hang, in which one movement begets another on what Nicholas Serota, its director, has dubbed the "conveyor belt of history."[14] This has been standard practice for displaying modern art since Alfred Barr introduced it at MOMA in the thirties. In its stead the curators of Tate Modern have resorted to expanded seventeenth-century genres (history, nude, landscape, still life) stretched beyond recognition in order to accommodate the diversity of modern and contemporary art. That this search for an alternative curatorial model should have involved having to go back *behind modernism*, the last cultural efflorescence of the philosophy of history, is instructive: it reveals the extent to which Tate Modern mirrors the general embarrassment of our age in the face of history. This is ironic in so far as this antipathy towards history and all forms of historical explanation is itself clearly amenable to historical explanation.

Serota's *Experience or Interpretation: The Dilemma of Museums of Modern Art* provides an insight into the thinking behind the rejection of history in the case of Tate Modern. Serota depicts the dilemma facing the modern art museum after the demise of the canonical modernist hang as a choice between "interpretation" and "experience." Where the former relies on an interpretative chronology to present a collection to the public, the latter offers visitors a disconnected series of aesthetic experiences through displays of individual artists. In the former, according to Serota, a curatorial interpretation of art and its history takes precedence over the freedom of the visitor's experience of the works, and in the latter vice-versa. Tate Modern opts for a mid-ground between the two, while leaning towards the latter: the historical hang is largely dispensed with, and most rooms feature the work of several artists, often in pairs for maximum rhetorical effect. Like the museums Serota most admires, Tate Modern aspires to *undercut* the opposition itself: neither a domain of official history nor mere personal preference, the curators of such museums seek to elaborate "personal interpretations" through carefully constructed "climatic zones" of experience.[15] The implication is that each of us is thereby empowered to chart our own paths through the collection, rather than deferring to the hidden hand of history.

What is striking about this, given the responses the building has elicited, is that throughout Serota's text "interpretation" is aligned with narrative authority, scholarship, didacticism and encyclopaedic historical instruction, whilst "experience" is aligned with concentration, contemplation and – at its extreme – with reverence, religion, and worship. This suggests that in Serota's vision of the modern museum "experience" implicitly fills the space vacated by religion in the culture at large and, hence, that the numerous invocations of the cathedral metaphor are not without cause. Tate Modern, inside and outside its exhibition spaces then, offers its public a series of carefully orchestrated experiences: in its galleries the works, and in the turbine hall the spectators, are set up in spectacular *mise-en-scènes*. Taken as a totality, Tate Modern presents not so much discrete works of art as the complete museum experience. The resulting spectacle eclipses the role once filled by appeals to history. As a result, Tate Modern can be said to gather, and give concrete expression to, that characteristic sentiment of our age which has manifested itself in various guises such as the "end of history," "the end of ideology," "the end of master-narratives," and the "end of art." The "pluralism of experience" installed in its place at Tate Modern just *is* the historical norm of our day.

It is the norm that history is no longer felt to be binding. Call this our "world," a world reflected back to us in the infinitely rearrangeable building blocks of experience in Serota's museum.

In such a world historically unrelated works are juxtaposed on the basis of "thematic" affinities which are often little more than formal echoes or similarities of subject matter and motif. One obvious problem with this curatorial strategy is that it runs the risk of unwittingly reintroducing a reductive formalism similar to the one it is designed to get away from, the one generally thought to go hand-in-glove with the modernist narrative it rejects. According to this theory what is significant about a work of art is the formal configuration which greets the viewer's eye: this alone is taken to be the source of whatever aesthetic experience the work is able to afford. What visitors to Tate Modern are confronted by, however, risks collapsing into a more reductive formalism still – precisely for being cut loose from any *meaningful* historical context. Thus, despite having little to say about the social context impinging on art, the modernist did have a story to tell about how aesthetic response – if it is to be meaningful – must be saturated with an experience of recent works in its tradition, especially how they succeeded or failed to reconfigure it. That this narrative is no longer *adequate* has long been apparent: but the kind of insights it was able to furnish are ruled out in advance by the new hang at Tate Modern. The question, then, is whether the attitude to history manifested by this hang has anything to put in its place.

It is apparent that the new hang does aspire to a different way of making sense of art's history. To the extent that it does, it is to be welcomed. The way in which works play off one another, for example, implies a different conception of history to that of mere chronology, and is opposed to any suggestion of historical determinism. On this conception, the conjunction between a contemporary and a modern work tries to make the latter available to us: and not necessarily in the pejorative, technological sense this term accrues in Heidegger, but in the sense that we might once again "breath its aura" or "inhabit its truth": conversely, it emphasizes that we are constrained to view the past through the optic of the present. Clearly, this is a more aporetic, Benjaminian conception of history, memory, and experience than that privileged by modernist art history. Nonetheless, if this intention is animating the hang at Tate Modern it remains to be sufficiently thought through. Thus, whatever reservations Serota or his curators may have about narrative and its twin burdens of interpretative decision and control, *some* narrative is necessary – if only to

prevent an under-theorized position sliding backwards into what it claims to be contesting. That is, to prevent a hang that evidently wants to be done with modernism collapsing, as a result of its aversion to history, into a more attenuated formalism than the one it rejects. Hence, although a different sense of history is implied by the new hang, the risks are apparent from the results. That is, a set of discrete ensembles of work designed to trigger aesthetic insight through novel juxtapositions: Andre and Cézanne; Monet and Long; Dumas and Matisse; Collins and Salcedo; Giacometti and Newman, and so on. These juxtapositions are of varying success, and some are more surprising than others, though it is clear that exhibiting art in this way does enliven, for those who *already* know the narrative from which it departs – and so may appreciate its departures *as* departures – the experience of viewing the collection. What it does for those who do not is a moot point. In this respect the non-chronological hang remains dependent upon the chronological hang it rejects for its success.

Moreover, the non-chronological hang cannot but create the impression that Tate Modern's curators believe works of art can be endlessly rearranged and recombined like so many commodities in search of the "striking" juxtaposition without doing violence to their *specificity*, or whatever meaning they hold.[16] Thus, whilst there is evidently *a* rationale for the collection's installation, one wonders whether it would really matter if works were swapped between domains (a question the hang raises internally in so far as some artists' work may be found in more than one domain).[17] In effect, the categories have been made so broad – not landscape, but "landscape/matter/environment" – and the comparisons so fortuitous, in order to accommodate the works' diversity, that an equally compelling rationale could be generated for any number of other possible permutations. This way of dealing with the collection has the effect of turning the museum as a whole into something akin to a Haim Steinbach display writ large: it turns the collection into a *resource* which is as pliable as it is intrinsically meaningless.[18] And this suggests – extremely problematically for my thesis – that if Tate Modern *is* a work in Heidegger's sense, then it is an expression of what Heidegger regards as the prevailing technological metaphysic of the age. This is problematic in so far as this is a metaphysic which is hostile to the very *existence* of art on Heidegger's account. It is a "mode of disclosure" for which everything that is, is constantly "on call," constantly available to yield up its quantum – in this case of experience – on demand. Such a metaphysic is nothing if not an exacerbation of modern subjectivism: it is particularly hostile to what

Heidegger calls "earth," the self-concealing dimension of the work of art. As a characteristic expression of the age, then, Tate Modern appears hostile to a *constitutive* dimension of the work of art as Heidegger understands it. Thus, although the thinking behind the hang may be that works of art are inexhaustible in the kind of "aspects" which may be revealed through inspired juxtaposition, this does little to dispel Heideggerian worries about the implications of trying to "challenge forth" such aspects.[19] On the contrary, such thinking, though predicated upon the correct identification of a fundamental property of works of art, only confirms the charge that this is a "technological" hang in Heidegger's sense. That is, a hang which *does not let the works be.* If this is correct, then how can I possibly appeal to Heidegger for an understanding of Tate Modern as a work?

I turn to this problem in the following section. But first there is a question that must be answered in the light of what we have seen, a question which makes the prospects for conceiving Tate Modern as a work in Heidegger's sense appear even less promising: where does all this leave the visitor to Tate Modern? If Tate Modern "opens a world" in which works of art, cut adrift from history, are presented as elaborately staged occasions for aesthetic experience, what is the visitor to take from their visit? To put it in Heideggerian terms: are these visitors Tate Modern's "preservers"? This looks highly unlikely given that Heidegger adopts this term in order to get away from the very idea of aesthetic experience and the connotations of feeling, sensuous apprehension and subjective experience that accompany it. More public than private, the work's "preservers" are those who live in the world it opens, those who inhabit, and thereby preserve, its truth. A "preserver" is someone whose relation to the work is more cognitive than affective, someone for whom "beauty" – if the notion figures at all – is a way in which truth occurs as unconcealedness, a way in which beings or, what is as a whole, comes into the light of its Being. Given, moreover, that a work is an "origin," a way in which the Being of beings is disclosed anew, a way in which, as Heidegger puts it, "accustomed ties to world and earth are transformed,"[20] the preserver of the work is that person for whom what is as a whole appears in a fundamentally new light in the world opened by the work. Rather than reducing people to their private experiences, then, "preserving" a work brings its true recipients, according to Heidegger, "into affiliation with" the truth occurring within it.[21] Preservers, then, are those people whose destiny a work founds and towards whom it is projected. Given everything I have said about Tate Modern, it is difficult to conceive of its visitors'

relation to it in this light. Were we to do so, given the way the work is displayed, particularly the way it is treated as a pliable resource and made to contribute to a larger theatrical experience, we could only conceive of these visitors preserving it as a kind of "spectacle." To the extent that visitors to Tate Modern find their identity as consumers of culture reflected back to them in its emphasis on display and a vague notion of experience, they might be its preservers. In this sense they inhabit the world Tate Modern opens, though it would be difficult to see how that world reveals anything new.

The Transformation of "Earth" in a Technological Age

To endorse this conclusion would be to come down on the Marxist side of the opposition I set out in the introduction this essay. It would be to perceive in Tate Modern nothing but spectacle and culture industry. Yet I suggested at the outset that one merit of entertaining the thought-experiment that Tate Modern might be a work in Heidegger's sense is that this would *undercut* facile celebrations and dismissals of its popularity alike. With this in mind I want to reconsider the idea of "earth" as it relates specifically to Tate Modern. What the interpretation advanced so far is lacking is an account of the how the works on display react to the hang. It says nothing about how the works *resist* their mode of presentation. As works of art they do not simply submit to such presentation: if they did they would not be works of art. That said, it is striking how it is works that manage to internalize the issue of commodification or spectacle within the conditions of their own display, and their viewers' participation in it, that resist it most effectively, and thereby disrupt their viewers' smooth transit through the galleries. This is what turns "visitors" to the *museum* Tate Modern into "preservers" of the *work* Tate Modern, "transforming," as Heidegger would say, their "accustomed ties to world and earth." This resistant potential of the works was obvious in the installation of Louis Bourgeois's towers, but it is also evident in works such as James Coleman's *Charon (MIT project)* or Sam Taylor Wood's *Brontosaurus*, works that cry out for an analysis of the ways in which they self-consciously position their beholders.[22] Works, moreover, that take on board the issue of their own theatricality – and, by implication, that of the museum – in doing so. This suggests that if Tate Modern is a work in Heidegger's sense, and thus brings together the traits of our technological

modernity, it may be the individual works within it that function as its earth: precisely in virtue of resisting the values – primarily the catch all "experience" and the theatrical *mise-en-scène* – to which that display, and the historical world opened by the work, struggles to submit them. Clearly this is not earth as Heidegger would understand it. Given that these works are already the product of human thought and labour, that is, already shot through with world, if these works do function as Tate Modern's earth it suggests that we are doubly removed from it.

Perhaps this is not such a non-Heideggerian conclusion after all. It sits well with Heidegger's views on the annihilation of earth in a technological age of total illumination and suggests that Tate Modern may reflect an aggrandizement of world in our age so massive, and a mediation of earth so total, that it is in the process of turning into something of an entirely different order altogether, something the nature of which is far from clear: a moment of "decision" or, even, "origin" in the history of Being.[23] It may also be that this is what enables us to entertain a thought today that Heidegger himself would never have countenanced and which, for him, would have remained an oxymoron, the possibility of a *technological work of art*. That we can entertain such a possibility today sheds some light on a refrain of Hölderlin's that Heidegger cites at the close of "The Question Concerning Technology": "But where the danger is, grows/The saving power also."[24] It suggests that, in so far as Tate Modern is a product of a technological age which also reveals the nature of that age, it may disclose what that age occludes. It is at once both "danger" and, in virtue of appearing *as* danger, what might "save" us from that danger. As Heidegger puts it: "the truth of Being flashes . . . at the instant . . . when Enframing [his term for the global institution of the technological relation to Being] lights up, in its coming to presence, as the danger, i.e. as the saving power."[25] That is, when the technological mode of disclosure appears *as* the technological mode of disclosure, a potential is released to go beyond such a relation to Being. Only then can a "thrust enter history" and the "danger" become a "saving power." Moreover, construing Tate Modern as a technological work that nonetheless resists a technological understanding of Being conforms to Heidegger's claim that a "decisive confrontation" with the essence of technology could only come from art, since the essence of art is related to that of technology.[26] Like technology, art is a mode of disclosure: unlike technology, art is a mode of disclosure that "sets forth" rather than "sets upon" the earth. Art remains responsive, unlike technology, to what is of the earth; it "lets the earth be an earth" rather

than seeking to dominate it. In the case of Tate Modern this means that although the world (or hang), seeks to illuminate the earth (or works) it must, nonetheless, set forth those works *as* works. That is, as a resistant force within the world of the work as a whole.

The example of Tate Modern also shows that any new and authentic *poesis*, or "bringing forth," must take its bearings from the age out of which it emerges rather than retreating, irrelevantly, behind it. Hence, contrary to the impression that Heidegger's examples and outbursts against modernity may convey, there can be no return to a pre-technological aesthetic. The truly great works of our day will therefore be both thoroughly technological, like Tate Modern, yet nonetheless harbor the potential to resist this element of their own essence. That is, they will exhibit a fundamental strife or rift in the depths of their own nature, just as Heidegger's account of the tension at the heart of the artwork would lead us to expect. Of course this conception of earth is very different from Heidegger's: though this would not seem so strange if Tate Modern really were an origin in a decisive sense. The question that now needs to be addressed is whether it is: that is, whether Tate Modern sets forth this earth, if that is what it is, into the "Open" of the world it opens *anew*. This is to ask whether Tate Modern constitutes an "origin" in Heidegger's sense; that is, the origin of a new relation to the Being of beings as a whole.

Conclusion: Tate Modern as an "Origin"

If Tate Modern constitutes an origin, I have suggested that the world it opens is a world adrift from history in which a vague, and sometimes quasi-religious, notion of experience is at a premium. The fact that this idea remains so ill-defined in all talk about "museum experience" at Tate Modern makes it tempting to consign it, as mere rhetoric, to the ever-expanding realm of spectacle in our culture. On this view Tate Modern would itself be further evidence of the commodification of culture. Though I have reservations about Tate Modern as a museum, I have not endorsed this view here because I am wary of such formulaic condemnations of the integration of culture in a mass society. Conversely, I have also declined to endorse the facile celebrations of that integration which greeted the opening of Tate Modern.[27] This is because the reasoning put forward by both sides misses the potential Tate Modern possesses as a *work* for resisting what it embodies as a *museum*. This is what saves Tate Modern from

being solely an expression of modern subjectivism as Heidegger under-
stands it. *As a work*, though not as a building or a museum, it cannot –
like the Greek Temple – be reduced to any subjective artistic or authorial
intention or vision. As a work, in common with Heidegger's better ex-
amples, it partakes of a generalized anonymity. Not the creation of Giles
Gilbert Scott, the architect of the power station; not the creation of Herzog
and de Meuron, the architects behind its conversion; not the creation of
Serota, the force behind its realization, nor the creation of the curators
responsible for its inaugural displays: *though something created nonetheless.*
It seems more pertinent to describe it as a "gathering" of the age, some-
thing more akin to an event or disclosure of Being than a mere artistic act
on any commonsense understanding of the term.

 So does Tate Modern "open a world" in Heidegger's sense? Clearly not
on the massive scale of the temple in "The Origin of the Work of Art."
Were that the case it would not only have to open a world, but also be
the origin of that world. While it may be true that Tate Modern gathers,
even concretises, the self-understanding of the age, the world it "opens" is
as much a mirror of our age as its ground.[28] In the last analysis, this
is probably also true of the examples – such as the Greek Temple – for
which Heidegger makes his most dramatic claims, suggesting that if Tate
Modern is not a work in the sense that Heidegger's temple is, this is not
because it is deficient when set against Heidegger's example but because,
in the sense Heidegger intends, nothing – other than the grammatical
structure of a language or a categorial framework – *could* open a
world. Thus if Tate Modern is not a work in the foundational sense
Heidegger intends, then neither are his own examples. And this suggests
that Heidegger's own conception of the artwork may need to be rethought.
This is what I have tried to do, in relation to our own historical moment,
with the idea that Tate Modern may be a *technological* work of art. Not a
work as Heidegger would have understood it, but a work in a sense that
builds on his understanding of the term nonetheless. In this way I have
sought to open up an alternative view of Tate Modern's cultural signific-
ance to any that has emerged to date. Tate Modern may not open a world
in the fundamental sense envisaged in "The Origin of the Work of Art."
Nonetheless, in virtue of setting forth a mediated earth into a world that it
gathers or re-focuses, even if it does not "originate" anew, Tate Modern
does not merely *reproduce* its age but, like Heidegger's own examples,
unleashes a *resistant potential* within it. And this demonstrates the relevance
of Heidegger's thought for current artistic debate.

This suggests Tate Modern may qualify as a world in the more modest sense the term carries in *Being and Time*. What we might call an "artworld." But rather than opening such a world I want to suggest an alternative hypothesis: namely, that Tate Modern, along with other *grand projets* such as Guggenheim Bilbao, is not so much an origin as a symptom of its demise – at least in its present form. Why do I say this? Self-consciously grandiose buildings are not necessarily signs of cultural vitality: they may also be seen as symptomatic national, cultural, or even technological, over-statements; that is, monuments designed to stave off, or mask, anachron-ism or impending obsolescence.[29] Whether this is true of Tate Modern, as a "cathedral" to the embodied experience of art in real time and space in an age of digital technology and the world-wide web remains to be seen: though the difficulties film and video work present for its curators and exhibition designers is already apparent. It may be that art is changing in ways that make museums increasingly inadequate vehicles for its dis-semination. The very idea of the "exhibition" as a presentation of *discrete* works of art, may be nearing obsolescence: a thought which, turned around, suggests that the museum or, indeed, the exhibition, is the only kind of *work* of which we are today capable. If this is right it would make Marcel Broodthaers "museum fictions" of the early seventies timely, and perhaps even world-disclosive – a thought which Broodthaer's many inheritors in the increasingly fused worlds of art-making and curating does nothing to dispel. These are highly speculative suggestions: were any of them to prove true it might one day be said of Tate Modern that it opened a world – an artworld – but in an unusual sense. It might be said that it opened the world of the end of art as we currently understand it – enshrining the event of that end in a monument to the individual work and museum in their present forms. It might be said that it heralded the collapse of the museum into the work. Whether this is cause for celebration, it is impos-sible to foretell.

Notes

I would like to thank: Ian Cole of the Museum of Modern Art, Oxford for the invitation to contribute to MOMA2-000 which provided the initial stimulus to write this paper; Murray Fraser in the department of architecture at Oxford Brookes for drawing my attention to the architectural history that informs the paper's conclusion; Dominic Willsdon of the Royal College of Art/Tate Modern for

discussion of a previous draft; and especially Béatrice Han, of the philosophy department at the University of Essex, for comments on early drafts.

1 See M. Heidegger (1962), "The Worldhood of the World" in *Being and Time* (J. Macquarrie and E. Robinson, trans.) (Oxford: Blackwell; original work published 1927), esp. pp. 102–14.
2 See M. Heidegger (1971), "The Origin of the Work of Art" in *Poetry, Language, Thought* (A. Hofstadter, trans.) (New York: Harper & Row), p. 43.
3 For such a reading see H. Dreyfus (1993), "Heidegger on the Connection Between Nihilism, Art, Technology and Politics." In C. Guignon (ed.), *The Cambridge Companion to Heidegger* (pp. 289–316) (Cambridge and New York: Cambridge University Press), esp. pp. 297–301. For a critique of the coherence of conceptual scheme talk in general, see D. Davidson (1984), "On the Very Idea of a Conceptual Scheme" in *Essays on Truth and Interpretation* (Oxford: Clarendon Press).
4 I have taken this example from C. Guignon (1989), "Truth as Disclosure: Art, Language, History." *The Southern Journal of Philosophy*, vol. XXVIII, Supplement, 105–20, p. 112.
5 See "The Origin of the Work of Art," p. 46 (Heidegger's italics).
6 For Heidegger's account of how the world is reduced to a "picture" as a result of this transition see M. Heidegger (1977), "The Age of the World Picture" in *The Question Concerning Technology and Other Essays* (W. Lovitt, trans.) (New York: Harper & Row), esp. pp. 128–34. For Heidegger's account of the rise of aesthetics as a reflection of this transformation in the sphere of art, see M. Heidegger (1991), *Nietzsche: Volumes 1 & 2* (D. F. Krell, trans.) (San Francisco: HarperCollins; original work published 1961), pp. 77–91.
7 See M. Schapiro (1994), "The Still Life as Personal Object: A Note on Heidegger and Van Gogh" and "Further Notes on Heidegger and Van Gogh" in *Theory and Philosophy of Art: Style, Artist, and Society* (New York: George Braziller). See pp. 139–40, and pp. 146–7 respectively.
8 See J. Derrida (1987), "Restitutions" in *The Truth in Painting* (G. Bennington and I. McLeod, trans.) (Chicago and London: University of Chicago Press; original work published 1978), esp. pp. 369–73. Though when Derrida goes on to remark "All these shoes remain there – for he painted many and despite the *pas d'idiome* one would like to pin down the very singular cause of this relentless effort: what was he doing, exactly?" (p. 381) it becomes difficult to see why Derrida is unwilling to grant Schapiro's point – since this remark effectively concedes it. Like Cézanne's apples and Mont Sainte Victoire or Monet's water-lilies, Van Gogh's pursuit of a set of distinctive *motifs* – including the shoes – cannot but beg precisely this question: *why*? A question which, simply in virtue of being provoked, has already implicitly acknowledged, as Schapiro would put it, "the artist's presence in the work."

9 On the topic of a point of view onto the world as a whole emerging from a work of art more generally, see M. Schapiro (1999), "Philosophy and World-view in Painting" in *Worldview in Painting – Art and Society* (New York: George Braziller).

10 In a recent review focusing on Gehry's ongoing collaboration with the Guggenheim, Hal Foster remarks "these museums trump the art: they use its great scale, which was meant to challenge the museum, as a pretext to inflate the museum itself into a gigantic spectacle-space that can swallow any sort of art, let alone any viewer, whole. In short, museums like Bilbao use the breaking-out of post-war art as a license to corral it again, and to overwhelm the viewer as they do so." See H. Foster (2001), "Why all the Hoopla?" *The London Review of Books*, vol. 12, no. 16, August 23, 2001, p. 25. That this process merely perpetuates itself can be seen from Juan Munoz's "Double Bind," which attempts to challenge Tate Modern's theatricality head-on – and in that sense only capitulates to its dominance.

11 The building was designed in 1947 and was semi-operational by 1952; it was not finally completed until 1963.

12 Thus, one of the reasons Hurzog and de Meuron won the competition for converting Bankside power station, is that their proposal respected the structure and fabric of the existing building.

13 See the preface to N. Serota (2000), *Experience or Interpretation: The Dilemma of Museums of Modern Art* (London: Thames & Hudson).

14 Ibid., p. 55. Serota is not alone in his antipathy for modernism. In "Showing the Century," Iwona Blazwick and Frances Morris, the curators responsible for the hang, speak of "rupturing the modernist paradigm" to reveal "not one but many modernities and modernisms": see I. Blazwick and S. Wilson (eds.) (2000), *Tate Modern: The Handbook* (pp. 28–39) (London: Tate Publishing), p. 33. That this hang is motivated by anti-modernist sentiments rather than more pragmatic considerations, such as the collection being too fragmented to tell the canonical modern narrative convincingly, is belied by the fact that Tate Britain has also been rehung in this way despite not suffering the same gaps. In this respect both hangs reflect the prevailing *doxa* of our day just as placidly as their predecessors did theirs. Perhaps this is inevitable.

15 Serota singles out Hallen für Neue Kunst in Schaffhausen, Insel Hombroich at Neuss, and the Museum für Moderne Kunst in Frankfurt for special praise in *Experience or Interpretation*.

16 By a work's "specificity" I mean, in this context, the historical factors relevant to the explanation of its possible meaning. In so far as we can only explain the creation of works of art by appealing to explanations which *could* have had a causal role in their genesis, locating them in a historical context will always be important if we want to understand them in terms their makers'

might have recognized. This is one stated intention of the curators of Tate Modern, though it is clearly incompatible with the way in which the works have been hung. What can we possibly learn about artistic *intention* from looking at Long and Monet together, for example? See "Showing the Century," p. 39. On the issue of historical constraints on interpretation more generally, see M. Baxandall (1985), *Patterns of Intention: On the historical explanation of Pictures* (New Haven, Conn. and London: Yale University Press).

17 The categories are "Landscape/Matter/Environment"; "Still Life/Object/Real Life"; "History/Memory/Society" and "Nude/Action/Body."

18 Steinbach's work consists of surprising, and sometimes bizarre, juxtapositions of commodities set on three-dimensional shelf displays or in specially constructed environments. That the collection is implicitly treated as a resource is apparent from the curators' descriptions of the hang as "flexible," "dynamic," "animated" and so on, and their stated intention to reconfigure it in various ways over the coming years. See "Showing the Century," p. 33 and p. 39. Such remarks are striking in this context because they treat the collection as what Heidegger would call a "standing reserve," an idea that is crucial to his account of how the technological mode of disclosure turns everything into a resource. This way of relating to the world turns it, in Heidegger's phrase, into a giant "gasoline station." The point is not just that it is exploitative, but that nature and, in this case, works of art are made to *stand by*: nature's energy is stored up, it is "on call" to be switched about and converted into whatever form is needed, just as the collection is on call to be endlessly reconfigured and recombined according to the curatorial will. See M. Heidegger (1977), "The Question Concerning Technology" in *The Question Concerning Technology and Other Essays*, pp. 14–17.

19 That the thinking behind Tate Modern's hang may be predicated on something like this idea is encouraged by Serota's praise for Rudi Fuch's use of "couplet" exhibitions at *Documenta 7*. As Serota describes it, this is a way of displaying one artist's work, successively, alongside a range of different artists in order to *bring out* various aspects of that artist's work. See *Experience or Interpretation*, p. 50.

20 See "The Origin of the Work of Art," p. 67.

21 Ibid., p. 68.

22 To my mind, such works' positioning of their spectators invites a revisionist re-reading of Fried's notion of "theatricality" in the light of recent art – concentrating on the way in which such works thematize what Fried calls the "primordial convention" that art is made to be beheld. See M. Fried (1980), *Absorption and Theatricality* (Chicago and London: Chicago University Press) and M. Fried (1998), "An Introduction to my Art Criticism" in *Art and Objecthood* (Chicago and London: Chicago University Press), pp. 40–54.

23 See Heidegger's remarks on a massive quantitative escalation becoming a qualitative transformation at the end of "The Age of the World Picture," pp. 135–6.
24 Heidegger takes these lines from Holderlin's "Patmos." See "The Question Concerning Technology," p. 34. See also M. Heidegger (1977), "The Turning" in *The Question Concerning Technology and Other Essays.*
25 See "The Turning," p. 47.
26 Heidegger discusses their common etymology in the Greek *techné* in "The Question Concerning Technology," pp. 34–5.
27 One dissenting voice from the uncritical eulogies was James Hall's even-handed review in the *TLS*: see J. Hall (2000), "The Age of the Isolated Individual." In *The Times Literary Supplement*, No. 5068, May 19, 2000, 18–19.
28 Though a convincing case could be made that the great railway stations of the nineteenth century, once dubbed "cathedrals of modernity," functioned as works of art in analogous ways to Heidegger's account of the temple.
29 Thus one often encounters a late rush of *grand projets* at the very moment that whatever they celebrate and, ostensibly, consolidate is nearing collapse. The most spectacular railway stations in the world were built in the States whilst Henry Ford was developing the first automobile production lines in Detroit; some of the grandest buildings of the British Empire went up shortly before the beginning of its collapse in India – not to mention the ambitious building programme of Nazi Germany.

Eyes Wide Shut
Some Considerations on Thought and Art

Adrian Rifkin

La spéculation dite intellectuel <<me>> socialise et rassure les autres sur <<mes>> bonnes intentions quant au sens et à la morale. Mais, de mon corps rêvé, elle ne leur propose que ce qu'entretient le spéculum du médecin; une surface désérotisée que <<je>> lui concède dans un clin d'oeil par lequel <<je>> lui fait croire qu'il n'est pas un autre, mais qu'il n'a qu'à regarder comme <<je>> l'aurais fait si <<j>>'étais lui.

D'autre part il existe un regard différent. En effet il suffit que le frayage, la frayeur fassent irruption dans le vu pour que celui-ci cesse d'être simplement rassurant, trompe l'oeil ou initiation à la spéculation, et qu'il devienne – si vous acceptez ce terme – du *spéculaire fascinant*, c'est-à-dire à la fois charmeur et maléfique. Le cinéma nous saisit en ce lieu, précisément. (Julia Kristeva, *La révolte intime*, Paris, 1997, p. 136)[1]

This incipit from Julia Kristeva serves as a guide for what follows. I have taken it from a chapter of one her more recent books, *La révolte intime*, in which she rethinks the relation between psychoanalysis and art and writing, establishing a broad discursive connection between the technicalities of case histories and the wide field of cultural speculation. One thought that I retain from the complexities of this quotation is the notion of an unreliable cohabitation of many of our techniques of analysis with the demands of art, standing as they do asymmetrically towards the unconscious and the body – the explication of the fantasm and the fantasmatic aspects of explication. My quotation is a minimal unit of theoretical discourse

with which to work, – yet this tracing of what we might think of as being art's and theory's tangential and contingent phonemes is at the heart of my procedure. At the end of Stanley Kubrick's *Eyes Wide Shut,* which will be my main object of attention, Alice Harford says to her husbsand Bill that one thing remains to be done – "to fuck." In its starkness, at the conclusion of such a fearfully complex visual and aural discourse, her assertion reminds us of something that comes before language . . . even if it be nothing but a figure invented after it.

The question of art and thought may be considered at a number of levels of definition and position, either through historical sequences of types of thought and art and their specific interactions, or through con-figurations of discourse that put the two terms into question in themselves and through each other – to suggest just two possibilities. In the first case the imbrications of Botticelli's visual forms and neo-platonist philosophy or baroque deformation and counter-reformation spirituality would be classic examples for a discipline of art history. Even so, their construction as exemplar through different understandings of iconology as narrative or as symptom, or via intellectual history and the social/ethnographic ana-lysis of the visual will yield quite different results. Each method offers the other a caution, but more than that, their blurring into each other under-mines any concept of a unitary archive or a singular grounding for the stability of either term – the image or the thinking in and around it. This is to say that comparative and reflexive thought inevitably turns to the non-disciplinary, to the metacritique entrained in the second alternative, to the cacophony of starting points. In effect metacritique in itself engages differance, erasing the boundary between apparent alternatives that may come only to maintain their distinctness when thought of as historically symptomatic.[2] "Art"and "thought"do separate around the absence from our vocabulary of a word like "arting".

Anyway, in the second case, the metacritical, we might turn to such radically different instances as Derrida's *pointure* or Freud's studies of art on the one hand or feminist and queer aesthetic politics on the other, in order to examine the character of displacements between theoretical and political perceptions of art and the complexity of political strategies in their philosophical tangencies and differences with each other *vis-à-vis* the image. While all of these could be mapped onto each other through archaeological, genealogical or textual analyses, they can also be organized around the questions like those arising from the position of art in the subject–object relation.[3]

Art may be a figure for or a conjunctural form of the infinitely complex mediation subject–object, which itself lies at the centre of thinking about thought. The images of the self thinking that represent the difference, say, between Descartes and Locke not only splits the idea of thought for sub-sequent philosophical activity, but also, in its implicit splitting of the arti-culation of eye and hand, suggests divergent modes of the investment of thought in art or in art as being thought. In Descartes we could say that thinking is like a painting:

> And on the same principle, although these general objects, viz. [a body], eyes, a head, hands, and the like, be imaginary, we are nevertheless absolutely necessitated to admit the reality at least of some other objects still more simple and universal than these, of which, just as of certain real colours, all those images of things, whether true and real, or false and fantastic, that are found in our consciousness (*cogitatio*), are formed.[4]

While in Locke it is more like looking at one:

> When the mind turns its view inwards upon itself, and contemplates its own actions, thinking is the first that occurs. In it the mind observes a great variety of modifications, and from thence receives distinct ideas.[5]

Art will thus at times become a metaphor for the subject–object rela-tion – the structure of signs and meanings within a work of art playing out these instabilities and contradictions. Or it may appear as a replacement for it. And it is the teetering between these two that interests me, as in the effect of a *trompe l'oeil* of a "dome" like that of St Ignazio in Rome, which, as it snaps in and out of its twin realities of flaccid, dead paint and ecstatic illusion, is that of mimicking a form for the subject.

Like this painted dome-thing, both flat and concave, the screen and the gaze in the work of Jacques Lacan are concepts that situate art at the center of the subject–object relation, or rather the *relation d'objet* that is the form of the subject in the symbolic, as a making present of its unfixity, ambivalence or unavailability; the model aporia of seeing/being-seen/seeing and the structure of desire without finality.[6] Flipping in and out of subjectification, now here, now fainting away, is an effect of art and a theoretical perception that coexist in the anachronic contingency of the symptom or the uncanny. It is neither a coexistence of rules nor one of historical necessities, but of a chance that gives rise to forms for an archive

of its own possibility – which, of course, includes concepts such as that of "historical necessity."

But to propose this splitting and iteration is, crucially, to insist on a *topology* of the two terms art and thought, rather than a mapping or a historical genealogy or archaeology. So, while we should nonetheless bear in mind that thinking and a thought are not the same, and that the same must go for art and thought in general, we should also for all that resist restricting what can be said in order to get this or other such formulations correct at every breath. There is too much experiment to be done in understanding the coupling of art and thought to risk closure on the grounds of procedural rigour. Rather the questions might best be discovered through a series of parataxes that offer neither a prima facie historical coherence nor a determined logic of relations, but more an intuition lent by art to thought.

Something that thought has realised via art, as it has in the hysterical symptom, concerns the *après coup* or deferred action as a fatal condition of thought itself; and that thought about this thing has no privileges in the matter. This is to say that, for example, in realizing its failure to enact an origin for a work of art, thinking can be warned of its need to distinguish between enigma and mystery in its own unfolding, between what can and cannot be unpicked, and that these may or may not be always the same. Think of John Cage's *Indeterminacy* as a precursor to the theory of differance; listening to his recording teaches the non-concordance of the enunciation, the sound that is its metaphor and accompaniment, the split between the manifest narratives and the structures of performance and the random character of pleasure.[7] In this almost excessively simple, mutual elision of thinking and object, the spun-out tedium in which the punctum figures itself in all its aleatoric singularity, thinking and the work of art can hardly be dis-identified.

Yet, in what way a thought and an art work, or the work of thought and the work of art, might stand in or equal one another is difficult to figure – if only because their relation to the figure, either to figuring or being figured, is not equivalent. No gerundive condition links the noun art with the verb to "think" and its declensions, nor with the noun "thought." Reason can proceed through this knowledge, without mastering its implications and yet being fully awake to them.

Think of a film script in which a spoken fantasy – an imagined sexual relation – becomes an object for its hearer, who not only sees it in their mind's eye but also undertakes its development and begins to act it out;

and that this fantasy then becomes a dream for its original speaker, quite different from the other's coterminous execution of it, even as this other walks the night in search of its projection into a reality that in turn no way resembles it; and that when all of that has been spoken at the moment of waking, then the dream, the daydream and the journey through them can become the nothing that they always were. And, further imagine that this is the moment when reason awakens and art fades . . . having done its work. The *néant* has been touched, reason is restored.

For it is not just the case that the sleep of reason engenders monsters (the title of a single image by Goya or a video of Bill Viola), but that sleep as such engenders monsters; and it is also the case that dreams become monstrous in a new way when they take on the coherence of waking thought; or that thought becomes monstrous when it takes on the sequentiality of the dream; and it is probably right to say that art does not sleep; or that if it is anaesthetized, which is a rather different situation, then such a sleep would have to be given a speculative name – kitsch, perhaps; in which case it does not engender monsters in its sleep, but becomes simply monstrous. But then thought too can be monstrous in the same dream-fulfilment shape of kitsch – race theory is a good enough example. Goya's print is the figure for a thought that had yet to be fully formulated concerning not only the relation between reason and its sleep, but between reason and its finality, which, in Adorno and Horkheimer's sense, is holocaust; and so, at the same time, this figure for the everyday of horror in Goya's time belongs already in its future and its past, as premonition and as trace.

If the image is a symptom, then it's not one in the same way that it was a print. It is a symptom of something that *will have* happened, but only when its visibility as a print shall have been reconfigured by this thing's happening. This is not a complicated way of saying that things take on a new significance with time, but that the *figuring* of a thought topology necessarily undoes the relation of the first and the last, in the way, for example, that J-L Schefer imagines the sacramental blood of the stabbed wafer after the Dracula of Hollywood.[8] Such folding is not a stylistic character of the baroque, but its lesson, and also a representation of the working of art on art in the polylogic substance of what is also not art. Folding in thought is like the half-way time between sleep and reason that is daydreaming, allowing for parataxis as if it were truly a form of reason; and at this point thinking approaches the form of art even in the absence of the gerundive "arting" to link with it.

In the opening sequences of Stanley Kubrick's final film, *Eyes Wide Shut*, of which I have just given one possible summary, very little happens at all. This is difficult to think, as the film is filled with nameable incidents, but any one incident or series of incidents is not quite what happens, nor do they add up to the same as the eventfulness of the film for the viewer. This is something more to do with the temporal stretching of incidents and the oddity of their superposition. The timing of sequences *is* something that happens, and as a process of temporal expansion it has something to do with both the time of the *Sleep of Reason*, coming into its being a symptom for an event that succeeded it, and with the theological speculations on time and the present so famous in Chapter 11 of Augustine's *Confessions*.

Indeed for *Eyes Wide Shut* theological haunting is precisely to the point. So much is it propelled by the sinning of intention that it can be thought of as a critique of cinematic sexuality in itself, or of the very desire for sexuality to be visible in cinema. In this folding, the work of art and work of thought lose their boundaries in a radical, anachronistic particularity of *this* anahistorical schema I am proposing, and *this* film. The orgy scene, a fragment of the night journey that I have already mentioned, is a climax of terrible vacuity, with its counter-rhythmic music to the tableaux of fucking that it deranges and drowns it out. It maps the repetition of the trapped gaze onto the hope of sin, and the will to intend sin that has driven Harford to gatecrash the elaborate masquerade. (Exactly which sin is an open question, for he is perhaps intending lust while committing envy – envy of his wife's imagined adultery.) The film thus elaborates a figuration that produces something like an Adornian critique of the modern subject, the subject of kitsch, but through the hyperbolic insistence on one of its conventional, cinematic figures of spectacular pornography rather than through its negation. If the masking of the faces in the proximity of a dangerous sexual energy reminds of *Don Giovanni* and the redemptive trajectory of the *Magic Flute*, this sustains a certain blankness, the over-loaded emptiness of an exhausted thought that can no longer riposte the kitsch that possesses it with irony.

Negation is sublimed as the refusal of the film's narrative to settle as the viewer's fantasy. Thus, insofar as the orgy revellers are *only* masked to match Harford's own projection – they appear to know each other – their mystery is a tautology. It's something we already know, simply another form of his anxiety manifested in his curious framing in the film's events. And the tautology is at last undone when his rented Venetian mask lies on

a pillow beside his sleeping wife towards the very end of the film. It is now, when the mask hides nothing, that he can tell all – all of the almost nothing that has happened to him, before they get up and go out to the children's Xmas fair, which resembles nothing more or less than the orgy, with its piles of puffy dolls and reddish glow. Negation is desublimated in the weird grammatical exchange between the Harfords, "What shall we *do* (him). . . . I think we should *be* grateful . . . (her)," which offers the couple a new future of being, yet still without a proper sense.

But to return to the opening incidents, they begin to unfold like this. Dr. and Mrs Harford (Bill and Alice) get dressed to go out to a party, go to the party, have some conversations, dance, flirt and then go home and have sex. During the party, while she is dancing with the sexually pressing Hungarian, he is upstairs in a luxurious bathroom, bringing round from near death a drugged young woman, "plaything"of his host. If something does happen here it is that neither the exact, real-time sequences of the film, nor the imagined elapsed time of the characters quite add up. In the time that she has taken to go to the lavatory before meeting her husband at the bar, both have entered encounters of an uncannily concordant duration, during which we observe them for differing numbers of min-utes; during which the Hungarian talks about taking her upstairs for sex in the sculpture gallery; and he, Harford, does go upstairs, leaving behind one scene of a sexual offer from two young women to another scene of a sexual undoing or aftermath. When the couple come together again, neither of these incidents is required by what immediately follows, and it is in this lack of immediate consequence that the sense of nothing lies, in the unsameness of the Harford's experience of the present.

The next day they get up, he goes to work and examines patients, chil-dren and young women, while she dresses herself in our full view. Her day is cut against his attention to his part-dressed patients, and she also keeps company of their daughter. If anything has begun to happen here, it is the unhinging, or, we could say, de-liaison of the woman's body as a sign from the sign as a woman's body, and the slight unsettling of this slippage itself on the axis of the sexual and the medical. The body of last night's young woman, naked in a deep armchair, it's upper thighs squeezed together, knees and feet splayed out and twisted in, haunts those of his clients who, like her, are waiting for a judgment of death or life. And just as she is accompanied by a rapidly tracked painting of a nude lying on a couch, half-seen through a glass screen in a multiple framing around and beyond the canvas, the paintings in the Harford's apartment and in his

office, ever hovering behind his movements, open up this duplicity of the signifying flesh in representation onto a radical uncertainty of representation itself, be it of flesh or that of flowers or landscapes. What representation offers is disjointed, banalized, made kitsch. Or, the investment is in the slippage, in the negation of significance: you might say it is in *signifiance* as meaning's elision, the founding chora's symptom as the sign for nothing's rich potential to transmit desire: the moment before the dome flips up.

Throughout *Eyes Wide Shut* the picture frame, the mirror frame, the framing of a doorway, or the horizontal of a shelf at a right angle to a door, the framing of a mortuary basin, a ceiling light or fibre panel, form a containing or an excluding angle to almost every shot of Harford's head or full-length body. These framings or exclusions, that sometimes take on the flattened and barely stated vertigo of Ingres' seated *Mme Moitessier*, are a form of the narrative's excess, objects that cannot be invested to make it mean one thing or another, but are, at the same time its condition. They are insistent in the film's opening shots (she being more closely associated with drapes), and they dissolve only in its final shot, when, in the muddled kitsch of the Xmas mall, both actors' heads are finally framed by the screen itself.[9]

But here I am getting ahead of myself and I should return to my exposition of the film's opening sections. Before projection becomes whole in this closing moment, the film has five other short passages of plenitude that arise out of Harford's introjection of his wife's fantasy. On the day after the party, then, he comes home after work, there are more framings and shots of Xmas decorations, and the couple then relax. But they have a bitter dispute, driven by the unwinding effect of cannabis. Here the aftermath of the temporal splitting at the party begins to have an effect as she asks him if he had sex with the two girls who flirted with him. The question is curious, blunt, yet fantasmatically indifferent. But then, in defiance of his amazement at the question on the grounds of his unique affection for her – that exactly mirrors her refusal of the Hungarian's offer – she recounts her own passage of hunger for a naval officer who had glanced at her in a Cape Cod hotel on their last summer's holiday. In Hollywood terms this is hardly a major infidelity; at the very worst it's something to confess and to forget before it becomes a sin. As she says all this, drunk, drugged, sobbing, laughing, she shifts uneasily between seated and kneeling positions, alternatively framed by the patterned curtains and an antique cabinet, while he is uniquely framed by their bed. But still nothing much

is happening. Or rather, what is happening, which is nothing as positivity, is a falling into *objet*-ness of the relations between this nothing's constitutive elements.

The split time in the party that we have felt, and that they, the Harfords, have not, is now about to be filled out. Called out to comfort the daughter of a client who has just died, Harford begins to see his wife and the officer having sex together. Her confession becomes a sin acted out by him in his daydream. His vision takes the form of a black and white porn film that fills the whole screen for a few seconds, now and on four following occasions, either in the street, in cars or in his office. A filmic narrative has started up at last, one with a conventional and predictable diegetic structure from foreplay to orgasmic closure – and one that represents the fantasmatic force of cinema itself. Shortly the dead client's daughter will declare her love for Harford and kiss him on the mouth, at which point too both heads will be framed by the screen; and here too the naked or half-clothed bodies, Alice, drugged beauty, nude painting, patients, etc. resonate in the cacophony of their indistinctness. But here I have said "also" as if this scene happened after the final shot. But this in turn points to the difficulty of thinking where the film *does* start, if its cinematicity or its own openness to cinematic figuration really begins with Harford's vision, the first figure of projection that it displays.

I should now say that the film is indeed my means of thinking Saint Ignazio's dome, or finding a figure for the friable distinctions of art and thought in the absence of that impossible but desired gerundive. The nothing of the film is the provision of materials for an eventual cathexis only after the empty space between them has excited the need for fantasy. Harford's invention of his wife's infidelity is the birth of narrative, the moment we ourselves sit in the cinema and the lights go down, but 36 minutes or so too late. It is a thought about art and a meeting of our need for it.

In her remarkable discussion of Giotto's colour Julia Kristeva offers us some directions about how to think our place in such a work of art.[10] Drawing on Freud's distinction between the "presentation of the *word* and the presentation of the *thing*" she argues that "This hypercathexis of thing-presentations by word-presentations permit the former to become conscious, something they could never do without this hypercathexis . . ." as, to summarise Freud, thought is "so remote from original perception" that, to become conscious, it must "be reinforced by new qualities." It is then within the "triple register" of a "pressure marking an outside, another

linked to the body proper and a sign (signifier and primary processes)." that Kristeva will discern the forces that invest the "artistic function."

Kristeva is concerned essentially with the complex libidinal and signifying economy of colour, in such a way that Giotto's blue is understood to fulfil this "artistic function" as the excess of the artwork's manifest necessities. Here I want to adapt her analysis analogically to approach the strange procedures of *Eyes Wide Shut*.[11] My concern is not now with colour itself, though in the paintings, the drapes, the densely elaborate lighting effects of Xmas trees and festive decorations as well as the blue light that often penetrates interior scenes from without, it has been one articulation of Kubrick's discourse. Rather it is with the very modalities of the erotic adventure tale itself and the routine décor of its social world set within conventions of cinematic narrative; that is to say, the *facture* of the film is "withdrawn toward the unconscious."[12]

Effectively my attempt to track the film's movements has already set in place a structure of sequences that have no value in a diegetic movement, but that, in their very lack of original sense, charge what follows them – which is always a fantasmatic replacement for their lack – with the quality of an event that might eventually make them into sense. At the same time there is no intention that the conventional cinematic system be overcome by resort to the distancing techniques of the materialist avant-garde of the 1960s and 1970s, that tended to identify the work of art with thought, but rather by its hyperbolic revelation of its own fantasmatic processes as nothing but screen and nothing but projection. Nothing, as a figure for what happens in the body before the repression of the drives, returns as the dysfunctional series of dysfunctional "events." The impeccable everydayness of the decors of luxury apartments, street life, orgies, coffee-shops or stores, in its very innocence, harbors the uncanny knowledge that the hypercathexis is not indeed directed to the very thing we most immediately think we want. Rather, only at one or two points in the film, what we want of *film* is granted – for example, that two heads be framed by the screen alone – and these moments are rare and fleeting and susceptible to change. The flipping in and out of being-a-subject far more complex than with the "Dome," which, in its ideology, must always work.

When Alice is wakened from her nightmare by Bill on his return from the orgy, he discovers that his fantasy, built on her declaration, has now become her dream of sex with the officer; and that it has developed to his exclusion and disadvantage and her humiliation. Thus excluded he sets off again to charge his already missed encounters with his newly strengthened

envy; he calls the dead client's daughter, he re-visits the prostitute he has already failed to fuck and fails again – she has been diagnosed HIV+, ironically medicalizing his desire; and finally, against his will, he finds out the truth of the orgy, which, indeed, was nothing that he could or should have known. Coming home again, to find his mask beside Alice's sleeping head, he weeps and tells all the nothing he has done. But at what or why does he weep? At this simple parataxis, of one thing beside another; in relief or in fright that there is no relation after all? Driven by the score of hard, single piano notes that both threaten and lead the movement of the scene? Or seeing the simple, surprising weakness of montage at the end of a century of cinema?

Does he weep for us, who, after all, want to cry at movies, the way we so seldom do in National Galleries? Is it before the space between art and thought, between an alibi and an excess? At the precipitous but fragile boundary between the waking state and sleep? Or is the film, simply, and nothing more, like those moments when Augustine bursts into prayer at his frustration in trying to hold on to what it is that is the present, and his thought becomes an art? All these, and more, might be metaphors for the title of this volume.

Notes

Eyes Wide Shut is a film that has achieved immense critical interrogation, to which I will not have the space to address myself here. Some recent works confirm my drift or the generality of my approach, such as: Diane Morel, *"Eyes Wide Shut*, ou l'étrange labyrinthe" (Paris: PUF, 2002; Sergio Bassetti, "La Musica secondo Kubrick" (Lindau: Torino, 2002), pp. 157–72; Barbara Creed, "The Cyberstar: Visual Pleasures at the End of the Unconscious," *Screen*, Vol. 41, No. 1, Spring, 2000. An unavoidable reference for my mode of writing about film is Jacques Rancière's "La fable cinématographique" (Paris: Seuil, 2001).

1 Julia Kristeva, *La révolte intime* (Paris: Fayard, 1997), p. 136. "So called intellectual speculation socialises 'me' and reassures others as to 'my' good intentions in regard to meaning and morality. But, in terms of my dreamed body it only offers them only that which is dealt with by the doctor's speculum; a de-eroticised surface that 'I' give up to him with a wink with which 'I' make him believe that he is not an other, that he has only to look as 'I' would have done were 'I' he.

Otherwise there exists a different look. In effect it is enough that a pushing aside, that fear burst into the seen so that it ceases to be simply reassuring, trompe l'oeil or the beginning of speculation, and that it becomes – if you

will accept this term – a *fascinating mirror-lens*, that is to say at the same time seductive and evil. Cinema precisely holds us in this place."

2 Up to date and innovatory discussion of these questions can be found in much of the most recent work of Georges Didi-Huberman, but see especially *Devant le temps* (Paris: Minuit, 2000).

3 For example, J. Derrida, *La Vérite en peinture* (Paris: Flammarion, 1978), S. Freud, *Leonardo da Vinci* (London: Routledge, 2001), S. Kofman, *L'enfance de l'art. Un interprétation de l'esthétique freudienne* (Paris: Galilée, 1985).

4 R. Descartes, *Second Meditation*, downloaded from the text translated by John Veitch (1901) at http://philos.wright.edu/Descartes/MedE.html, with thanks.

5 J. Locke, *Essay Concerning Human Understanding*, downloaded from the text at http://www.ilt.columbia.edu/publications/locke_understanding.html, with thanks.

6 J. Lacan, *Les Quatre concepts fondamentaux de la psychanalyse, le séminaire livre XI* (Paris: Seuil, 1973) and *La relation d'objet, le séminaire livre IV* (Paris: Seuil, 1994). As with Julia Kristeva, I am working from quite microscopic units of these texts regarding the subjectifying split from the object on the one hand and the subject's position in language on the other.

7 John Cage/David Tudor, Reading/Music, *Indeterminacy* (2 CDs, 1992), Smithsonian/Folkways.

8 Jean Louis Schefer in numerous essays and writings, but especially see *Dracula, le pain et le sang* in *Choses Écrites* (Paris: P. O. L., 1998), pp. 337–63.

9 A visual strucuture of drapes and number of kinds of drape, from draped lights, illuminated bulbs, and Xmas tree decorations to conventional curtains or venetian blinds and cloaks as an articulation of intense differences that are not named, but made present, is another theme of this work – on which I have myself just concentrated on a fragment of elements.

10 Julia Kristeva "Giotto's Joy" in *Calligram*, ed. N. Bryson, 1988.

11 "One might therefore conceive colour as a complex economy effecting the condensation of an excitation moving towards its referent, of a physiologically supported drive and of 'ideological values' germane to a given culture . . . ," Kristeva writes, tracking colour's value as something, in the "constant presence" of this triple register, as "withdrawn toward the unconscious." If this is both despite and on account of its coded uses and banal necessity, "colour . . . escapes censorship; and the unconscious irrupts into a culturally coded pictorial distribution." Ibid., pp. 36–7.

12 For a comparative study of the relations between narrative uncanniness, time and being a subject, that has much inspired me, see Laura Mulvey's fine article on Roberto Rossellini's *Viaggio in Italia*, "Vesuvian Topographies – the eruption of the past in *Journey to Italy*" in *Roberto Rossellini: Magician of the Real*, edited by David Forgacs, Sarah Lutton and Geoffrey Nowell-Smith (London: BFI, 2000).

Bibliography

Books

Allen, J. and Young, I. M. (eds.). (1989). *The Thinking Muse: Feminism and Modern French Philosophy*. Bloomington: Indiana University Press.

Alpers, S. (1983). *The Art of Describing: Dutch Art in the Seventeenth Century*. Chicago: University of Chicago Press.

Armstrong, P., Lisbon, L. and Melville, S. (eds.). (2001). *As Painting: Division and Displacement*. Boston: MIT Press.

Aulagnier, P. (2001). *The Violence of Interpretation: From Pictogram to Statement* (A. Sheridan, trans.). London: Brunner-Routledge (original work published 1975).

Baxandall, M. (1985). *Patterns of Intention: On the Historical Explanation of Pictures*. New Haven and London: Yale University Press.

Belting, H. (1985). *Giovanni Bellini. Pieta. Ikone und Bilderzahlung in der venezianischen Malerei*. Frankfurt/Main: Fischer Taschenbuch.

Berger, M. (1989). *Labyrinths: Robert Morris, Minimalism and the 1960s*. New York: Icon Editions.

Blazwick, I. and Wilson, S. (eds). (2000). *Tate Modern: The Handbook*. London: Tate Publishing.

Bois, Y-A. and Krauss, R. (1997). *Formless: A User's Guide*. New York: Zone Books.

Brand, P. and Pertile, L. (ed.). (1996). *The Cambridge History of Italian Literature*. Cambridge: Cambridge University Press.

Van den Broeck, P. and Cousens, P. (eds.). (2000). *Art Working 1985–1999*. Brussels: Palais des Beaux Arts.

Bibliography compiled by Eleanor Quince.

Cavell, S. (1979). *The World Viewed: Reflections on the Ontology of Film.* Cambridge, Mass.: Harvard University Press.

—— (1979). *The Claim of Reason: Wittgenstein, Skepticism, Morality and Tragedy.* Oxford: Clarendon Press.

—— (1994). *Must We Mean What We Say: A Book of Essays.* Cambridge and New York: Cambridge University Press.

Cheetham, M. A. et al. (eds.). (1998). *The Subjects of Art History.* Cambridge and New York: Cambridge University Press.

Clark, T. J. (1973). *The Image of the People: Gustave Courbet and the 1848 Revolution.* London: Thames and Hudson.

De Courtivron, I. and Marks, E. (eds.). (1981). *New French Feminisms.* Brighton: Harvester Press.

Davidson, D. (1984). *Essays on Truth and Interpretation.* Oxford: Clarendon Press.

Derrida, J. (1987). *The Truth in Painting* (G. Bennington, and I. McLeod, trans.). Chicago and London: University of Chicago Press (original work published 1978).

Descartes (1969). *The Philosophical Works of Descartes* (E. S. Haldane and G. R. T. Ross, trans.). Cambridge: Cambridge University Press.

Edie, J. M. (ed.). (1964). *The Primacy of Perception.* Evaston, Illinois: Northwestern University Press.

Elliott, E. (ed.). (2001). *Aesthetics in a Multicultural Age.* Oxford: Oxford University Press.

Fairclough, H. R. (ed. and trans.). (1966). *Horace, Satires, Epistles and Ars Poetica.* London: Heinemann, Cambridge, Mass.: Harvard University Press.

Faunce, S. and Nochlin, L. (eds.). (1988). *Courbet Reconsidered.* New York: The Brooklyn Museum.

Flam, J. (ed.). (1996). *Robert Smithson: The Collected Writings.* Berkeley: University of California Press.

Foster, H. (1996). *The Return of the Real: The Avant-Garde at the End of the Century.* Cambridge, Mass.: MIT.

Foucault, M. (1977). *Language, Counter Memory, Practice.* (D. Bouchard and S. Simon, trans.). Ithaca: Cornell University Press (original work published 1969).

Frantis, W. (ed.). (1997). *Looking at Seventeenth Century Dutch Art: Realism Reconsidered.* Cambridge: Cambridge University Press.

Freud, S. (1973). *New Introductory Lectures on Psychoanalysis.* London: Pelican Books.

—— (1985). *Penguin Freud Library* (Vol. 14): *Art and Literature.* London: Penguin Books.

Fried, M. (1967). *Art Criticism in the Sixties.* New York: October House.

—— (1980). *Absorption and Theatricality: Painting and Beholder in the Age of Diderot.* Chicago and London: Chicago University Press.

—— (1998). *Art and Objecthood: Essays and Reviews.* Chicago: Chicago University Press.

Fry, R. (1924). *Art and Psychoanalysis*. London: Hogarth Press.

Gaskell, I. and Kemal, S. (eds.). (1991). *The Language of Art History*. Cambridge: Cambridge University Press.

Goffman, E. (1959). *The Presentation of Self in Everyday Life*. Garden City, New York: Doubleday.

Gombrich, E. H. (1966). *Norm and Form: Studies in the art of the Renaissance*. London: Phaidon Press.

Grayson, C. (ed. and trans.). (1972). *L. B. Alberti. On Painting and On Sculpture. The Latin texts of "De pictura" and "De statua."* London: Phiadon Press.

Guignon, C. (ed.). (1993). *The Cambridge Companion to Heidegger*. Cambridge and New York: Cambridge University Press.

Guyer, P. (1979). *The Claims of Taste*. Cambridge, Mass. and London: Harvard University Press.

—— (1993). *Kant and the Experience of Freedom. Essays on Aesthetics and Morality*. Cambridge: Cambridge University Press.

—— (ed.). (2000). *Cambridge Edition of the Works of Immanuel Kant: Critique of the Power of Judgement*. (P. Guyer and E. Matthews, trans.). Cambridge: Cambridge University Press.

Guyer, P. and Cohen, T. (ed.). (1982). *Essays in Kant's Aesthetics*. Chicago and London: Chicago University Press.

Guyer, P. and Wood, A. W. (eds.). (1998). *Cambridge Edition of the Works of Immanuel Kant: Critique of Pure Reason*. (P. Guyer and A. W. Wood, trans.). Cambridge: Cambridge University Press.

Hegel, G. W. F. (1975). *Hegel's Aesthetics: Lectures on Fine Art* (T. M. Knox, trans.). Oxford: Oxford University Press.

Heidegger, M. (1962). *Being and Time* (J. Macquarrie, and E. Robinson, trans.). Oxford and Cambridge, Mass.: Blackwell (original work published 1927).

—— (1971). *Poetry, Language, Thought* (A. Hofstadter, trans.). New York: Harper & Row.

—— (1977). *The Question Concerning Technology and Other Essays* (W. Lovitt, trans.). New York: Harper & Row.

—— (1991). *Nietzsche, Volumes 1 & 2* (D. F. Krell, trans.). San Francisco: HarperCollins (original work published 1961).

Henrich, D. (1992). *Aesthetic Judgement and the Moral Image of the World*. Stanford: Stanford University Press.

Herrick, M. T. (1965). *Italian Tragedy in the Renaissance*. Urbana: University of Illinois Press.

Hope, C. (1980). *Titian*. London: Jupiter Books.

Irigaray, L. (1985). *The Sex Which is Not One* (C. Porter, trans.). Ithaca: Cornell University.

—— (1993). *An Ethics of Sexual Difference* (C. Burke and G. Gill, trans.). London: The Athlone Press.

Jay, M. (1993). *Downcast Eyes: The Denigration of Vision in Twentieth-Century French Thought*. Berkeley, Los Angeles, and London: University of California Press.

Johnson, G. A. (ed.). (1998). *Sculpture and Photography. Envisioning the Third Dimension*. Cambridge and New York: Cambridge University Press.

Johnson, G. A. and Smith, M. B. (eds.). (1993). *The Merleau-Ponty Aesthetics Reader*. Evanston, Illinois: Northwestern University Press.

Jones, A. (1994). *Postmodernism and the En-gendering of Marcel Duchamp*. New York and Cambridge: Cambridge University Press.

—— (ed.). (1998). *Body Art Performing the Subject*. Minneapolis: University of Minnesota.

Jones, A. and Stephenson, A. (eds.). (1999). *Performing the Body/Performing the Text*. London and New York: Routledge Press.

Kant, I. (1988). *Logic* (R. S. Hartman and W. Schwarz, trans.). New York: Dover.

Kant, I. (1987). *Critique of Judgement* (W. S. Pluhar, trans.). Indianapolis: Hackett.

Krauss, R. (1985). *The Originality of the Avant-garde and Other Modernist Myths*. Cambridge, Mass. and London: MIT Press.

—— (1993). *The Optical Unconscious*. Cambridge, Mass. and London: MIT Press.

—— (1999). *A Voyage to the North Sea: Art in the Age of the Post-Medium Condition*. London: Thames and Hudson.

Kristeva, J. (1984). *Revolution in Poetic Language* (M. Walker, trans.). New York: Columbia University Press.

Kruks, S. (1981). *The Political Philosophy of Merleau-Ponty*. Brighton: Harvester.

Lebovics, H. (1999). *Mona Lisa's Escort. André Malraux and the Reinvention of French Culture*. Ithaca and London: Cornell University Press.

Lee, R. W. (1967). *Ut Pictura Poesis. The Humanistic Theory of Painting*. New York: W. W. Norton.

Lefort, C. (ed.). (1968). *The Visible and the Invisible* (A. Lingis, trans.). Evanston: Northwestern University Press.

Linker, K. (1994). *Vito Acconci*. New York: Rizzoli.

Malraux, A. (1978). *The Voices of Silence*. Princeton: Princeton University Press (original work published 1953).

Melville, S. (1986). *Philosophy Beside Itself: On Deconstruction and Modernism*. Minnesota: University of Minnesota Press.

Merleau-Ponty, M. (1962). *Phenomenology of Perception* (C. Smith, trans.). New York: Humanities Press (original work published 1945).

—— (1964). *Signs* (R. McCleary, trans.). Evanston: Northwestern University Press.

—— (1964). *The Primacy of Perception*. Evanston: Northwestern University Press.

Metzger, C. and Montmann, N. (eds.). (1998). *Minimalism*. Stuttgart: Cantz Verlag.

Meyer, P. H. (ed.). (1965). *Diderot Studies VII*. Geneva: Droz.

Meyer, J. (2001). *Minimalism: Art and Polemics in the Sixties*. New Haven: Yale University Press.

Michelson, A. (1969–70). *Robert Morris*. Washington, D.C.: Corcoran Gallery of Art and Detroit: Detroit Institute of Art.

Miller, J-A. (ed.). (1977). *The Four Fundamental Concepts of Psycho-Analysis* (A. Sheridan, Trans.). New York and London: W. W. Norton.

Moi, T. (ed.). (1986). *The Kristeva Reader*. Oxford: Basil Blackwell.

Morris, R. (1998). *Continuous Project altered Daily: the Writings of Robert Morris*. Cambridge, Mass.: MIT Press.

Nash, J. C. (1985). *Veiled Images. Titian's Mythological Paintings for Philip II*. Philadelphia: The Art Alliance Press, London and Toronto: Associated University Press.

Nelson, R. S. and Shiff, R. (eds.) (1996). *Critical Terms for Art History*. Chicago: University of Chicago Press.

Nochlin, L. (1971). *Realism*. Harmondsworth: Penguin Books.

O'Brian, J. (ed.). (1993). *Clement Greenberg: The collected Essays and Criticism*. Chicago and London: University of Chicago Press.

Orton, F. and Pollock, G. (1996). *Avant-Gardes and Partisans Reviewed*. Manchester: Manchester University Press.

Ost, H. (1992). *Tizian-Studien*. Koln: Weimar, Wein: Bohlau Verlag.

Panofsky, E. (1969). *Problems in Titian, Mostly Iconographic*. London: Phaidon Press.

Pincus-Witten, R. (1977). *Postminimalism*. New York: Out of London Press.

Pope, A. (1960). *Titian's Rape of Europa*. Cambridge, Mass.: XXX.

Potts, A. (2000). *The Sculptural Imagination: Figurative, Modernist, Minimalist*. New Haven and London: Yale University Press.

Podro, M. (1982). *The Critical Historians of Art*. New Haven: Yale University Press.

—— (1999). *Depiction*. New Haven and London: Yale University Press.

Preziosi, D. (1991). *Rethinking Art History*. New Haven: Yale University Press.

Roskill, M. W. (ed. and trans.). (1968). *Dolce's 'Aretino' and Venetian Art and Theory of the Cinquecento*. New York: New York University Press.

Ross, W. D. (1946). *The Works of Aristotle*. London: Oxford University Press.

Rousseau, J. J. (1991). *Oeuvres Complètes*. Paris: Gallimard.

Sartre, J-P. (1956). *Being and Nothingness* (H. Barnes, trans.). New York: Washington Square Press (original work published 1943).

Savile, A. (1993). *Kantian Aesthetics Pursued*. Edinburgh: Edinburgh University Press.

Schapiro, M. (1994). *Theory and Philosophy of Art: Style, Artist, and Society*. New York: George Braziller.

—— (1999). *Worldview in Painting – Art and Society*. New York: George Braziller.

Seppala, M. (ed.). (1996). *Doctor–Patient: Memeory and Amnesia*. Porin: Taidesmuseum.

Serota, N. (2000). *Experience or Interpretation: The Dilemma of Museums of Modern Art*. London: Thames & Hudson.

Snow, E. (1994). *A Study of Vermeer*. Berkeley: University of California Press.
Sobchack, M. (1992). *The Address of the Eye: A Phenomenology of Film Experience*. Princeton University Press.
Strawson, P. F. (1974). *Freedom and Resentment and Other Essays*. London: Methuen.
Sutton, P. C. (1998). *Pieter de Hooch, 1629–1684*. New Haven: Yale University Press.
Tatarkiewicz, W. (1974). *History of Aesthetics*. Paris: Mouton, Warsaw: PWN– Polish Scientific Publishers.
Todd, O. (1998). *Albert Camus: A Life*. London: Vintage.
Verniere, P. (ed.). (1965). *Oeuvres Esthetiques*. Paris: Garnier.
Welchman, J. (ed.). (1996). *Rethinking Borders*. Basingstoke: Macmillan Press.
Weinberg, B. (1961). *History of Literary Criticism in the Italian Renaissance* (2 vols.). Chicago: University of Chicago Press.
Williams, B. (1978). *Descartes: the Project of Pure Enquiry*. Harmonsworth: Penguin Books.
Wittgenstein, L. (1953). *Philosophical Investigations*. Oxford: Blackwell.
De Zegher, Catherine (ed.). (1996). *Inside the Visible: An Elliptical Traverse of 20th Century Art in, of and from the Feminine*. Boston: MIT Press.

Articles

Bal, M. and Bryson, N. (1991). Semiotics and Art History. *Art Bulletin*, 73.
Budd, M. (2001). The Pure Judgement of Taste as an Aesthetic Reflective Judgement. *The British Journal of Aesthetics*, 41, no. 3, 252–4.
Ettinger, B. L. (1992). Matrix and Metamorphosis. *Differences*, 4, no. 3, pp. 177–96.
Ettinger, B. L. (1999). Matrixial Gaze and Screen: Other than Phallic, Merleau-Ponty and the Late Lacan. *PS*, 2, no. 1, 3–39.
Foster, H. (2001). Why all the Hoopla? *The London Review of Books*, 12, no. 16, pp. 24–26.
Guignon, C. (1989). Truth as Disclosure: Art, Language, History. *The Southern Journal of Philosophy*, 28, Supplement, 105–20.
Hall, J. (2000). The Age of the isolated Individual. *The Times Literary Supplement*, 5068, pp. 18–19.
Hertz, N. (1983). Medusa's Head: Male Hysteria under Political Pressure. *Representations*, 4, pp. 34.
Keller, H. (1968). Tizians Poesie für König Philipp II von Spanien. *Sitzungsberichte der Wissenschaftlichen Gesellschaft an der Johann Wolfgang Goethe-Universitat*, 7, no. 4, pp. 107–200.
Krauss, R. (1966). Allusion and Illusion in Donald Judd. *Artforum*, 4, No. 19, pp. 24–6.
Nemser, C. (1971). Subject–Object Body Art. *Arts Magazine*, 46, no. 1, pp. 38–42.

Rosand, D. (1971–2). 'Ut Pictor Poeta'. Meaning in Titian's Poesie. *New Literary History*, 3, pp. 527–46.

Rosenberg, H. (1952). The American Action Painters. *Art News*, 51, no. 8, pp. 22–50.

Smit, H. (2000). Kant on Marks and the Immediacy of Intuition. *Philosophical Review*, 109, pp. 235–66.

Index

Cinthio, Giraldi, 14, 18: *Orbecche*, 17
Cixous, Hélène, 140: *The Laugh of the
Medusa*, 139
cold war, 92
Coleman, James: *Charon (MIT
Project)*, 188
Collins, James, 157, 186
communication, 100, 118, 125, 126
Cornell University, 159, 166
Costello, Diarmuid, 6, 7
Courbet, Gustave, 71–84: *Origin of the
World*, 3, 71–84; *The Painter's
Studio*, 80
Crimp, Douglas, 159
Cupid, 18

Danae, 9: as painted by Titian, 19–21,
25
Danto, Arthur, 168
Delft (Netherlands), 32, 47
Derrida, Jacques, 104, 181, 198
Descartes, René, 199: and
Enlightenment, 2, 7, 29–34, 38, 39;
and existence, 29; and knowledge,
30; *Meditations*, 2, 3, 29–32; and
the senses, 29–32; and wax, 29, 30,
47
Diana, 10, 24
Diderot, Denis, 52, 67: "Lettre sur
les sourds et muets," 52, 66, 67;
"rapport theory," 52, 53
Dolce, Lodovico, 10, 11, 23: *Didone*,
15, 18; *Marianna*, 15
domestic space, 39–48
Dou, Gerard, 35
Dumas, Marlene, 186

empiricism, 52, 55, 64
Enlightenment: Cartesian, 2, 7, 29–34,
38, 39; complexity of, 28; Kant and,
2; and language, 102; as wax and
brick wall, 28–48

epistemology, 114, 126: abstract, 158;
post-Cartesian, 51; post-Lockian, 51
eroticism, 10, 11, 18–20, 22, 25–6, 206
Eros, 25
ethics: and art, 111–27
Ethiopia, 22
ethnography, 198
Ettinger, Bracha Lichtenberg, 5, 131,
135, 138, 140, 141, 147–51: *After the
Reapers*, 152; *Eurydice*, 152; *Inside
the Visible*, 136; and the "matrixial
stratum," 145
Euripides, 18
existentialism, 76, 93, 95, 96, 113
Eyck, Jan van, 36

femininity, 129–32, 134, 138–40,
149–53: and poetry, 130
feminism, 8, 74, 80–3, 129–32, 135,
138, 150–2, 158, 198
Ferrara, Jackie, 157
fetishism, 81, 83, 139, 146, 150
Florence, 13
formalism, 79, 80, 111, 119, 140, 143,
185
Foster, Hal, 111
Foucault, Michel, 82, 163: and
author-function, 79
Fracastoro, 15
France, 92, 95, 170
Freud, Sigmund, 7, 138, 139, 142, 149,
150, 198, 205: and castration, 145,
147, 150; and the "uncanny," 144,
145, 147
Freudian, 141, 143, 144
Fried, Michael, 4, 7, 80–1, 113, 114,
125, 126, 162, 163, 169: on
Anthony Caro, 121; *Art and
Objecthood*, 77, 112, 156; *Courbet's
Femininity*, 80; and the object, 118,
124; and value, 118
Fry, Roger, 79, 140–4, 146